THE ENTANGLEMENT

THE ENTANGLEMENT

HOW ART AND PHILOSOPHY
MAKE US WHAT WE ARE

ALVA NOË

PRINCETON UNIVERSITY PRESS
PRINCETON & OXFORD

Published by Princeton University Press
41 William Street, Princeton, New Jersey 08540
99 Banbury Road, Oxford OX2 6JX

press.princeton.edu

All Rights Reserved

Library of Congress Cataloging-in-Publication Data

Names: Noë, Alva, author.
Title: The entanglement : how art and philosophy make us what we are /
 Alva Noë.
Description: Princeton, New Jersey : Princeton University Press, [2023] |
 Includes bibliographical references and index.
Identifiers: LCCN 2022042341 (print) | LCCN 2022042342 (ebook) |
 ISBN 9780691188812 | ISBN 9780691239293 (ebook)
Subjects: LCSH: Aesthetics. | Art—Philosophy. | Humanity.
Classification: LCC BH39 .N64 2023 (print) | LCC BH39 (ebook) |
 DDC 111/.85—dc23/eng/20221228
LC record available at https://lccn.loc.gov/2022042341
LC ebook record available at https://lccn.loc.gov/2022042342

British Library Cataloging-in-Publication Data is available

Editorial: Matt Rohal
Production Editorial: Kathleen Cioffi
Text Design: Heather Hansen
Jacket Design: Anna Jordan
Production: Erin Suydam
Publicity: Maria Whelan and Carmen Jimenez
Copyeditor: Hank Southgate

This book has been composed in Arno Pro with Futura Std

Printed on acid-free paper. ∞

Printed in the United States of America

10 9 8 7 6 5 4 3 2

In memory of Hubert L. Dreyfus

If you want to see something new, walk
the same path every day.

—CHINESE PROVERB

CONTENTS

PREFACE

Life and art are entangled. My aim in this book is to understand this simple statement and to explore its surprising and far-reaching implications.[1]

To say that life and art are entangled is to propose not only that we make art out of life—that life, so to speak, supplies art's raw materials—but further that art then works those materials over and changes them. Art makes life new. We become something different in an art world. And crucially, our world has always been an art world.

One upshot: art is very important. We haven't understood art and its place in our lives, and we haven't understood ourselves, until we come to appreciate art's generative, transformational, and, indeed, emancipatory power.

Another upshot: because human nature is the stuff of art, it is, really, a misnomer to speak of human nature at all. We are questions, not answers, and in this we are like artworks. We are aesthetic phenomena. To understand and know ourselves, we need to undertake an aesthetic investigation of that work-in-progress that is the self we are.

It is no part of my purpose to say No to science, or even to a science of the human. My aim, rather, is to say Yes to art, and to the importance of the aesthetic attitude that art sustains.

In this book I resist the tendency, in evidence across different communities of thought, and in our popular culture, to underestimate style and the aesthetic by associating these, erroneously,

with fashion on the one hand, say, and something like natural pleasure (if there is such a thing), or mere preference, on the other. If we don't come up with a better, a richer, a more plausible appreciation of the aesthetic, we can't hope to develop an adequate understanding of human being.

Human beings are organized, in the large, and in the small, by habit, custom, technology, and biology. This organization is what lets us have a world and cope with it. Without it, there is no human life; maybe there is no life at all.

But it also constrains us; it holds us captive, defines our *ordinary*, and confines our intuitions. There is no way of delivering ourselves once and for all from the unfreedom that makes us what we are. Even our bodies, thought of as chemical and nervous processes, are organized for regulation and self-maintenance.

It could seem fanciful and romantic, unscientific, even ridiculous, to hold that art and philosophy have the power to emancipate us, not from the reality of organization altogether, but from the particular habitual modes of being that make us up now. But this is my claim: art and philosophy are the ways that we *re*-organize ourselves.

Art and philosophy aim at ecstasy, total release from the states that have pinned us. Philosophy targets the understanding, yes. And art aims at aesthetic pleasure. Okay. But these are surface attributes. Art and philosophy require of us that we work ourselves over and make ourselves anew, individually and ensemble.

Not long after I started work on the book about art and human nature that was to become *Strange Tools*, which came out at the end of 2015, a friend asked me whether I was giving up philoso-

phy of mind. I was startled by the question. It had seemed obvious to me that the problem of art—what it is, how it works, why it matters, and especially the question of aesthetic experience, what *that* is—is a central problem for the theory of mind. In this book I try to explain why this is so.

A. N.
Berkeley
August 2022

1

ART IN MIND

At the very beginning of history we find the extraordinary
monuments of Paleolithic art, a standing problem to all
theories of human development, and a delicate test of
their truth.

—R. G. COLLINGWOOD

LIVING IN THE ENTANGLEMENT

Collingwood wrote the words above almost a hundred years
ago.[1] His challenge is clear. If we've been making art since the
dawn of our history, then art is not the product of that history,
but one of its conditions.

I try, in this book, to take this challenge seriously. Art may not
come first. How could it? But it arrives at the start and there could
be no beginning without it. Art is not an add-on, a mere cultural
extra, but a basic and central part of what makes culture possible.
"Art," as Collingwood also wrote, "is the primary and fundamen-
tal activity of the mind."[2] This is at once a statement about art and
a statement about the mind: art is not a late addition to the
human repertoire, and the work of art, its making and uses, be-
longs to our basic character as human beings.

You might think that the "primitive" mind finds its most
natural expression in song and dance. But that's not really the

3

point. Not that we haven't been singing and dancing since our very beginnings. But art is much more than song and dance. Art, in its proper sense, is a kind of reflection and resistance. Art is irony. Art, for all its physicality and concern for material stuff, its ties to making, building, doing, as well as singing and dancing, is more like philosophy than it is like play; it is rigorous and demanding. Art aims at ecstasy and transformation. Art rocks our worlds.

Collingwood believed that history was central to the work of philosophy. I don't undertake historical research in this book. But there is a quasi-historical puzzle at its heart. We confront right off a striking puzzle about origins.

Consider: we find it natural to write our words down; we know how to do this. But how did we ever do this for the very first time? How did we even come up with the idea that speech, which is bodily, fluid, and tied to the breath and to social relationships, has the kind of articulateness and structure required so that it might be *writable*? The problem is this: to think of speech as possessing a kind of intrinsic articulation is already to think of it as made up of parts, combined and recombined; it is, that is, already to think of it as writable. So it would seem that the idea of language as writable had to preexist the invention of writing. Before there was writing, there was already, and from the beginning, the writerly attitude. (This is my topic in chapter 5.)

There is a similar quandary that arises when we turn to pictures (which I do in chapter 4). As Collingwood warns us not to forget, we have been making and studying pictures for not less than forty to fifty *thousand* years, that is, for as long as there is any reason to be confident that we—animals like us who inhabit the world and experience it as we do—have been around on this planet. But how did we learn to do this? How did we

come to acquire the capacity to contemplate the situation in which we find ourselves with the detachment needed to see it as if it were a mere scene or tableau that could be held still and written down, that is, *depicted*? We are no longer surprised by this capacity for detached viewing, for we live and have always lived with pictures. We know how to use them and how to think of the world as revealed in them, fixed by them, captured in them, even if only very few us can make them very well. But this tendency to look at the world as if it were represented pictorially would be impossible, or rather, not even really intelligible, if not for the fact that the pictorial attitude in some sense precedes the invention of drawing and painting, if not for the prior availability of a picture understanding.

We confront this puzzle about origins even when we turn to areas of our life that seem, at first glance anyway, entirely unmediated by graphical technologies such as writing and drawing, or any other technology for that matter. Human beings have sex, after all. You might think that here, with sex itself, we reach a kind of natural bedrock. Sex has features, so we might think, that stem directly and immediately from the body. Marks of arousal such as blood flow, the secretion of fluids, the swelling of tissue, the very quality of orgasm itself, these seem to be fixed points biologically, the very same for people everywhere and at all times. Maybe so. But caution is due even here. The body is itself a carrier of style and meaning, and even our bodily experience is infiltrated by what you might call a self-conception. Insofar as sex is something that we do with another person, we do it only always under some self-conception of who we are and what we are doing with or in relation to the other. You can no more factor out the social and conception-bearing weight of human sexual engagement than you can factor it out of our linguistic lives. What would it be to be a talking person, a speaking

agent, a linguistic body, in the absence of one's participation in, and one's understanding of, the meaning of one's participation in linguistic encounters with another? As long as there have been human bodies, it seems, these bodies have been bearers of subjective and intersubjective significance—expressed in what we call style—that have no reflection in mere physiology. Even sex, then, is something that we enact or carry out as consumers of and participants in a larger culture of ideas and images. What could tempt us to think otherwise? (The body and style are the topic of chapters 7 and 8, respectively.)

These puzzles about origins remind us of Plato's Paradox of the *Meno*.[3] To learn something new, you must recognize it when you have found it. But if you can do that, you must have known it already. Augustine posed a similar puzzle in *The Teacher*.[4] It is not possible to teach, for students cannot learn something that does not already make sense to them. They are the arbiters of truth, not the teacher. Plato's solution, and Augustine's, is to suppose that the knowledge is already in place. The work of inquiry, or the work of the teacher, is to enable a kind of recollection, a process of making explicit what we already know implicitly.

My own solution is similar to theirs. We already need to view the world from the standpoint opened up by speech, by writing, by pictoriality, by sociality, in order for us to have any possibility of inventing or coming to possess these things. But this is true because, in a sense, we have always had them. We have always been all the things we are.

This is the force of Collingwood's challenge. But is this believable?

Perhaps it would be better to say that *the very fact* of the great monuments of Paleolithic art means that we have to go back *way* farther, tens of thousands of years farther back, to arrive at

anything that deserves to be called our true beginnings. Art, at least as I am thinking of it, cannot be something present at the dawn, for it is too sophisticated. Seeing, dancing, talking, making love, yes. But not art. And this conclusion, it would seem, is underwritten by the appreciation that while art must be the product of culture, these other activities—talking, perceiving, dancing, having sex—these are *natural*.

If you've been feeling vertigo, this won't help you regain your balance. You can't go far back enough. Humans are not machine-like, nor are we beasts. We don't just perform according to rules, nor do we rut; we *experience* our sexuality, and the latter can't be separated from other thoughts and attitudes and values and *self*-understandings. Likewise, we don't just grunt, we talk, and where there is talking, there is not only communication, but there is miscommunication, and there is, inevitably, talk about talking, and there is joking and ironic play. The point is that seeing, dancing, talking, and sex are not and have never been simple; they are sophisticated from the start. (Or to borrow a formulation common in some philosophical circles: they are *always already* sophisticated.) And this means that they participate in art, that they have always participated in art, and that it is through this participation that they become what they are.

At this point, the response might be to say that we need to press back *even farther* if we want to come face-to-face with the natural animals, the mere living bodies, that we really and most truly and most originally are. But this won't work either. We, that is, we psychologically modern *Homo sapiens*, are the ones who talk, and cook and dress; we use tools and make pictures. It is here, amid this repertoire of skillful, technological organization, that the human mind, our distinct manner of being alive in and to the world, shows up. Go back too far, in the hopes of explaining who or what we are, and we lose ourselves.

It is very tempting to think that we can sharply distinguish what we do at the first order, as it were by *nature*, or by habit, from the second-order ways that we think about and experience our own performance. To be *merely animal*, so the thought goes, is to operate effectively at the first level without any participation at the second. What it is to be an animal is thus understood as having a certain *lack* in comparison to a person. Concomitantly, the nature of a human being is thought to be that which it shares in common with "mere" animals. But for now, let us dwell on the discovery, which has been my leading idea: in human being, the two levels are entangled; there is no first order without the second, and the second loops down and affects the first. This doesn't mean we need to give up the distinction. But it does mean that we have no hope of isolating our "true nature" in some core that we share with animals and that can be explained in biological terms alone. We are entangled, and we ourselves are products of this entanglement.

ART'S PRIMACY

I said above that we have always been all the things we are. But it would be more accurate to say that we are ourselves a happening, a becoming. Wherever we first show up, we show up not only as creatures of habit, but as creatures of habit whose very habits incorporate our own acts of resistance. This is entanglement. The things we know best, that make us what we are—our mental powers and personalities—are made up by art, or by art and philosophy. We ourselves, then, are the very stuff of art. We are living in the entanglement.

Let me try to make this clearer.

I begin with the fact that human life is structured by organized activity. Organized activity is the domain of habit; it is typically

skillful, and expressive of intelligence, as well as a range of other sophisticated cognitive powers such as attention. But it is also basic, in the sense of being both spontaneous and also foundational in relation to other activities and goals. Breast feeding, talking, and walking are examples of basic and foundational activities, in this sense. They are, also, typically, goal directed.[5]

Technology plays a special role in connection with organized activities. For tools and technologies themselves depend on being securely integrated into patterns of organized activity. To every tool or technology there correspond suites of organized activity, and organized activities are frequently clustered around tool-using and tool-making activities. Driving and writing are good examples.

Dancing, in the sense in which we dance at parties and weddings, is an organized activity—it is spontaneous and "natural," but expressive of intelligence and sensitivity; it is typically social and serves all manner of communal functions (celebration, courting, etc.); dancing entrains what we do and how we move with characteristic and recognizable temporal and spatial dynamics.

The existence of tools, technologies, and organized activities is art's precondition, rather as straight talk is the precondition of irony. Art does not aim at more tools, more technology, better organization. Instead, art *works with* these constitutive habitual dispositions; artists make art out of them. So, to return to dancing—which forms the topic of chapter 3—dance artists don't merely dance the way the rest of us do at weddings and parties; rather, they take the very fact of dancing and make art out of it. Instead of showcasing it, merely showing it off, they are more likely to disrupt it or interrupt it and in so doing expose it for what it is, an organized activity. In this way they reveal us to ourselves.

Or to use a different example: pictoriality—both the making and using of pictures (in whatever medium, e.g., photography, drawing, painting, digital media, etc.)—is a culturally embedded and settled communicative activity, and has been so, as we have already acknowledged, for millennia. We are fluent with pictures in personal as well as commercial transactions. Think of the pictures of cars advertised by the dealership, or of chickens and broccoli sent out by the supermarket in the weekly circular, or of the photos of grandma on the mantel shelf, or of the selfies we take together at the ball game, not to mention the superabundance of pictures streaming in social media. These pictures carry explicit or implicit captions, and their meaning and content, what they *show*, is secured, usually, by these captions. We seldom need to think twice—there is almost never anything to think twice about—when it comes to seeing what these pictures show. But pictorial *art* is a different thing altogether. The artist isn't participating in the economy of picture-making, but is reflecting on it, or exposing it, putting *it* on display. (Note, this may not be *all* that the pictorial artist is doing, just as choreographers are interested in a great deal more than dancing. For example, artists of all stripes, choreographers and painters in particular, are participants in an art culture; art targets other art, almost always.)

Art practices, then, are tied to *making* activities, to human doing and tool use, for these latter are its preconditions and form the ground from which different art forms or media arise and on which they do their work. Choreographers make art out of dancing, and pictorial artists make art out of picture-using activities. Literary writers, for their part, make art out of the raw materials given by the basic fact that human beings organize themselves, or find themselves organized, by speech, telling, and writing. But art is not itself merely a making activity. Artists

make things not in order to surpass mere technology or manu-
facture, not because they can do it better or in a more "aestheti-
cally pleasing" way. They make things, finally, because we are
makers; that is, we are beings whose lives are given shape by the
things we make and by the ways we find ourselves organized in
good measure by things we have done or made. By making, and
by exposing what our making takes for granted, art puts *us* on
display. And it does so in ways that change us and, finally, liber-
ate us from the bonds of habit and character.

How so? Here is where what I am calling entanglement
comes more fully into play.

Art loops down and changes the life of which it is the artistic
representation.[6] Take the case of choreography. How people
dance today at weddings and clubs is shaped by images of danc-
ing provided by choreography. Our dancing, mine and yours,
incorporates art dancing, however indirectly.[7] Over time, across
generations, the entanglement of dancing and the art of danc-
ing is effected. The entanglement is not so great as to make it
the case that the line between the dance art, or choreography,
and what we are doing at weddings is effaced entirely. But now
the line becomes itself a problem, a source of questioning and
puzzlement. As an example from painting's recent history, con-
sider the fertile exchange, at art schools, and in the art world,
between fine art and commercial art in the mid-twentieth
century (e.g., the Bauhaus, Warhol).[8]

What I am arguing, and what I hope to substantiate in the
following chapters on dance and dancing, pictures and seeing,
writing and speech, and also the body, is that technology is a
modality of organization; it is a ground of habit. Technology
is culture. But *art*, as I am thinking of it here, is not *more tech-
nology*; it is not *more culture*. Art refuses culture, by disrupting
its habitual operations. In this sense it emancipates us from

culture. It does this by simultaneously unveiling us to ourselves—putting the ways in which we are organized by technologies and habits of making on display—and by doing so in ways that supply resources to carry on differently. Art shines forth and loops down and disorganizes and thus, finally, enables the reorganization of the life of which it is the representation and against which it is a reaction. This entanglement of life with nonlife, technology and the reflective, disruptive work of art, becomes essential to life itself, or at least to our distinctively human form of life.[9]

The thing that we need to appreciate, and that we somehow often fail to do, is that talking and seeing are problems for us, for they are organized activities that govern, as it were, without the consent of the governed. It is this fact that explains the *felt need* for visual art, linguistic art, and also philosophy. We are creatures of habit, but we are never only that. We are creatures of habit who, as I have remarked above, always actively resist or at least question our own habits. We are not controlled by rules, determining how we talk, or how we experience the visual world, or our own bodies. But there are rules, and we are troubled by them.

Irony, it turns out, is no less a precondition of straight talk than the former is of the latter. That is, there could be no straightforward and direct use of language for any purpose at all if there were not also the possibility of taking up a playful, or a subversive, or a questioning attitude to language. The point here is not causal but conceptual. A form of linguistic life that left no space for linguistic play would be radically unlike our human lives with language. The availability of irony is, for us, then, a condition of the very possibility of the things we do with words. Irony, we might then say, is, as some philosophers might put it, a transcendental precondition of our lives together.

Compare my claim here to philosopher Donald Davidson's proposition that to have beliefs, an animal must have the concept of belief, and that for an animal to have that concept, it must possess a full-blown conception of truth and falsehood; for a belief is not merely a *record* of how things are, as it were, but a *response* and a *taking* that always, of their nature, raises the question whether things are the way they are taken to be.[10] Davidson thought that you would need to have a language to have the resources for framing this kind of rich conception of belief, and so he thought that nonlinguistic animals do not have beliefs. This is a provocative and maybe overly strong way to make a more innocuous point: there is nothing in the life of a nonlinguistic animal that suggests that it worries about whether its beliefs are true.[11] Its existence is not troubled in that way.

Now I will try to show that to be a language user is to be sensitive to a whole host of demands—so-called normative demands pertaining not just to the question of how we speak, but to that of how we ought to speak—that require of us that we have access to something to which we do in fact have access, namely, writing as a canonical system for representing what we are doing when we are talking.[12] Similarly, pictoriality, as we will consider in chapter 4, is a way of working with and thinking about *what we see* in a way that is sensitive to how fragile and problematic our seeing is. And so in these and other ways we come to appreciate that just as truth presupposes irony, so life presupposes, or is at least preconditioned by, the possibility of art. We make art out of life, yes, but, as we now understand, we make life out of art. Art is one of life's preconditions. Art does not come *first*, not in any temporal sense. But art is not a late-comer either. There is no technology of pictures, or application of writing to linguistic communication, *without art*. To borrow a way of speaking due to art historian Whitney Davis, we ourselves only rise to visuality,

to linguisticality, to thought, when we also rise to painting, poetry, and philosophy.[13] Art is a condition of the possibility of our lives as we know them.

From the standpoint of the entanglement, living in the entanglement—our speech, our vision, our dancing, our bodies, sex show up for us already permeated by and inflected with art. We cannot factor the art and philosophy out of our basic experience. You'd have to go back to an imaginary prehistory to get at experience that was not in these ways entangled and re-entangled with art and philosophy.

The Garden of Eden

Just a brief further word on this, our imaginary prehistory.

"In the beginning was the word, and the word was with God, and the word was God."[14] This Biblical phrase captures our insight. With the word, everything is given. For a word presupposes the whole shebang, that is, all the words, and all the worries about what the words mean, and all the pleas and excuses, but also the relationships and stories of life and death. This New Testament idea seems well anticipated in the details of Genesis. Adam is made in relationship with God, and then there is Eve, and the serpent, and the other animals so that he might not be "alone." The natural condition is one of sociality even if it is also, before the great act of disobedience, a state of childlike naïveté. But with that one bite of the apple, innocence is lost and the more arduous, more adult, life of trial and tribulation begins, as it is known to all of us. It is the act of disobedience that brings Adam and Eve into conflict with God, who speaks to them and gives them orders, as a parent, that is to say, as a person would; and it is this act of disobedience that first gives them their "self-conception." Once they have disobeyed God, they hide from

Him, they seek to escape criticism, and they blame each other and the serpent; now they know both shame and its correlate, lust, and also the imminence of death.

We can see that Adam and Eve emerge from Eden as fully formed, self-aware, motivated persons. Nothing essential is lacking for there to be what we might call society or civilization; theirs just happens to be a society of two. All that's missing is more babies. And of course with more babies comes the first murder of Abel by Cain. But while a novel occurrence, the first murder, its shape and possibility, was present proleptically in the moral and emotional landscape that is already in place at the moment of expulsion.

Now one might object to this Biblical story precisely on the grounds that it falsifies what is surely the accomplishment of natural evolution over deep time and cultural evolution across many tens of thousands of years. But this story—Adam and Eve's story—seems to capture, as no evolutionary account is able to, the fact that the human being is not an organic system that *later* acquires consciousness, but is, if you like, a singular exemplification of consciousness, with all its facets—social, linguistic, moral psychological—from the outset. ("A dynamic singularity," to use Hurley's phrase.[15])

It is not much of a stretch, I think, to notice that art is everywhere in Genesis. God is the maker, the artist, and we are His handiwork. And Genesis is the telling of our story, in the terms *we* understand, that is, it is *our* story, as told not by God, but by us. So we come to understand ourselves according to a story of our own devising in which our own origins are made up.

And remarkably, this simple fable, just a few short paragraphs long, prefigures certain aspects of what will come to be known later, in philosophy, as the mind/body problem. Some early Christian thinkers argued that carnal desire is a consequence of

the Fall, but since nothing that happens is not good, since every-thing that happens is *from God*, carnal desire must be good. It is good and natural precisely, or just because, it is something that we must resist and deny. This kind of Christian thinker occupies a position that is the ancestor of a materialist naturalism. The sex drive is innate and we have to deal with it. But other thinkers, somewhat later, foremost among them Augustine, have a picture according to which there is no straightforward reading off of our needs, pleasures, or drives from, as it were, our *natural* condition. According to Augustine, love and marriage were already there for us in Eden.[16] The Fall stems from disobedience, and our pun-ishment, as Augustine sees it, is a twisting and distorting of the will with the consequence that sex, love, and marriage are no longer our unproblematic birthright but something difficult that we need to work on and try to achieve. For Augustine, the con-flict is *psychological*, not physical, and it is irreducible to our physical condition. Our wills are deformed and we are now at odds with our own bodies. Impotence, on the one hand, and "nocturnal emissions," on the other, are evidence that we have no control over what we do, no harmony with ourselves. This is our lot and our punishment. Mind and body have lost the inte-gration they knew in Eden.

What is important for our purposes is that we would need to go back to our first days in the Garden to find ourselves, as we were, before the entanglement has given us the resources to become what we are—fully, recognizably human. Which is just another way of saying that there was no human being before the entanglement.

2

DOMESTIC
ENTANGLEMENTS

The artist cannot and must not take anything for granted,
but must drive to the heart of every answer and expose
the question the answer hides.

—JAMES BALDWIN

The idea that nature and culture are entangled is widely ac-
cepted among both anthropologists and cognitive scientists; it
is almost a commonplace. What makes us special (as Boyd puts
it), or the key to our success (in Henrich's words), is not what
is inside us, so to speak, in our brains, but rather the ways that
we have learned to cooperate, the strategies of distributed intel-
ligence that we have mastered, our tools and technologies.[1] On
its own, the human individual is a naked ape who would prob-
ably not fare much better than a baby if plopped down in the
deserts of Australasia or the jungles of South America. But
dressed, equipped, trained, armed with the lore of a commu-
nity, and accompanied by others, the human being is indomi-
table. We are the smartest species there is, but not because you

and I are so smart. It is the work of the *we* that explains human adaptive success.[2]

This idea that a human is a kind of natural cyborg, that we are the product of what might be called the entanglement of human nature and human invention, as philosophers as diverse as Donna Haraway and Andy Clark have proposed, is central to what I call "the New Synthesis."[3] Modern biology achieved its full explanatory power, its ability to account for life, its variety, and origins, thanks to the Original Synthesis, that is, the integration of Darwinian evolution with Mendelian genetics, but also with the new molecular biology that came of age in the mid-twentieth century. But if we are to explain the *human mind*, it is now believed by many, we need a New Synthesis, that is, we need to join biology, so understood, to the theory of cultural evolution. For it is cultural selection, and cultural modes of sharing, change, and transmission, rather than genetics or natural selection, that explains the emergence of uniquely human cognitive accomplishments, a process that, as we have already considered, probably began around one hundred thousand years ago. It is culture, layered on top of biology, that explains how we became human.

I do not underestimate the importance of this scaffolding.[4] But my target in this book is a different phenomenon. Whereas this type of entanglement is domesticated for the purposes of scientific explanation, the entanglement I have in mind is more radical and pulls us in an opposite direction, forcing us to acknowledge the limits of what we can use science to explain.

Human life, to repeat, is *organized*. We can focus on its organization at different levels. For example, we can look at cellular organization or at larger systems at work in the body (e.g., circulation, respiration, the immune system). We might even look at the human body as a physical system and pay attention to the way physics operates both on it and in its confines.

Or we may consider the level of organization called habit.[5] However hard-won our skills may be—those of mobility, language, literacy, whatever—in maturity, they take the form of habits. What is distinctive of a habit is that it is the tendency to act or perform, to move or to respond, to take up an attitude; it is the tendency to lump together, see, or categorize, or even to feel, that kicks in, as it were, unbidden, and seemingly of its own accord. Habits are simultaneously enablers and impediments; they are ways that we find ourselves organized.

There is an idea, a kind of fantasy, of a person who would transcend the constraints of habit. Sometimes something like this is indeed possible. A surgeon uses a list so that habitual ways of acting are checked by information about "best practices." The same is true of astronauts or of anyone who is acting in a strange environment.

But it is easy to see that habits, and, in particular, skills, are the substrate that makes any kind of action, intention, or competence possible. So there is no such thing as a habit-free existence. Yes, the astronaut moves each foot deliberately and checks him- or herself with care, but what makes this kind of concern possible is a fundament of habitual ways of thinking, handling, discerning, and actuating.

Let's think of our habitual selves as our first-order selves. This is the way that we just find ourselves being. To be a person, thought of this way, is not to be an automaton, but it is to be liable to all manner of automatic inclinations, and it is, in a way, to be a slave to one's liability to automatism.

Technologies—thought of as narrowly or broadly as you wish—are connected to automatic being (and so to unfreedom). To learn to use a tool is to learn to use bits of the world to extend the substrate of our constitutive organization. Tools let us reach farther, turn harder, cut more effectively, move

about and also navigate with greater range, and so on. Tools and technologies—pencils, shoes, cars, computers, space ships, maps, mirrors, spoons, tweezers, axes—are in this way *organizers*; they impose new habits; they require them.

And since habits compose us, quite literally, making us the kind of beings that we are, technology remakes us, by organizing us in new ways. The history of technology is thus the history of new ways of human being and becoming, new ways of getting organized.

So we may with justification speak of the entanglement of human nature with technology.[6] And if we think of technology as the fruit of culture, as we should, then we can speak of human nature as entangled with culture and of human being as a kind of bio-cultural phenomenon. This is why I said, in *Strange Tools*, that human beings are cultural by nature.

Now *art*, as I understand it, is not technology. Rather, art, which always works with the material culture of technology, is not in the business of organization, or the establishment of new habits. Art aims, instead, at the disturbance of habit. Art is a kind of reflective activity.[7] Works of art—whether pictures or writings or dances or songs, or whatever—represent and explore us by reworking the raw materials of our organization. I don't mean that artists—always and everyday—are revolutionaries; that is a particularly and narrowly contemporary ("avant-garde") conception. But the very *work* of art—the work of drawing, say—can end up being revolutionary, emancipatory, anyway.

Consider, as an example, the depiction of a pig, made some forty-nine *thousand* years ago in Sulawesi and only recently documented as the world's oldest extant painting.[8] We know next to nothing about why this picture was produced, but if we suppose that it is art, then we know, at least, that it is a gesture made against the background of some context of caring, and we

know, I think, that this caring is bound up, directly, or indirectly, with *seeing* and *making*, and with *pigs*. Abstracting away from everything that we don't know, we can suppose, I think, that this made-thing would have invited questions: What is it? What does it show? What is the nature of that which it shows? How does that nature get altered by, or reconfigured, thanks to this act of drawing? And what is showing, what is seeing anyway? And what is achieved in the making, or in the collective behold-ing, of that which is made? And what is the right way to behold? How do you see it? How do you take it in correctly? If we think of this *pig* as a communicative gesture in a space of vision and manufacture, then what would it be to *get* it?

Of course, it is also possible that this is no work of art at all, but nothing more than, as it were, a move inside a system of notation, a record, or a notch, a count, or a warning, not something to be looked at and contemplated, but something to be relied on, taken for granted, something at the limit of notice. That is, it could be that the uses of this picture are, so to speak, *technological*, that is to say, aiming at information and regulation rather than, as it were, the uncovering of as of yet concealed questions.

If technology, like everything that resides at the level of habit, is first order, then art is a second-order practice. Its values have to do with the ways it puts the first order—who and what we are, or see, or need, or feel, or care about; the implicit organ-izations that make us what we are—on display.

It is this making explicit of what is implicit, this unveiling of ourselves to ourselves, that is the source of art's *reorganizing* power. For to model ourselves in the artwork—to put, in our example, all the assumptions or unnoticed questions about pigs, seeing pigs, making pigs, caring about pigs, or whatever, on display—is to give us resources, and in fact is likely to com-pel us, to be different going forward. Pig art serves as a resource

for thinking and rethinking our relation to pigs, seeing pigs, see-
ing mere pictures of pigs, and so on, that is, our relation to our-
selves in relation to all this. So pig art, in effect, has the potential
to change our first-order life not only with pigs, but with
picture-pigs, pig-thoughts, and so much more.

In this way, second-order art practices loop down, to use Ian
Hacking's phrase, and change our manner of first-order habitual
organization.[9] The representation changes what is represented.
Having done so, new *implicits* take shape that in turn demand
more reflective work of disclosure, that is, more art, and the
circle of influence continues. But actually, things are more com-
plicated still. For the first order—our pig-oriented lives, but
also our pig-picture-using activities—had prefigured the pos-
sibility of and need for the second-order representation from
the start. To make an art-pig is only to activate the potential for
irony, sophistication, and self-awareness that was already in the
offing in all our pig-dealings. The first order was never, as it
were, really truly only first order. Second-order reflection on
our manner of being, that is, on our first-order habits, organized
activities, and so on, is a condition of the possibility of those
activities themselves. (This is tied up with the fact that however
habitual we are capable of being, we are never true automatisms
or machines; and this may also be connected to the idea that no
machine, however well it "does" this or that, will ever achieve
genuine thought or consciousness.)

Which is not to give up the distinction between first and
second order altogether. We need this distinction if only so that
we can bring the novel and important phenomenon of *their
entanglement* into focus. The first order and the second order—
habit and technology, that is to say, *life*, on the one hand, and
art, on the other—are entangled. And it is *this* entanglement
that is so crucial, and that is the phenomenon that forms the

topic of this book. For it is this entanglement—not the *inte-gration* of human being with cultural product, but rather the transformation of the ways that we are organized by reflective resistance to the ways that we find ourselves organized—that is the key to understanding our true nature. Or rather, it is the key to understanding why *nature*—the idea of a fixed way that things just are, once and for all, as it were—loses its application to maker-creatures like us.

Now part of what makes it difficult to keep this radical entanglement of art and nature apart from the more domestic entanglement of the New Synthesis is that technology (which organizes) and art (which reorganizes) are frequently materially identical. For example, the pig-tool and the pig-artwork, as fundamentally different as they are, might overlap in one and the same object. Or take a different example: if we take writing to be a technology for representing speech—this is a simplification that I will correct when I turn to language in chapter 5—then writing is an instrument of organization; language becomes a habit structure built up out of an intertwining of both speech habits and writing habits. Thought of this way, writing is culture, writing is technology, writing is organizer, writing is regimentation. But writing can also be something other, it can be art, it can be the means of representing what we do and what we are—the unveiling of ourselves to ourselves—in ways that utterly transform us by reorganizing us, by crashing rules and regimentation. Indeed, writing, in our lives today, is both of these things. Writing can be drilled into us in school as an apparatus for regulating and governing our linguistic personalities. But it is also an instrument that lets us handle, reflect on, and work with our own thinking, talking, speaking, arguing, and feeling. The difference, then, between writing as art and writing as technology, the very task of keeping these two apart,

becomes itself a phenomenon of entanglement; indeed, it becomes, in effect, an *aesthetic* problem.

I will say more about how I am using this term "aesthetic" in the second part of the book (in chapters 6 and 9 especially). But the basic idea is that aesthetic matters are always contestable, and they concern, always, gaining a clearer or different view of what is there already; they concern bringing what we already perceive (or know) into focus, or into a new or different focus.

It is the fact of this radical entanglement of art and life that makes the task of understanding ourselves into an aesthetic problem, and, as I will show, it is art and philosophy that provide us with the best means for undertaking this work of self-understanding.

To recapitulate: I use the term "entanglement" to refer to the ways in which what we are is changed by the work of reflection, specifically, the work of art, and, as we shall see, philosophy. We are, as it were, of our most fundamental "nature," creatures who are changed by the reflective and creative resistance to the ways that we find ourselves habitually organized, a reflectivity and resistance that is manifest in art and philosophy. The problem we face, as students of ourselves, is that of catching ourselves in the act of making ourselves. This problem is, in ways that will become clearer, an aesthetic one.

The next three chapters—3 through 5—are, in a way, case studies. I try to show that dance, vision, and speech are entangled with choreography, pictures, and writing, respectively. These are distinct modalities of entanglement. In the next five chapters (comprising part II), I turn to the body and also to aesthetics, ethics, and style. In the book's final chapters (part III), my topic is the question of the nature of nature.

3

DANCE INCORPORATE

We have learned to love all the things we now love.
—FRIEDRICH NIETZSCHE

A young child of seven or eight years old already moves her body, when she dances, with a sensitivity to what is expected of her. Perhaps she has seen Billie Eilish and Taylor Swift in their videos; she has danced with Mom; she has a bank of personalities and images that supply her with a felt sense of what is right, of what *feels* right. Remarkably, what feels right has everything to do with what would look right to others, with her sensitivity, however unarticulated, to how others would respond to her. The young person identifies with her own body and her movement; without any deliberation at all, she strives to incorporate the movement quality she has seen in others, perhaps only in the image; she does this spontaneously.

This dancer is not burdened; her energetic taking up of dancing is a voluntary and maybe joyful stretching out, an entering into a social reality in which she actualizes herself. But what she accomplishes, what she actualizes—this is a remarkable and distinctively human form of intelligence at work—is nothing less than the embodiment of choreographic ideas or images of

which she is not the author. Her dancing, unencumbered and free as it is, indeed, her body itself, is the location of *entanglement* between her native impulse to move and an idea, or better, a publicly available picture or model, an artistic or choreographic representation, of what movement is supposed to be, how it is supposed to look and feel. This circular, dynamic, looping process repeats itself, in her, and in all of us, over historical time, until this spontaneous thing that we call dancing is something that is not only made and continuously being remade, but is also, somehow, for all that, something found, encountered, and, as it were, pregiven.

This is an example of the kind of entanglement that is my target in this book.

DANCING AND DANCE, A DISTINCTION AND A PROBLEM

The eight-year-old dancer loves to dance. Dancing is her preoccupation. Indeed, dancing is a skillful activity that is taken up spontaneously and without explicit training by many people everywhere. Dancing occurs in different settings. At weddings, people dance to celebrate, and also to experience for themselves the erotic meaning of the occasion. At clubs, people join in a frenzy of collective play and release; it is hardly possible to enumerate all the different goals, needs, and curiosities that motivate people on the public dance floor, but no doubt attraction, desire, the wish to see and be seen, and the impulse to be intimate with others would be on the list.

Dancing is an *organized activity*; it is like looking, walking, talking, and driving.[1] These activities are skillful and socially embedded; that is, they are hooked up to the larger interests and projects of the people who adeptly pursue them. For ex-

ample, we drive *to work* or *in order to go shopping*. Even when we pursue activities such as these as ends in themselves—e.g., when we are *just taking a walk*—there are larger schemes of interest and value that we aim at (we walk *for the exercise*, or *to clear our heads*, or whatever). And so it is with dancing.

As with walking and the rest, dancing is *habitual* in at least two different ways. First, some of us are habitual dancers in the sense that we dance regularly; that is, we dance a lot. But second, and far more interestingly: for most of us, indeed, probably for all of us, *how* we dance is habitual. Our dancing is at odds with planning and deliberation. To the degree to which we excel, we do so by letting ourselves go; we act without undue attention to what we are doing. We just dance. In these ways, dancing is the spontaneous expression of skill and personal style. How we dance is connected to who and what we are; it is something that we embody, but also something that we have taken on, rather as we have taken on a way of talking (such as a dialect).

I say habitual, but this does not mean mindless. To dance well is to manifest a distinct kind of intelligence; dancing isn't just moving; it is, usually, moving in coordination with others, as well as with the music; it requires attention (to beat, rhythm, phrasing) but also, more generally, a sensitivity to gesture, expression, timing, feeling, social relationship, humor, and more. Like other organized activities, dancing is a blend of sensitivity and limitation, cognitive vitality and habitual capture.[2]

I have said enough about dancing to be clear what I have in mind: *it is a skillful activity that is personal and embodied, and also embedded in a wide variety of different manners in social life.* I would like now to contrast dancing (dan*cing*) with *Dance* (Capital-D Dance), which is, I believe, none of these things.

Notice, to begin with, that Dance professionals are not simply people who do what the rest of us do when we dance, but

in exchange for payment. It is easy to imagine that there are "professional dancers" in this further sense. In fact, the existence of such dance-partners-for-hire was, I believe, a mainstay of dance halls back during the World War II era. No, when we speak of professional dancers as we usually do—whether we mean practitioners of Classical European, Chinese, or Indian Ballet, or Contemporary Dance, or whether we have in mind the Rockettes, or, in yet another vein, Beyoncé or Michael Jackson— we are thinking of people who have an *entirely different kind of relationship* to dancing than we ordinarily do, we ordinary dancing people.

It isn't just that Dance artists are likely to draw on a specialized training, or that they labor to achieve heights of virtuosity, or that they rely on vocabularies of movement that are quite removed from those deployed by the rest of us when we party. All this is accidental; after all, there are lively and important forms of Dance that eschew not only virtuosity but also the specialized movement vocabularies of a Dance tradition; these artists make works out of everyday dancing or even everyday action or movement.[3] No, the point is much more fundamental than this, and also more subtle. Dance is never just dancing, even when that's precisely what it looks like. Let me explain.

Dancing, as I have already stated, is an organized activity. It is first order; something that we do. *Dance*, in contrast, is a second-order *practice*. Dance puts dancing on the stage; it offers enactments or displays or (to use a word I usually try to avoid) *representations* of dancing on the stage. And so, of Dance, or of choreography—I use these terms more or less interchangeably—we can say that it puts *us*, and, in particular, the fact about us that we are dancers, on display. Dance unveils us to ourselves in the modality of dancing.

It is helpful, for certain purposes at least, to think of Dance's relation to dancing as like that of the model unit in an apartment complex to any of the rented or available units. The model unit is no more than that, a model; it is exemplary. It need not be *better* than the other units, or different from them in any materially significant way; it may be just another random unit. What makes the model unit *exemplary* is nothing material, or intrinsic; it is rather, and only, the use to which it is put.

And so with Dance and the dancings that are so much in evidence in our lives. Dance exemplifies dancing, not because it is better dancing (although it may be), nor because it differs in any materially significant way from regular dancing (it may not: the dancers on the stage *may* be doing just what we would be doing in the club or at the party). As with the model unit, the source of the distinctive exemplary character of the dancing of Dance is not its intrinsic character but the use to which it is put. You or I may dance at the wedding to celebrate the occasion, or to establish a friendly intimacy, or even, in the way that we cite, sample or playfully affect familiar dance gestures, thus to display our cultural sophistication.[4] But the dancer on the stage is not doing this sort of thing at all; they are not participating in the modality of cultural exchange we call dancing; rather, they are putting the modality itself on display; they rely on dancing, take it for granted, but they do so as artists, approaching it from outside the ordinary frame in which dancing is at home. Dance/choreography is dancing of the second order, *meta-dancing*, or better, it is an investigation of dancing. The artist puts dancing itself on display, and so, in effect, the artist gives us (yet another) model or depiction of what dancing is (or can be, or might be, or has been) for us.

Dancing Entangled

So then what does choreography, that is to say, Dance, have to do with dancing? This question now begins to assume a thicker, more representative character, for what we are really asking is, What does art have to do with life?

I offer a playfully paradoxical answer. Dance has both *every-thing* and *nothing* to do with dancing. Dance has nothing to do with dancing because, whatever Dance is, it is not just more dancing. Dance and dancing occupy radically different places in our lives. The latter is an organized activity. The former more like a species of philosophy. But because Dance would have no significance but for the fact of dancing as an organized activity itself, Dance has everything to do with dancing.

But the connection of Dance and dancing is even tighter still. Dancing may be categorically distinct from Dance, that is, from choreographic art, as I have urged. But, at the same time, danc-ing *incorporates* choreography.[5] This was the upshot of our re-flections on the eight-year-old girl. This is the phenomenon of entanglement. *We* come to embody choreographic ideas when we dance. We do so naturally (!), and we cannot avoid doing so. And this in turn gives more and new information to chore-ographers who investigate what it is we are doing when we are dancing. Dance alters dancing and dancing informs Dance. This looping is the source of the entanglement the elucidation of which is our goal.

The fact of the entanglement of dancing and the art of Dance means that both are likely to be alive and present in any single dance-act. The little girl is registering a whole art tradi-tion in her dancing, however naïve. And the dedicated artist on the stage is making art out of such materials as this little girl's impulse to dance. And in the same way, the teenage

dancers at the party may be at one and the same time just danc-
ing, taking part in the social realities and ambitions of dancing
with and for your friends, but they may also be, in a way, mak-
ing art, for they may also be, whether they think about this or
not, putting not only themselves, but dancing itself, on dis-
play, and in such a way as to disrupt dancing's usual function-
alities. So *dancing* is everywhere on the stage, and *Dance* is
everywhere in the school cafeteria where the school dance
is held. This is the reality of the fact that Dance and dancing
are entangled.

We would make a big mistake, however, if we thought that
this entanglement means that the difference between Dance
and dancing collapses. The sharp difference between the two is
a precondition of the very entanglement that might seem to
threaten the distinction itself. And crucially, as I have stressed,
the distinction is conceptual; that it can be blurred in practice
is no obstacle to its reality or its importance.

One consequence of the entanglement is that it is not possi-
ble, for you or me or anyone else, to dance in a way that is unaf-
fected by the influence of Dance and its history. The looping (to
use Hacking's term again) and sedimentation (to use Husserl's)
have been going on for so long and with such generative energy
that you'd have to do something impossible—for example, go
back to Eden, that is, go back to a make-believe prehistory—to
witness our "natural," "true" impulse to dance and to investigate
how it differs from what we know dancing has become (predi-
gested, culturally worked over, etc.).

Again, it is not that we can't differentiate dancing from
Dance. We can and we must, for these correspond to different
dimensions of life. Nor is the point merely that it is the fact of
their entanglement that makes it frequently impossible to dis-
tinguish what happens in the disco and what happens on the

stage, or that it is the fact of entanglement that makes dancing/
Dance meaningful in all the ways it is.

No, this is our crux: for us, dancing, as an anthropological
phenomenon, has no fixed nature apart from its entanglement
and its history. This means that we cannot hope to put dancing
itself, as if it were a natural fact about us, under investigation as
a natural phenomenon. Dancing has no nature; it is something
changing and shifting, something whose identity is dependent
on the existence of art. Which is not to say that we cannot in-
vestigate it, or any other aspect of ourselves. This is what we do
when we create choreography, or when we philosophize. Cru-
cially, the fact of entanglement brings into focus the limits of
positive science and the inescapable need for the modes of re-
flective exploration that are art and philosophy.

The Urgency and Ecstasy
of Dance and Philosophy

Dancing gives rise to Dance, the art of dance, which in turn
gives dancing new resources, and this circular, generative recur-
sion drives us forward. The entanglement of art and life—
exemplified by what I have been entertaining about choreogra-
phy and dancing—is what gives our cultural existence its
necessarily historical dimension.

Choreography loops down and remakes dancing. But the im-
pulse to depict dancing itself, to produce choreographic images
of dancing, seems, as I have already hinted, to arise spontane-
ously out of the act of dancing itself. Why should this be?

Remember, dancing, as I am thinking of it, is habitual and
implicitly functional. We dance to celebrate, or flirt, or exercise,
or whatever. Dancing, like eating, sex, or talking, typically has
multiple ends; it never has no ends at all. And likewise, dancing

is habitual; we do not, we cannot, choose the movements that come naturally to us or feel right; if anything, these habitual tendencies govern what we can even want to do on the dance floor; they describe the arc of our possibilities. The habits, the possession of which enables us to dance, also hold us back.

So the impulse to make choreographic models of ourselves dancing—the impulse to make art out of dancing—is precisely the consequence of the dual facts that we neither know what we are doing, nor why we are doing it, when we are dancing, and, on top of that, that we seem unable to do it any differently. Choreography, by disrupting how we would otherwise dance, not only unveils us to ourselves, but sets us free, or at least enables us to do things differently going forward (which may just mean getting entrained by new habits).

The aim of art is ecstasy. I don't mean passion, emotion, or pleasure, although it may afford all of these. Its push is for release and its point is to undo the stasis that is our ordinary, our normal, and our most familiar condition. Choreography and other forms of art aim at *ek-stase*, the destruction of the stasis that holds us captive and that makes us what we are.

Far from stripping choreography of its "affective charge,"[6] by representing it as somehow philosophical, I am seeking to bring out its primary impulse, itself affective, but not only affective, one that is shared by all the arts, including, as I understand it, philosophy.

From this lens and standpoint, philosophy too is one of the arts. Consider that philosophy does to our thought and talk what choreography does to dancing. In effect, it shuts it up, or stops it, or interrupts it. It takes these earnest doings—talking, dancing, arguing—and samples them, looks at them sideways, brackets them, or, in Husserl's memorable choice of phrase, "reorients us" to them.[7] And philosophical reorientations, like

choreographic ones, are productive. They change the way that
we think, or dance, going forward. They change what we are.

NEWMAN'S NOTE AND THE MEANING
OF "CHOREOGRAPHY"

Barnett Newman, the painter, tacked a note on the wall at the
entrance to the Betty Parsons Gallery on the occasion of his
first solo show in New York City in 1950. With this note, he in-
vited visitors to the gallery to step up to the paintings, to look
at them up close, rather than from afar. This act of Newman's,
this direction, is a choreographic act. But what makes it choreo-
graphic is not the fact that he sought to *guide* or *govern* the
movements or attitude of his audience. The choreography in
Newman's direction consists rather in the way it, the direction,
effects the upsetting, interrupting, or disrupting, of what visi-
tors to the gallery would otherwise have been spontaneously
inclined to do.[8]

I do not know what Newman's intention was. Perhaps he
wanted people to experience something they could only experi-
ence up close. But what he did, in effect, was incite visitors to
act contrary to habit. Habit dictates that we step back to inspect
the large object on the wall, that we adjust ourselves so that we
take up an optimal viewing distance, one that would let us view
what interests us as a whole. Ordinary perceiving is made up of
just this kind of unthought activity, these silent adjustments
that are necessary if we are to bring the world into focus, to
cope with what engages us. We peer, squint, turn, we draw close
or step back. The stamp collector bends close. When two
people talk, they position themselves so they can see each
other. Not too close, not too far. There is no need to take out a
tape measure. In each context, we *feel* the tension that indicates

that we have not yet found the optimal position, and we natu-
rally, that is to say, unthinkingly, but with the greatest of skill,
adjust and negotiate until the tension is released. Again, not too
close, not too far, just right for the situation at hand.[9] Seeing,
like other modes of perceptual exploration, is embodied in
skills such as these. We bring the world into focus. We achieve
access to it. We don't contemplate pictures in the head when
we see. We work to see and the seeing is the working itself; the
ground of that working, what makes it possible, is our bodily
know-how, our understanding, our curiosity, our need, our sen-
sitivity to context.

The effect of Newman's urging, as I understand it, is not to
organize our movements in the gallery, but rather to *disorganize*
them, to disturb our predisposition so as to be orchestrated and
moved by the object on the wall. He created a new situation, a
choreographic situation, in which we are made to do precisely
what our understanding and our competence lead us not to do.
He asks us not to take up the optimal viewing point, but to resist
doing so. He forces us, in this way, to respond to his paintings not
as objects to be inspected, but as situations, or occasions, in
which we find ourselves unmade, unorganized, set up against our
own dispositions. This is the choreography in Newman's note.

It is important to appreciate that habit, unthinking engage-
ment, skillful attunement to the world drawing on what we
know and can do, is not a bad thing. It is our achievement, and
without it there would be no human, indeed, no animal life. In
Dewey's image: life is the circular making of oneself and one's
experience through doing and undergoing and intelligently
coping with the effects of one's own doings on oneself.[10] We
are, in the fullest sense, creatures of habit.

But it is also critical that we admit that because we are, in this
sense, creatures of habit, we are also confined and constrained.

We are like Gregor Samsa, who wakes up to find that he is now an insect. We wake up and find that we are governed by the manner of our organization. Organization enables, but it also disables. Organization is an existential, a biological, necessity, but it is a problem for all that.

The effect of Newman's direction is not to produce a new or different experience, whatever he may have aimed at; it is the upsetting of that which makes ordinary experience possible. What is upset, really, is the very basis of our competence as perceivers, that is to say, as conscious human beings. And what this upsetting of our nature (all our natures) affords is not so much a new experience, or a new seeing, as an unveiling to ourselves of the myriad ways in which our ordinary, habitual modes of coping and engaging make us what we are.

I offer Newman's example as a glimpse into the meaning of the choreographic. Choreography disorganizes. In doing so, it sets the stage for letting us reorganize. Choreography, like philosophy, is a reorganizational project.

CHOREOGRAPHY: TWO DIFFERENT CONCEPTIONS

The idea that choreography is tied to organization is, in a way, a commonplace. I have heard it said that we are all choreographed all the time. But this is only half true. What this proposition gets right is the fact that, as we have already noticed, we human beings are organized by habit and body schema and learning, by technology, and by our environments. When we think of choreography in this way as tied to the ever-present fact of our organization, then we can say, for example, that a military general is a choreographer, or that traffic patterns in a city are a

choreographic phenomenon. In this sense of the term, every object, by dint of what it affords or solicits, is, as the choreographer William Forsythe has suggested, a choreographic object.[11] Objects—doorknobs, paintings on the wall, whatever—these solicit us and, in a way, *move* us. And so in this sense, what we call design, in whatever domain—furniture, manufacturing, architecture—is always a kind of choreographic engineering. In this vein, we are entitled to think of stagecraft itself as aiming at the choreographing of an audience's looks and attention, or of architecture as the choreography of our active living in human-devised structures. And it is in this sense that evolution itself, or rather, the coevolution of animal and environment, is a choreographic event or process.

When we think of a choreographer as the one who is in charge, the one who decides, for example, on the dancer's steps, and when we think of a good dancer as one who has been trained to do what the choreographer demands, to do the moves, to follow the score, to enact the plan, when we think and talk in this way, we are thinking of choreography as tied to organization in this familiar way.

This conception of choreography as designing our coordinated movement also captures beautifully the somewhat surprising fact that choreography has a much wider range of application than dancing. On this conception, choreography *is* an organizational practice; it is planning and control. It is counterpoint, the alignment of events of a kind in space and time, as Forsythe says. And, to repeat, it also captures the fact that organization is, simply put, important. It is the pervasive and abiding condition of human beings that we are organized, that human beings, and all living beings, are, by their very nature, governed by situation and habit.

But for all this, I recommend a different conception.

Yes, choreography is tied to organization, but not in the way this familiar picture would have us think. Choreography is not, not really, in the organization business. It is not the most general discipline of imposing organization. Choreographers are not engineers of behavior or movement in the way that designers, like evolution itself, may very well be.

Choreography takes organization for granted. It makes this fundamental and indeed biological fact that we are governed by habit and situation, or by other forms of social control, its presupposition. And its aim, its project, is not to tune us up, or organize us better, but rather, to interrupt or disrupt or, more bluntly, to screw up these inherited, invisible, unnoticed, familiar, conditioning forms of organization. Choreography aims at disorganizing us. Choreography unveils the sometimes lovely, sometimes ugly ways in which we are always already organized and does so in ways that must change us.

This is the source of its value. Choreography is important not because we crave better dancing, or better forms of organized engagement (even if we sometimes do). Choreography is important because, given that we are dancers, given that we are moving embodiments of organization and habit, we need to free ourselves from all that.[12]

4

STYLES OF SEEING

Where, if not from the Impressionists, do we get those
wonderful brown fogs that come creeping down our streets,
blurring the gas-lamps and changing the houses into
monstrous shadows? To whom, if not to them and their
master, do we owe the lovely silver mists that brood over
our river, and turn to faint forms of fading grace curved
bridge and swaying barge? The extraordinary change that
has taken place in the climate of London during the last
ten years is entirely due to this particular school of Art.

—OSCAR WILDE

PICTURES IN CONTEXT

There is an old-fashioned party game for children. Each child
reaches into a brown paper bag whose contents are hidden from
view; the task is to name what you hold in your hand. Even famil-
iar household implements such as a comb, a cork, a thimble, a
feather, a sponge, a spoon, and the like, can be delightfully baf-
fling. To the touch they can seem fragmented and disunified, a
chain of empty properties. The moment of recognition can be
thrilling. Beneath your touch, the properties assemble them-
selves as integrated wholes. Now *they*—the objects themselves
rather than the isolated qualities—show up in your perceiving.

Context plays a similar and similarly invisible role when it comes to pictures. It is rare that we encounter pictures whose preassigned task is not evident. Pictures, whether in print or online, or wherever, typically come with captions attached. And even where there is no caption, pictures very frequently have readily apparent rhetorical or communicative functions. The picture of husband and child that adorns your desk, or your Facebook page, the photo in your passport, the pixelated rendition of an oven stuffer in the newspaper circular, the animal figures in children's books. We know in advance what these pictures are for, what they are, in the normal case, used to show. Pictures rarely puzzle us.

Remove the context, however, and what would otherwise serve as a picture, as a display or a presentation, becomes an opacity and, sometimes, a curiosity, a puzzle, or even a work of art.

Why do we find pictures interesting?[1] Why do we make them and use them and look at them?

I suspect that there are as many different answers to these questions as there are reasons for showing, displaying, looking, and studying. Our interests may be personal; they might have to do with science or engineering, with education, with religion or politics. It is not the job of a theory of pictures to tell us why parents can't enjoy the Easter Egg Hunt without filming it, or why lovers, these days, even as they embrace, are liable to keep one arm extended to make the selfie that they might later post to social media. Pictures are made and put to work in what can only be described as many complicated ways. I think of there being a vast picture-psychology, or picture-economy, or picture-anthropology, and this is as reticulate and changing, as trending and historical, as our lives themselves.

Which is not to say that we can make no theoretically important generalizations. A picture is an instrument for showing, or

putting on display. And the relevant context in which pictures succeed or fail to perform their function of showing is a communicative one. We use pictures to show. And, the lure of psychological or neuroscientific models of how pictures work notwithstanding, pictures do not secure their pictorial function by themselves alone. A picture cannot provide its own caption, and without a caption, the picture is not a picture but a blank or a pictorial misfire. Of course, explicit captions are very often missing. In that case it is other aspects of the context that do the caption's job of letting you know, in advance, as it were, what you are looking at.[2]

There is also a version of the bag game that I described at the outset played with pictures. Photographs of familiar objects, taken from unexpected or nongeneric angles, and for no apparent reason, are puzzle objects, not pictures. They lose their transparency.

It is worth remembering that even though there have been big changes in pictorial media in the last few decades, and in the last few centuries, resulting in recent very rapid change in what we habitually do with pictures, the fact remains that human beings have been making pictures for about as long as there have been human beings, or rather, for about as long as there have been what are known as psychologically (as distinct from anatomically) modern human beings, that is to say, for more than forty thousand years. Pictures have played a role in organizing our communicative and visual activities of showing since prehistorical times.

Now, as I have already suggested, not all pictures are artworks, nor is it the case that all art painting, photography, or sculpture is pictorial. Is there a special interest or value attaching to *pictorial* works of art? And if so, what explains this special standing?

The outlines of an answer are clear: artwork pictures are not themselves moves or gestures or transactions within the complicated, multilayered, life-embedded economy of pictures to which I have referred. They are not, in this sense, pictures at all, that is, instruments functioning within and constrained by a communicative context for the purposes of showing. Pictorial artworks are not like the pictures in the family album, or newspaper, or online catalog or magazine, only better, or more beautiful, or more innovative, or more noble or exalted in their subject matter. But nor are they entirely alien to those more domestic deployments. My proposal is that paintings, photographs, and plastic works of art that are pictorial are significant not because they are special pictures, but because of the special importance that pictures have in our lives and because of the distinctive manner in which they, works of art, exhibit the place of pictures in our lives. Moreover, and I'll explain this as I continue, artwork pictures do this: they put us and our picture-making activities on display, in a way that enables us to do it all differently.

Art, speaking generally now, is bound up with making, construction, doing, putting together, tinkering, and manufacture. Why? Not, I propose, because artists are bent on making special things. But rather because making is so special for us. Making activities—technology in the broadest sense, but also forms of activity that are not conventionally thought of as technological or tool-using activities such as talking and looking—make us what we are. A strange tool, in my sense, is not a tool at all, although it may be materially identical to one, and its work, its value, is in the way it unveils the way tools make us what we are.

As with choreography and dancing, then, picture-making as an art has both nothing and everything to do with pictures. Nothing, because pictorial works of art are not, in a way, pic-

tures at all, that is, implements for showing this or that deployed in this or that communicative context.

But also everything! For painting and the other pictorial arts would have no point at all if not for the organizing, central role of pictures in our lives.

This is not meant to be a piece of dogma. I am trying to describe the phenomenon. Artworks—keeping with pictures—are puzzle objects in all the ways that the pictures in the newspaper or in the ad only exceptionally ever are. Indeed, they are, I would go so far as to say, philosophical objects. You can never simply say what the artwork picture shows, in the way that you can say what the passport photo shows. Or if you can—as when you say, "This is Leonardo's portrait of the Duke's mistress," or "This is Toyin Ojih Odutola's portrait of her brother"—you have at most just begun to touch on the meanings of the picture as an artwork. When we are in the setting of art, moreover, there is never a function or set of possible functions that settles the questions, the difficulties, and the inabilities to comprehend that we find posed in the setting of the artwork; there is never a caption that would be authoritative. In this sense, then, art is disruptive. Always. Everywhere. The artwork picture looks like a picture but doesn't discharge pictorial functions as we would, in a different setting, expect. I don't mean, when I say this, that art always startles or agitates or shocks. That would be avant-garde-ist or modernist in a parochial way. But that is not the view. Paintings and other pictorial works of art stand to the background place of picture-making in our lives in something like the way that irony stands to straight talk (as we have considered in a previous chapter). They are different, but each presupposes the other.

To recapitulate: we need to distinguish picture-making from the making of pictorial artworks, and I distinguish the ways that

we *use pictures* in our familiar lives (online, in the newspaper, in the family photo album, on billboards, in textbooks, but also in making plans for a construction project, in geometry, and so on) from the way that pictures avoid and evade straightforward use when they are artworks. Painting as an art, then, is a second-order activity; it puts picture-making and picture-use, as a first-order activity, on display, and does so, I will try to show, in ways that are liable to change the first-order activity itself, or (and this will prove to be important as we go on) other nearby and related first-order activities. Or to put it more succinctly: picture-art (e.g., painting) and mere picture use are entangled.[3]

SURREPTITIOUS SUBSTITUTIONS

Pictoriality is an always present background to our seeing; we take it for granted and fail to notice the ways that it shapes what seeing is like. It shapes our experience of seeing, and it shapes our theorizing about seeing. To discover the picture-dependence, and the different manners of picture-dependence, of our own visual consciousness can require a massive effort of reorientation.

Art historian Anne Hollander reminds us of the way that pictures can organize, tacitly, a looking activity. In *Seeing through Clothes*, she calls attention to the fact that when we peer at ourselves in the mirror, it is sometimes as if we were looking at ourselves in a picture; we take ourselves in *as depicted*.[4] She observes that when we examine ourselves in this way, we first compose ourselves, in the mirror's frame, rather as if we were composing a kind of provisional self-portrait (what today we might call a selfie). The picture, she says, "gives the standard by which the direct awareness is assessed."[5] Seeing yourself in the

mirror—if we follow Hollander's suggestion—is, sometimes at least, a *picture-dependent* way of looking or seeing. It is a way of seeing that is available to us thanks to the fact that we have pictures, that we are savvy with pictures as instruments for showing and putting on display. It is on the model of picture-seeing, and also picture-making, or composition, that we directly encounter ourselves in the mirror.

The idea that seeing is the beholding of a picture, that the experience of the seeing itself is felt to be a kind of looking into a frame, is so entrenched in our first-order experience that we don't even notice it. Consider a passage from *Jane Eyre*, one among many that I might have chosen from this or other authors, in which we are offered an account of what Jane *sees*, in this case upon arriving at her new place of employment.

> I looked up and surveyed the front of the mansion. It was three stories high, of proportions not vast; a gentleman's manor-house, not a nobleman's seat: battlements round the top gave it a picturesque look. Its gray front stood out well from the background of a rookery, whose cawing tenants were now on the wing. . . . Farther off were hills. . . . A little hamlet, whose roofs were blent with trees, struggled up the side of one of these hills: the church of the district stood nearer Thornfield; its old tower-top looked over a knoll between the house and gates. . . . I was yet enjoying this calm prospect and pleasant fresh air . . . yet surveying the wide, hoary front of the hall, and thinking what a great place it was for one lonely little dame like Mrs Fairfax to inhabit, when that lady appeared at the door.[6]

What is striking in this descriptive language is not only its detachment, its attempt to capture the look of a scene as if from

afar, and by dint of an act of survey; it is the fact that Charlotte Brontë writes as if she is describing a picture before the eyes, or as if she is composing one; she writes as if the world is a kind of picture to be beheld. I am tempted once again to use Hollander's words: "A picture gives the standard by which the direct awareness is assessed."

In Brontë's words, we get a glimpse of the way pictoriality shapes our attitude to our visual encounters, but does so, somehow, *surreptitiously*.[7] It isn't that Brontë is wrong, or mistaken, in the way that she characterizes what Jane sees, or how Jane experiences what is before her. And yet there is something somehow naïve, at least thought of in a certain way, in the supposition that mere seeing, or true seeing, can be just that. Seeing *is* just that, and yet, seeing is only that, for Jane, and for Brontë, and for us, thanks to an entanglement of visuality and pictoriality that is both obvious and, at the same time, hidden and problematic for all that. Describing what we see is *immensely* complicated and requires a negotiation; somehow, remarkably, we may fail even to notice this.

This kind of insensitivity to the subterranean negotiations that may be required even to bring visual life into focus is striking in the work of many philosophers and cognitive scientists. P. F. Strawson, for example, avers that visual experience presents itself as an awareness of "objects, variously propertied, located in a common space and continuing in their existence independently of our interrupted and relatively fleeting perceptions of them."[8] Seeing, for Strawson, is taking in how things are before one or around one. And for Strawson, a neutral, straightforward, theoretically unbiased articulation of the character of such an episode of seeing should take roughly the form: "It sensibly seemed to me just as if I were seeing such-

and-such a scene" or "My visual experience can be character-
ized by saying that I saw what I saw, supposing I saw anything,
as a scene of the following character . . ."[9] This is not offered as
a piece of theory, but as an elucidation of "the common con-
sciousness," amid which "visual consciousness resides," a
bringing to articulation of what he calls "the real realism of
common sense," an attitude to what there is that enlivens our
experience of seeing.[10]

Strawson, like Brontë, treats visual experience as embody-
ing the attitude of detached contemplation; we see what is
happening around us as if it were pictured for us, a still life,
captured for study. Strawson would have been surprised,
I think, and maybe embarrassed, to be reminded how *pictorial*
his characterization of the ordinary seeing of everyday life
turns out to be. The charge can certainly be brought. "Scene,"
his word of choice, is a term from the theater—an arrange-
ment of props and designs configured in such a way as to pro-
duce a given impression on an audience, to look a certain way
to them confined, as they are, to their seats. To characterize
seeing as an awareness of "the scene before one's eyes" is to
betray an implicit comparison of the perceiver with an audi-
ence member contemplating mere stage-setting or pictorial
decorations, as if vision were always the detached and disin-
terested exercise of powers of observation of mere appear-
ance. Other philosophers, such as John Campbell, emphasize
the perceptual reality of the *view*, as in, "we take in the view
from here."[11] But we forget that even "the ordinary notion" of
a "view" is hybrid and quasi-pictorial in its conception. This
is brought home wittily by Agatha Christie. There is a mo-
ment when her fictional Belgian detective Hercule Poirot and
his trusted associate Captain Hastings are forced to trek along

a country path in pursuit of their investigations. Upon reaching a summit, Hastings blurts out,[12]

"Look at that, Poirot! Look at that view!"

"Yes, well views are very nice, Hastings. But they should be painted for us so that we may study them in the warmth and comfort of our own homes."

And Poirot goes on: "That is why we pay the artist, for exposing himself to these conditions on our behalf."

As with Hastings, Strawson's description of seeing *surreptitiously substitutes* the pictorial world for the reality that we know in our perceptual experience. That is, he switches the contemplation of still lifes (e.g., a pear and a peach in a bowl on a table, staged for our inspection, frozen visibilia) for homely seeing. For Strawson, a visual experience is precisely a kind of inspection of the world from afar, as if to look were to put frames around a display. In this respect, it is a way of thinking of experience as modeled on the picture.

It is important to appreciate that this *crypto-picto*-conception of seeing shapes not only theories of seeing—framing it as an experience of detached contemplation of the scene—but the very conception of *what we see*, e.g., scenes, or tableaux of "objects, variously propertied" standing in different relations to one another. The very notion of an "object" is not one that we can simply take for granted in the setting of our perceptual lives. From the standpoint of a more phenomenological, or a more enactive, task-oriented, situated conception, the world is not simply, unproblematically, an assemblage of objects for us to find, frame, and inspect, as if we stand to the world as we might stand to the contents of a display case in a shop window. To suppose so is to rely on what Merleau-Ponty called "the prejudice of the world."[13] We need a richer vocabulary to make sense of what there is in the

visual world, which is, after all, where we *reside*, and on which we
depend, and is not merely something that we, as it were, look at
or inspect. There are also the *places* through which we move, the
fields in which we toil and play, the *grounds* on which we stand,
the *furniture* that we use, the tools with which we engage our
tasks, the shoes and clothing that we wear; there are all manner
of Gibsonian affordances and Heideggerian equipment.[14] The
environment shows up for us in all this variety. There are all sorts
of different ways in which we encounter the situations in which
we find ourselves. The idea that a situation, or milieu, to use
Merleau-Ponty's term, is a table set with *detached objects variously
propertied* has the potential to falsify experience no less than the
idea that all we ever really see are sense data. And it is an idea
ready-made for and, I suspect, dependent on and so first made
available by the institution of pictures.[15]

Again, it is almost as if the picture, which is an instrument
for capturing and thinking about the world we see—literally
something that we sketch, draw, daub, or design—is substi-
tuted, surreptitiously, for experience itself. We think that we are
describing, investigating, or characterizing our experience,
when we are really just imagining pictures. We will go on to
consider other examples of this kind of surreptitious substitu-
tion. We think of speech as imbued with the properties of well-
punctuated and correctly spelled sentences. We describe the
way that we represent our talking to ourselves and mistakenly
believe that we are describing talking. Or, as we explored in the
previous chapter, we look at the spontaneous and joyful expres-
sions of the young dancer, and fail to notice that she is already
a repository of an artistically sanctioned model of what dancing
is supposed to look and feel like.

I have been writing as if my purpose is to convict Strawson of
an error or to prove that seeing, in its real nature, is not pictorial

in any of the ways that Strawson seems, unwittingly, to assume. But Strawson isn't *wrong* when he characterizes visual experience as the inspection of a scene, not any more than Brontë was wrong in the manner of her scenic and picturesque descriptions. If there is a mistake in the vicinity here, it would be the mistake of thinking that one is simply, and, as it were, without the least presupposition, describing what seeing is like for us *really*—its true phenomenology—when in fact one is reflecting only on something that we happen to do when we see, that is, on a *style* of seeing, a style that is, as it happens, heavily dependent on the picture as a standard of what we are doing when we see and so, in a way, on a whole ideology or cultural apparatus of seeing. The mistake, if there is one, is an untrue naïveté that leaves one thinking that one is just saying how things are—compare: just saying what the differences between boys and girls are—while at the same time failing to notice that one is participating in the making of entanglement.

Still Life Seeing, as Strawson delineates it, is utterly inadequate if we think of it as a model of vision tout court. But it describes perfectly well one kind of seeing; it names an individual style of seeing. And moreover, it is a style of seeing that we could not live without. Not any more than we could live without objects or concepts thereof. We *need* objects. For example, we need them for science. *Our* insight is that we need pictures *so that* we may have objects.

Two qualifications are in order here. First, as noticed in a footnote above, there are competing conceptions of the object. We can think of objects as free-standing and autonomous entities that confront us as individuals "variously propertied." But there is also the conception of the object, or the thing, that is closer to the furniture, gear, background, equipment, and affordances of our practical lives. It is objects in the former sense,

not the latter, that are, as it were, made available to us thanks to pictures. But second, nothing I say here should be taken to imply that pictoriality is, as it were, alone responsible for object-hood in this way. Surely language too, with its subjects and predicates, functions and arguments, and singular terms, is bound up with objecthood no less than (as I would say) pictoriality.[16]

In sum, Strawson's Still Life Seeing is a mode of perceptual consciousness that is picture-dependent. And his insight—and it is the very nature of his own insight that he fails to appreciate, despite its validity—is an aesthetic one, for it is his sensitive recognition of a significant style of seeing, one in which we ex-perience the world as consisting, as it were, of tableaux of ob-jects variously propertied, fixed for us to behold, there for us the way that we find pictures hanging on the wall.

THE PAINTERLY ATTITUDE

Strawson is what in philosophy is known as a Direct Realist. His intention is to show, as against skeptics or others who would deny that we know the world immediately in perception, that we don't need an argument to justify the claim that our seeing at least *seems* to present, for us, the world *out there*. Experience itself, or what is sometimes called *phenomenology*, he believes, offers immediate confirmation of the idea that perception is for us a direct relation to an object. His purpose is to resist what he takes to be, although he doesn't use these words, the latent pic-torialism of the sense-datum theory, according to which per-ceptual experience presents itself to consciousness, most truly, most authentically, as encounters with flat colors, shapes, and other mere sense data. When we in daily life talk about seeings as if they are encounters with objects themselves, according to

the theorists of sense data, we make an unconscious inference and "go beyond" what we really see. Strawson's Still Life conception is offered as the antithesis to, or at least an antidote for, what is for him a wild distortion of the character of everyday seeing. The view that he opposes is beautifully captured by artist and critic John Ruskin, writing in a teach-yourself-to-draw manual in the 1850s:[17]

> Everything that you can see in the world around you, presents itself to your eyes only as an arrangement of patches of different colours variously shaded.
>
> We see nothing but flat colours. . . .
>
> This, in your hand, which you know by experience and touch to be a book, is to your eye nothing but a patch of white, variously gradated and spotted.

Now Ruskin's approach is pictorial twice over. First, he's interested in pictures from start to finish. His purpose is to advise students on how they must look at things if they are to succeed in representing them pictorially.[18] But second, he claims that, properly described, seeing is never anything more than an encounter with the kinds of properties that we work with when we make certain kinds of pictures, for example, "patches of colours variously shaded" or "flat stains of colour." Although there's quite a difference between these "patches variously shaded" and Strawson's "objects variously propertied," it isn't difficult to appreciate that Strawson and the sense-datum theorist to whom his own position is opposed are both in the thrall of pictures. It's just that they have very different ideas about how pictures—as things that we make and inspect—get into the act of supporting episodes of visual action. Or one might also say: they work with different understandings of what a picture is.[19]

Direct Realists, like Strawson, accuse sense-datum theorists (among whom we might count, in addition to Ruskin, also Hume, Berkeley, Russell, and Ayer) of a flat-out falsification. Indeed, we can agree that they are guilty as charged, at least if what we take them to be insisting on is that the *only* true or accurate way of talking about visual experience is one that confines itself to flat stains of color and the like, that is, if we take them to have the view that we literally misdescribe what we see when we mention objects such as pears and deer. Such a view seems, well, ridiculous. It really is the result of a bait and switch: we set out to describe what we see, but we end up examining the surfaces of imagined paintings of what we see. We look at the world with a painterly eye. But we forget that we are doing so.

But there is another way to understand what is going on here. Ruskin, like Strawson, has discovered, unwittingly as it were, a *style of seeing*, that is, a way of experiencing what one sees that is available to us thanks to our (perhaps only) implicit fluency with pictures. And this is a bona fide discovery. There is nothing silly or misguided about the sense-datum theorist's original appreciation that, for example, it is possible to look around and be impressed, not by the shapes of things, but rather by their mere outlines; we sometimes experience the elliptical outline of the circular plate rather than its circularity. We can admit this without accepting the further dogmatic assertion of the sense-datum theorist that we *only ever really* see the ellipse and that the circularity is a kind of posit or inferred entity. We don't need to allow that dogma of the sense-datum theory to appreciate its underlying insight, namely, that we see objects, but we also see their profiles and outlines, apparent colors, apparent sizes and shapes.[20] Similarly, we can see street lamps, but we can also enjoy what happens when we squint, creating beams and hazes and shimmers. This is the truth in the sense datum theory: not

that we only ever see "sense data," but that we typically *can* and that we sometimes do.

Strawson and Ruskin are agreed, it would seem, in their misunderstanding of the nature of their disagreement. Each identifies a different style of seeing, and each confuses this for an insight into what seeing really is, into its true nature. But both of them are really very far from anything to do with nature, thought of as the zone of existence that is independent of us and perhaps unmarked by such things as culture. In truth, their disagreement is an aesthetic one; it is an aesthetic disagreement that masquerades as one pertaining to the metaphysics of experience or the nature of mind. They are tracing out strands of the interweaving of the entanglement.

THE SNAPSHOT CONCEPTION

And they are not alone. This same conception of seeing as the entertaining of a picture in the head is on display in Descartes, who had argued that visual consciousness is confined to the "immediate effects produced in the mind as a result of its being united" to a body that is acted on by the environment; our tendency to make judgments about "things outside us" is merely the result of habit and convention.[21]

This *picture* picture of seeing—the snapshot conception—is of more than merely historical interest. It has lively support among contemporary philosophers and scientists. For example, Jesse Prinz argues that visual consciousness is the product of what he calls, after Ray Jackendoff, "intermediate level representations in the visual system."[22] What he has in mind is the level of computational representation corresponding to what David Marr had called "the 2½-D sketch."[23] This "sketch" is a neural rendering of what we literally see or how things look,

something like a line drawing in which the perspective-relative shape and size of distinct objects is represented. The crucial thing about the 2½-D sketch is that it is (supposed to be) merely a representation of how things *look*; it is not a representation of things themselves, or of how things, in any perception-independent way, actually are. It is a mere picture.

Prinz proposes that it is this sort of pictorial representation of which we are visually conscious when we are visually conscious. It is not tomatoes, but a certain structure of appearance, one perfectly captured by a drawing or photograph, that gives the content of visual experience. It is obvious that this way of thinking about the character of vision takes not only pictures, but also a kind of implicit comparison of seeing with seeing pictures, for granted. Indeed, the reference to pictures is literal and specific insofar as the view is framed in terms of representations and "sketches."

The snapshot conception of seeing informs a great deal of cognitive science, even when it is officially disavowed. To give one example: in a recent paper written by Cohen, Dennett, and Kanwisher, the question is posed, Just what is the bandwidth of perceptual experience?[24] They are concerned to combat a certain kind of, to their way of understanding things, naïve view according to which when you see, you enjoy an awareness of all the detail in the scene before you. Drawing on work on change blindness and related phenomena, they argue that visual experiences have "ensemble" contents; that is, they may represent "a crowd" or "a group of people" without any detailed rendering of each member of the grouping.[25] Anyone familiar with painting is familiar with such devices. Degas, for example, can draw the bookcase overflowing with books and papers and can make a convincing case for their presence without actually rendering each book in uniform detail. But what Cohen and company

don't seem to appreciate is that far from puncturing the *picture* picture of seeing, they are just refining it, suggesting, basically, that visual pictures are more "impressionistic" than they are "realistic." Their very question—What is the bandwidth of visual experience, that is, how informationally rich is a visual experience, really?—presupposes something like the idea of a channel from world to mind through which a representation such as a pictorial rendering is transmitted.[26]

THE ENACTIVE APPROACH

In my first book, I roundly attacked the idea that vision is pictorial.[27] The retinal image is not a picture. It is not made. No one can see it. Vision is not a process in the brain whereby the brain produces an internal picturelike representation. And the phenomenology of visual experience is not picturelike; that is, it isn't the case the world shows up in our visual consciousness in sharp focus and uniform, high-resolution detail, from the center out to the periphery, as it might be rendered in a drawing or a photograph. We are not cameras. Eye, head, neck, body, movement. We see with all that, and then only thanks to our impulses, curiosity, feeling, and drive.

I still think this is basically right. The world shows up to consciousness, so I argued, not as *in here*, as *represented*, but rather, as *available*, as *within reach*. And the different qualities or ways that things have of showing up—visual or auditory or tactile— correspond to and can be explained in terms of the different ways that we *are able to achieve access* to things. All of which depends on things themselves, to be sure, *what they are, where they are in relation to us*, but also, crucially, on our bodies, our skills, our situations, and our interests. We achieve the world's presence and we do so dynamically, and actively, drawing on

different kinds of knowledge and understanding, sensorimotor as well as conceptual. The idea that seeing is like seeing pictures in the sense that when we see we enjoy a highly detailed, uniformly focused, high-resolution *picture* of the scene before our eyes is, I still believe, unjustified by reflection on the phenomenology itself; it is a theoretical prejudice born of the assumption of a *picture* picture of seeing.

But one thing I have never been able to explain, to my own satisfaction, is why it is that despite criticism like mine—as well as that of Merleau-Ponty, Austin, Gibson, Dennett, or Latour—the dubious and wrongheaded pictorial conception refuses to die.[28] *This fact*, the enduringly attractive allure of the *picture* picture, itself requires explanation.

We are now in a position to say something about this. Pictorialized ways of thinking about vision refuse to die not because visual phenomenology is pictorial, after all, *truly*, but also not because we are victims of a metacognitive illusion according to which we mistakenly believe that visual phenomenology is pictorial, when it isn't. No, picture consciousness won't die rather because we live in a picture world, and because we have lived in a picture world our species life long. We have learned to use our fluency with pictures not only to think about what seeing is, but *to see*. We literally see with pictures, sometimes at least, just as we may sometimes literally think with words or with notations.

So it turns out that there is a sense in which seeing *is* pictorial, at least sometimes and in some respects. And curiously, *this* fact, that visual experience may sometimes be pictorial, is not in opposition to, but is rather a consequence of, the basic idea of the enactive approach, or so I have now come to believe. For according to the enactive approach, perception, thought of at maximum generality, is an organized activity of engaging with the environment making use of *skills of access* (concepts, sensorimotor

skills).[29] Different sensory modalities, or even the contrast be-
tween perception and thought itself, come down to differences
in the ways that we deploy our understanding. The *varieties of
presence* correspond to different styles of knowledgeable engage-
ment with the world. Experience, according to this approach, is
not something that happens in us or to us; it is something that we
do; it is something that we make, or make up, something that we
enact. And we do so by making use of the resources available to
us in the situations that we find ourselves in. And among those
resources are the tools and technologies, including language,
and—why not?—*pictures*, that in part constitute our known
worlds, the environment that scaffolds us.

Correctly understood, then, the enactive approach predicts,
explains, and even demands that we acknowledge the possibil-
ity of modes of visual experience—modes of achieved access
to what there is—that would be pictorial.

Which is not to back off, in any way, from the rejection of the
picture picture, or the snapshot conception, which, as we have
seen, is still very much alive in the fields of visual neuroscience,
cognitive science, and the philosophy of perception. But it is to
rethink what this well-entrenched approach gets wrong, and
also what it gets right.

Pictures as Proxies

We have noticed that there is a surreptitious substitution made
between pictures and experience. We describe the one when
we mean to describe the other. But it is crucial to realize: *this is
actually what pictures are for.*

We think of pictures as natural phenomena, a bit like reflec-
tions, that somehow just arise owing to the nature of things. We
forget that pictures are things that we make; they are handmade

bits of craft; they are technology. They are graphical devices used to establish points, or illustrate thoughts, or, canonically, as I have urged, to put something on display, to show something. But they can achieve these functions only because of the way that we use them, and, in particular, because we use them as *stand-ins* for the things, and the episodes of seeing the things, that happen to concern us.

A picture is a kind of grapheme. To understand its basic character, it is useful to compare it to written words, which are also graphemes. The dictograph, to use another name for the written word, is a stand-in, or proxy, for spoken words and our ways of using them. We treat the mark on paper as if it were the word, and thus we use this device as a token for thinking about and better understanding ourselves as users of the word. This substitution is not exactly conscious, but it is not unwitting or misguided either. Writing lets talking reach new heights; language and *graphein* are thoroughly entangled. Of course, the substitution *can* be misleading. The graph on paper has little to do with the fluid, always variable, ever contextual, totally embodied, breathy, gestural character of the spoken word. To let the graph *be* the word, or to let it serve as its proxy in our linguistic self-understanding, is a radical and potentially risky thing to do (a bit like letting different kinds of marks on paper or wood serve as stand-ins for God).[30]

And it is the same way with pictures. We use pictures as props for communicative acts. The picture is a kind of model that we select to go proxy for the thing that we want to show, or for the way of seeing the thing. *Here*, we say, *take a look at this roof*, or at *my grandmother*, or *at this skin lesion*. We use the picture to stand in for the relevant episode of seeing, or the relevant thing that we are interested in seeing. And we do so advisedly. That is, our practice of so doing depends, as it were, on the correct licensing.

We know how and when it is useful or appropriate to take the picture as a workable substitute for the thing that interests us. Just as we don't mistake the color or size of the balsa wood in the architect's model for the color or size of the house that is being modeled, we understand, quite generally, how to use pictures to show the features that interest us.[31]

And as dictographs enhance our speech possibilities, so *pictographs* vastly expand our resources for seeing, for they give us tools to think about and experience our own seeing in new ways. A picture is so different from the temporally extended, attentionally punctuated and shifting, emotionally invested, situationally alive thing that we call seeing. And yet, thanks to pictures, we find it natural to think of "seeings" as like pictures; presentations of a world framed and articulate (as on the Still Life Conception), or, alternatively, as flat and devoid of representational significance (as on the Painterly Conception). And the crucial thing to appreciate is that this is not just an idea or thought *about* seeing—a kind of theorist's illusion—it is a resource *for* seeing. Seeing becomes something different in a picture world. (As it is also made new again in a language world.)

When thinkers like Strawson or Ruskin, or Descartes, or Marr, Prinz, even Dennett, stake their claims on this or that absolute conception of perceptual phenomenology, they betray their insensitivity to the entanglement of visuality and pictoriality, and thus the ways that we make and remake what seeing is in a picture world (which is also always an art world). They mistake our own sanctioned models for thinking about what we are doing when we see (or talk, or dance) for something like the *nature* of these things we do. It is important to appreciate that so much philosophy, like so much cognitive science, seeks to use the scientific method to decide about the nature of something whose character it has entirely misunderstood.

FROM PICTORIALITY TO VISUALITY

Some readers might resist the suggestion that technology and art—however transformative—can affect something so basic in our biology as vision itself. Surely, if pictures influence our seeing, they do so, at most, only in local, cultural ways; they leave vision as a medical phenomenon, or a biological one, untouched.

Well, *that's* just what is at stake in our investigation. The entanglement of pictoriality and vision puts pressure on the idea that really there is such a thing as natural or biological vision. Can we factor out natural vision from its more aesthetic admixture?[32]

To see why we should take the possibility of the entanglement of vision and pictures seriously, consider a parallel line of thought about language.

I don't think that it is much of a leap to assert that language shapes thought and experience. Maybe not all thought or all experience bears the marks of linguistic influence. But some experience seems to be language-dependent, not merely in the sense that it is the experience *of* language—e.g., the experience of telling a story—but because it is experience, or thought, that relies on linguistic resources—words, concepts, terms, etc.—to be the experience or thought that it is. Consider, for example, statements like "they don't make elementary school students memorize multiplication tables anymore" or "he was in the hospital last New Year's, for a whole fourteen days!" If you have language, it is easy to grasp thoughts such as these. But it is entirely unclear what it would mean for a person or an animal to grasp them in the absence of language.

Now what makes this interesting and relevant is the fact that language is cultural; while not the product of any one person's invention, it is something that we have made together, or that we have evolved together. To say this is not to

deny that language is grounded in human biology. Language, by current reckoning, first shows up for our species some seventy-five to one hundred thousand years *after* the emergence of anatomically modern *Homo sapiens*.[33] It took vast stretches of cultural time for anatomically modern human beings to make language. Language then in turn went on to transform our capacities for thought and experience, capacities that are obviously grounded in our biology. Language and thought have become *entangled* in the sense that thought, insofar as it has tapped the resources of language, has become something different.

Recall that there is evidence (in the form of the cave paintings of Chauvet and Lascaux, for example, and as Collingwood reminds us) that graphical mark-making practices, including the making of pictures, are as deeply rooted in our prehistory, in our species history, as language is; pictoriality shows up on the scene, in the prehistorical record, at roughly the same time that language is thought to have shown up.

So maybe what goes for language and thought goes for pictures and vision. The idea is that vision is remade in the setting of pictoriality in something like the ways that thought is remade in the setting of language. Or, as we will consider in the next chapter, the way that talking is remade in the setting of the graphical activity of writing.

WORLD STYLES

I have been examining the entanglement of visuality and pictoriality, that is, the ways that pictures and picture-art have made and remade what seeing is. There are, we are now in a position to grasp, *styles of seeing,* and some of these are picture-dependent in the sense that they are scaffolded by and rely on our anteced-

ent conversance with pictures, a conversance that is molded by pictorial art.

But I need to say more to explain this idea that vision has *stylistic* variations. Surely seeing is, well, one thing, built into our brains and bodies through the whole of evolution. Ditto for other modalities of sense perception such as hearing, touch, taste, and smell. These are organic processes, not ways of getting dressed up or adorning ourselves. What could *style* possibly have to do with it?

To answer this question, I need to approach it from both sides. From the one side, seeing and the other sense modalities are not processes that take place in us—although they depend on such processes; they are, rather, organized activities (like talking and writing and walking), and so they are subject to stylistic variation. But from the other side, we have tended to neglect the richness and importance of *style* as a phenomenon in its own right. In bringing style into the discussion, my aim is less to demote sensory perception or mental life from their biological status, but rather to promote style as a basic category needed even to make sense of biological phenomena. Finally, I need to explain the broad implications of this idea—what I take to be a major breakthrough—that seeing, and the other sense modalities, are stylistic phenomena.

Let us begin with some general considerations about style. Scientists interested in the mind have tended, as a family, to neglect the phenomenon of style. Style, after all, is the stuff of fashion and trendiness. But in fact, style is a perceptual and cognitive category of the first importance.

In its original meaning, the term refers to the stylus, or pen, with which we make a mark; by extension it comes to refer to the distinctive manner with which anyone wields a pen, an instrument, or even their body. It is a brute fact—if there are brute

facts—that you can recognize people by the marks they make. And not only that: people of a shared mark-making or writing community tend to apply the pen in recognizably similar ways. From the writing alone it is sometimes possible to glean not only the identity of an author, but when they wrote, and where. The same is true of art in all its varieties and also, of course, in the domain of dress, furnishing, and other fields of design. But the important point is more general and more basic: human activity bears the real, perceptible, stylistic mark of its originator.

Style is a filter that both enables and disables. Many of us can readily perceive the differences between clothing and hair styles of the 1950s, 1960s, 1970s, and 1980s; these stylistic differences just pop out; they are palpable. From a greater historical distance, however, these differences tend to lose focus. A younger person today would probably be blind to them, just as only those with specialist knowledge are likely to be able to *see*, let alone care about, the difference between the way people dressed in the 1870s and the 1890s, for example. Cultural remove can also blind us to relevant differences: what a Chinese person finds stylistically salient may be unnoticeable to a German person of the same generation. The same blindness to style that operates when we are culturally too distant is also in force when we are too close. It requires a specially trained eye, I think, to pick up on the precise ways in which *today's* clothing and design carry stylistic markers that may come, one day, to stand out; today's styles are hard to discern because they are, as it were, in the background; they are taken for granted and function as a baseline and default. As time passes, however, and as baselines shift, what was invisible and unobtrusive comes to stand out like a sore thumb.

This is why, as the art critic Peter Schjeldahl has written, forgery is a dish best served up warm (a point made originally by Nelson Goodman).[34] The idea is easy to appreciate with mov-

ies. It is usually immediately obvious when a period drama was produced. It is easy to see that the Western, although set in the 1890s, was filmed in the 1970s; for what was invisible in the 1970s—the choices that weren't really choices, in the treatment of wardrobe and hair, say—now cry out for attention. It is difficult, although presumably not impossible, to transcend one's own stylistic limitations because what we do tends to leave traces of who (and what and when) we are.[35]

We are all, all of us, to some degree or another, sensitive to style—in art, dress, speech, design, manners, and so on. And we are all also, to some degree, correspondingly insensitive. This is an area in which it is possible to refine one's powers of discrimination, but also to neglect them. The relevant powers of discrimination are *aesthetic* in nature.

And this aesthetic sensitivity to style has a much wider field of application than we have indicated so far. This is a major discovery of Husserl and Merleau-Ponty. The idea that what exists, or rather, what exists *for us*, in the domain of the human, is marked by style, was prominent in Husserl: "*All that is together in the world*," he wrote, "has a universal mediate or immediate way of *belonging together*. Through this the world is not merely a totality, but an all-encompassing unity, a whole (even though it is infinite)."[36] And Husserl characterizes this unity as an "overall style" and as a kind of worldly habit.

In the *Phenomenology of Perception*, Merleau-Ponty builds on Husserl's insight and fleshes it out. For Merleau-Ponty, there is a sense in which the *world* has a habitual, understood way of showing up, that is, a style. "I experience the unity of the world," he writes, "just as I recognize a style."[37] And he explains,

This unity [of the world] is comparable to that of an individual whom I recognize in an irrecusable evidentness prior

to having succeeded in giving the formula of his character, because he conserves the same style in all that he says and in all of his behavior, even if he changes milieu or opinions. A style is a certain way of handling situations that I identify or understand in an individual.[38]

Objects hang together, according to Merleau-Ponty, not as a pile of properties, but with a kind of natural integration or unity that is the very paradigm of what he calls style. And this unity, this way of being and responding, is evident to us; we are sensitive to it directly. So it is clear he has "style" in mind when he writes,

> The unity of the thing, beyond all of its congealed properties, is not a substratum, an empty X, or a subject of inherence, but rather that unique accent that is found in each one, that unique manner of existing of which its properties are a secondary expression. For example, the fragility, rigidity, transparency, and crystalline sound of a glass expresses a single manner of being.[39]

And he continues:

> If a patient sees the devil, he also sees his odor, his flames, and his smoke, because the meaningful unity "devil" is just this acrid, sulfurous, and burning essence. In the thing, there is a symbolism that links each sensible quality to the others. Heat is given in experience as a sort of vibration of the thing, color in turn is given as the thing going outside of itself, and it is a priori necessary that an extremely hot object turns red, for the excess of its vibration causes it to shine.[40]

Indeed, from passages like these we can appreciate that "style," in Merleau-Ponty, functions not only as a marker of the

human, but also, as it were, in lieu of talk of the a priori and the necessary. Style serves, very much like Wittgenstein's idea of the grammatical relation, as a device for getting at what other thinkers have had in mind when they write about modal normativity, that is, conceptual truth, analyticity, but also the synthetic a priori.

The crucial thing is that, for Merleau-Ponty, we don't judge, infer, expect, believe, or know, for example, that the landscape before our eyes conceals beyond it yet another landscape beyond which lies yet another, and so on; in these cases what we see "announces" its significance and thus affords or enlivens the sense of the presence of what is in fact out of view, not present, or not yet encountered. Similarly, what has been, the past, "announces," within limits, what will be, the future, or at least, as Merleau-Ponty would say, its general style. It is in an effort to explain this thought that Merleau-Ponty writes, "My world is carried along by the intentional lines that trace out in advance at least the style of what is about to arrive."[41]

For Merleau-Ponty, then, as for Husserl, style is tied to meaningfulness and coherence. The style of the world shows up in the way that objects and situations implicitly refer to each other, announce each other, or go together, or in the way that a person's manner of action is the expression, in a way, of who or what they are. This is why the natural world itself is, as Merleau-Ponty puts it, "the horizon of all horizons, and the style of all styles."[42]

A sensitivity to style is a sensitivity to the meaningful but not quite definable interconnections between things, the interconnections that give our world, as Merleau-Ponty says, its unity. There is, therefore, a certain kind of understanding of the world, a certain kind of sensitivity to its real meaning, that is, precisely, a matter of style. And this kind of understanding is aesthetic.[43]

STYLES OF A GENRE, NOT SPECIES OF A GENUS

Which brings us back, finally, to perception. One of the big explanatory obstacles faced by traditional theories of perception is that of giving a rich account of the connection and difference among the sensory modalities. On the one hand, it's obvious that seeing is one thing, and that touch, hearing, smell, and taste are another. On the other hand, it has proven intractable to grasp what it is about the neural events associated with experiences in these different modalities that is responsible for their felt differences. Neural systems, when it comes to conscious experience, are explanatorily opaque. This is the famous explanatory gap between the brain and consciousness.[44]

But this whole question of explaining the felt character of experience in neural terms alone shivers away when we take seriously the thought that *visual*, for example, refers not to something in the head—the sort of thing that could be a property of cells, or assemblies of cells—but precisely to a manner of engaging with the world; it is a way of acting in and with the world. You don't look inside the dancer to find out what makes Tango different from Swing. You look to what the dancers are doing, to what they are doing differently, in the setting of their activity, to grasp the difference. Likewise with perception more generally. To understand the difference between seeing and other modalities, look not to what goes on in us, but to the different manner of our skillful involvement with the world around us.[45]

The different sensory modalities, from this standpoint, are precisely distinct *styles* of involvement with the world. They differ one from the other as different skilled modes of embodied engagement with the situation. Indeed, from this point of view, the very contrast between perception and thought (i.e., the dis-

tinction between *seeing* the Statue of Liberty and *thinking* about it) becomes a stylistic one; it is a difference in the *ways* that we skillfully achieve the world's presence, the kinds of skills we deploy, and the manner in which we deploy them.[46] If we think of the problem we face as that of understanding how we achieve the world's presence, in both thought and perceptual experience, then the answer is that we do so by actively exercising different kinds of skills and knowledge to achieve the world's access.

This *Skills and Styles Approach* lets us give a principled account of the difference between seeing and touching, say, or thought and perception, more generally, but it also lets us appreciate something subtler, namely, the fact that these very distinctions that we labor to explain can themselves seem arbitrary, soft, or fungible.

Consider, after all, that to *see* something, from a certain point of view, anyway, just is *to think about* it; very often to think of a thing is to contemplate it with the eyes. And similarly, our different sensory modalities ordinarily operate together smoothly and influence each other. Is the taste experience of a cool tomato entirely distinguishable from the tactile sensation of its distinctive consistency, textures, and temperature as you crush it with your tongue and teeth and swallow it? And is your visual impression of me as we talk separable from what you hear?

But if the differences at issue—real as they are—are *stylistic* differences, then it should not be a surprise that they exhibit this very kind of squishiness, contextuality, and relativity. This is a hallmark of style. You can recognize a person from behind by the way she walks, by her style or manner of movement, but it may be almost impossible to give an adequate explanation of what it is about the walk that lets you pick it out as different from the way someone else walks, and as distinctively pertaining to the

walk, say, and not to the posture, or the attitude, or whatever, and that is so distinctively expressive of this particular person's way of being. You can see it, but you can't say it. Style resists being made explicit.

Which brings us back to what is our crucial finding. *The problem of the sensory modalities, and of their character, is a problem of style, and so it is, finally, an aesthetic problem. To address it, then, we must use aesthetic means.* Aesthetics, as we will consider in a later chapter, is primarily in the business of bringing what you already know, or what is already there, to new and different kinds of focus. Stylistic differences are real; they are perfectly substantial. But they are very much creatures of context and standpoint, which has everything to do with their aesthetic character. What pops out in one context may be barely discernible in another. As an example, in 1979 the Sex Pistols and Talking Heads were stylistically antagonistic to the music of Neil Young, say, or Bruce Springsteen. But people today, viewing things from a greater distance, and maybe from a standpoint of indifference, may be more likely to be impressed by their stylistic unity. Folks today see things differently, but it cannot be said, in any final, objective, all-things-considered sense, that they are in error. So, too, with the aesthetic: aesthetic differences are real, but fragile and disputable.

A further consequence of the conception of the aesthetic that we are discovering: if the differences between the sensory modalities, or between perceiving and thinking, are stylistic, then they are aesthetic, and if they are aesthetic, then they are not fixed, settleable, or amenable to disposition.

And so, bringing this discussion back to our starting point, the same points go, mutatis mutandis, for the intravisual variations in style that we have been considering throughout this chapter. There are styles of seeing. We've been focusing on

picture-dependent styles, for example, Hollander's Mirror Selfie Seeing, the Painterly Seeing of Ruskin, and the Still Life Seeing of Strawson. But it is the nature of the beast that there is no fixed number of such styles.

For this reason, it is fruitless to insist on a definitive listing of styles, or a ranking of them according to fundamentality. It may be tempting to suggest that pictorial styles of seeing are somehow less basic, less "natural," than styles of seeing that are nonpictorial. Crucially, as we have considered, there *are* nonpictorial styles of seeing too. A lot of seeing, after all, as we have noticed, may be unreflective and task-oriented. I use my eyes to find my shoes, put them on, and tie them, but this visual guidance of my action is almost below the threshold of notice. There is no contemplation, no awareness of looks or appearances. It would be better to say that my seeing—as it functions here, in the wild, so to speak—is swallowed up in my involvement with what I am doing. Or a different example: the shortstop doesn't study the ball, or examine it, or think about it, or even watch it. He positions himself before the ball is even hit to the place where he and his coach think it is likely to be hit; he readies himself and then pounces. He "keeps his eye on the ball." He attunes his whole person, his hips, feet, eyes, and soft hands, to the ball-in-motion.

But "seeing in the wild" is no more insulated from the effects of our own doing, manufacture, and concerns than picture-dependent seeing is, although it is relatively insulated from pictoriality itself (which is why I call it "nonpictorial"). This is a task-dependent way of seeing, but tasks, like playing shortstop, or putting your shoes on, are entangled too; to be a task-dependent way of seeing is to be a way of seeing that is literally scaffolded by the worldly, that is to say, human-made, structures and meanings, that make up the places where we reside.[47]

5

THE WRITERLY ATTITUDE

> All nations began to speak by writing, since they were
> all originally mute.
>
> —VICO, *THIRD NEW SCIENCE* §429

> All choice of words is slang. It marks a class.
>
> —GEORGE ELIOT

Sometimes philosophical or conceptual questions dress up in the garb of historical ones. The question "What is life?" for example, may disguise itself as a question about life's origins, about what happened, say, when lightning struck the primordial ooze.[1] Our topic in this chapter is like this. When and why did we as a culture or as a species start using written language? But as throughout, my main concerns are not historical. What is at issue in this chapter is this: What is writing, and what is its relation to speech or to language more generally? My main aim is to bring out the ways in which language is a phenomenon of entanglement.

Language is a topic very familiar to philosophers in all traditions. Writing, in contrast, is almost entirely neglected in the

analytic tradition.[2] Almost, but not entirely. Frege invented a system of writing he called the *Begriffsschrift* ("concept-script"), whose purpose was to do a better job than conventional writing at making the real structure of thoughts and their logical relations explicit.[3] Logic and mathematics required this, Frege believed. Wittgenstein, whose preoccupations were more overtly philosophical than Frege's, argued, in his first philosophy, that a proposition (a thought, as he called it) is the propositional sign "in its projective relation to the world."[4] Wittgenstein did not pay attention, I think, to the distinction between the spoken propositional sign and its written version. But he seems to have been convinced, like Frege, that philosophical clarity can be achieved by, and maybe even requires, the deployment of a perspicuous method of *representing* our language, that is to say, a system of writing. This idea—that philosophy should try to make perspicuous or surveyable representations ("übersichtliche Darstellungen"), models, sketches, pictures, of our "grammar"—is a central tenet of Wittgenstein's later philosophy as well, and I think that we can take this to be tantamount to the demand that philosophers turn their attention to writing.[5]

WRITING AND SPEECH, THE SIMPLE VIEW

Insofar as there is an official view of the relation between language and writing, in analytic philosophy, and in contemporary linguistics, it is that language (thought of now as speech or the capacity for speech) and writing (thought of as a means of representing speech) have no interesting or important connection. Speech is biological, a trait of the species; it is genetically endowed and universal. Writing, in contrast, is a cultural innovation, a technology, that is at most a few thousand years

old. You don't need writing to talk; you don't need writing even to make poetry or song (that is to say, literary art). Most languages of the past were not written, and even today many speakers are not literate. If anything, so the official view would have it, writing gets in the way of a clear understanding of the nature of language. This is because writing, it is supposed, is a very imperfect representation of speech. Writing systems may capture some features of our spoken language (such as word order), but they leave others unmarked (such as phrase structure, e.g., the way "the" and "boy" *go together* and form a unit in "the boy sings").[6] Finally, writing, as a cultural instrument for representing speech, so it is assumed, is conventional and prescriptive through and through, and this obscures the fact that language, as a natural phenomenon, is neither of these.

What is the relation between speech and writing according to this widespread, simple view? In a nutshell: we are language users by nature, and writing is a technology for amplifying and extending our natural linguistic capacities. Writing lets us "talk" to people who are beyond the reach of our voices or who are unable to see our signing hands; writing lets us record what we think for posterity; writing lets us keep track of what we say or have said, and so it makes law and, indeed, science, mathematics, and philosophy possible. Writing is a transformational technology—in the phrase of the biologist Patel—comparable to fire and the wheel.[7] But it is a technology, that is to say, a culturally transmitted innovation. Language itself, the capacity for speech, in contrast, is a natural expression of innate, universal human nature.

This simple view is too simple; I'd like to explain why this is so.

Consider the statement that writing is a way of capturing, representing, and so extending speech. Not exactly. This may

be one of its uses. But we are familiar with kinds of writing that are not, in the relevant sense, linguistic at all. Musical notation is a way of writing music; it is not a way of writing speech. If it is a way of expressing thoughts, then these are distinctively musical thoughts that cannot be expressed in ordinary language. Mathematical notation is another example. We don't write in English or Arabic when we prove a theorem. And although you can read a proof out loud, you can read it out loud in any language you choose; what you are reading is not in a language, although your reading of it is.

It is plausible that the deep origins of writing are to be found at least as far back as the very early Neolithic period (as early as eleven thousand years ago), in making activities whose purpose was not to encode or represent *speech*, but rather to keep score, or keep track, or tally, calculate, or count up. The first writers are more likely to have been accountants or re-counters whose tellings were confined to flocks and offspring.[8]

If this is correct, then writing may be, in a surprising sense, autonomous of speech. Not in the sense that there were ever writers who were not also speakers. But in the sense that the first writing may not have been put to work for linguistic purposes (for purposes of talking, that is, or for representing what we do when we talk). That is, the first writing may not have been consequent on speech in the way that the simple view supposes.

But there is a second, even more profound sense in which writing may be autonomous of speech. As we are now thinking of it, the first writing methods were technologies for directly engaging and directly cognizing a world or a domain of interest; they did not engage the world or the domain *by way* of representing our linguistic ways of so doing. In this sense, they would have been on all fours with speech itself and may be

thought of, in a way, in their own right, as kinds of languages, or maybe as ways of *language-ing*.

So the first writing systems may well have been themselves language-like and, in the relevant sense, speech-independent technologies. It is important to notice, also, that even if it is difficult to conceive of creatures capable of using picture-making and score-keeping technologies who were not also capable of speech, we have little reason to believe that speech has a claim to being prior to, or older than, writing. As far as we can tell from the archaeological record, speech and graphical activities showed up together some forty to fifty thousand years ago. It may very well be the case that only a being capable of speech would also be capable of articulate mark-making. But the same point is probably true in reverse. Speech and writing—at least in the wide sense of pictoriality and mark-making—are as old as the hills.

In fact, it could very well be that the graphical is both more ancient and more fundamental. Animals make, they do, they act. But acting, making, doing, of their nature, tend always to leave a mark. For example, by the very act of walking from here to there, again and again, our ancient ancestors would have in effect made roads ("laid down paths in walking"). And it is hard even to think of acts of taking, holding, ingesting, excreting, or otherwise manipulating that would not manifestly alter and, typically, ornament and redesign the environment.

Experience itself is a making activity. We make our experience. Experience—here I echo Dewey—is a circular process of doing and undergoing the effects of what one has done, a process that demands of us that we keep track of the ways our own actions alter the situations where we find ourselves.[9] So then human consciousness, as a family of ways of acting and enacting ourselves, can be thought of as graphical in its origins.

It is suggestive, if nothing more, to be reminded that the first occurrences in ancient Greek of the word for line or drawing or writing (*graphein*) are actually in reference to the cut made on the body by a pointed arrow.[10] The first writing, in our literary tradition anyway, was violent scarring. Writing, or drawing, is grounded in something basic and social, namely conflict.

But there are other considerations that strongly favor, if not exactly the priority of the graphical over the linguistic, then the priority of the cultural over both the linguistic and the graphical. I have in mind the growing consensus that language, pictoriality, mark-making, clothing, and a wide range of sophisticated tools and making activities (including the effective control of fire) first show up in the Upper Paleolithic around 50,000 years ago.[11] The crucial fact is that this is more than 150,000 years *after* the existence of *anatomically*, that is to say, physically (and so also, neurologically) modern *Homo sapiens*. There can be little serious doubt, then, that the events that bridge that time interval and scaffolded *our* emergence were of a cultural nature. And given that these events had the effect of enabling radically new ways of living, thinking, feeling, expressing, and doing—how else can we characterize the revolutionary significance of language and pictures?—it seems that the modern mind is in a very real sense the product of human cultural achievement (or evolution) some 50,000 years ago. And all of this—this emergence of our experiential peers—seems to have been *coeval* with the start of writing, at least if we think of writing, as I recommend that we do, as autonomous of speech and grounded in ancient mark-making activities.

The upshot of this, then, is that the simple view reveals itself as thoroughly unsatisfactory. Writing is one thing, yes. And speech another. So far so good. And yes, without doubt, the use of writing for straightforwardly linguistic ends—the use of

writing to perform linguistic acts as well as the use of writing to record language—is a fairly late cultural innovation. But writing itself, in the more extended sense of graphical activities of scratching, scoring, marking, drawing, but also, maybe, spitting, spraying, cutting, stamping, soaking, used for cognitively significant purposes, both antedates and is conceptually independent of its application to language. Moreover, writing, in this extended sense, may be no less bound up with human origins and, indeed, the origins of human consciousness, than is speech itself.

The simple view's assumption that speech falls on one side of the nature/culture divide, and writing on the other, cannot be supported. Not only because speech and writing are thoroughly entangled with each other, but also because, at least on the assumption that speech and writing, like pictoriality, are both achievements very late in our history as a species—taking form only tens of millennia after our attainment of our current genetically set bodily form—the very opposition of nature and culture needs to be rethought.

THE WRITING DOCTRINE

In this setting, then, the pseudohistorical question with which I began becomes not *why and when did we invent writing,* but rather, why did we at some point in our cultural history come to apply an already extant graphical toolkit *to* the case of speech?[12]

Before trying to frame an answer, I want to direct our attention to a further way in which the simple view may be too simple.

Let us grant that *written language,* as we conventionally think of it, is modern, and that speech is ancient. In this sense, at least,

speech is prior to writing. This still leaves open the possibility—one that I want us to take seriously—that *our concept* of language, and so also, our lived experience of talking and otherwise using language, is *writing-dependent*.

It is striking that we, we who are in fact residents of the written-language world, find it so very natural to think of speech as something that we can write down. For us, it is as if a written word on paper, computer screen, or blackboard *just is* the word itself. It is the word's image, or maybe, it is the word's face.

And we find it natural seeming that words are the kinds of thing that have spellings. We can write them down. We can't write down any old sound. We don't write down the floor's creak or the wind's whistle. Those sounds don't have spellings. But words come, or seem to come, with spellings attached.[13]

What comes first? The sounds themselves, or the letters in reference to which we pick them out? This is a hard issue. The possibility I want us to take seriously is that, now at least, sounds show up for us the way that they do thanks to the ways that we have learned to play with them, or conceptualize them, and crucially that writing is an important, maybe *the* important, instrument of this conceptualization. We don't stand outside speech, as we might if we were transcribing an alien code, when we spell. Spelling, like other aspects of writing, is something that we do inside of language. Spelling, as Wittgenstein might have put it, is a language game.[14]

And it shouldn't be surprising that our experience of speech is so bound up with writing. It is hard to think of any other technology the mastery of which is so universally and with such lockstep cultural uniformity imposed on the young, from the earliest age, and for the duration of their education. We positively drill writing and writing-oriented ways of thinking about what we do when we speak into our children.

This raises the further question whether it is even possible for us to step back from the writing orientation so that we might experience our own capacity for language, or our own speaking and hearing, apart from the image of speaking and talking that writing supplies. This would be analogous to asking, Is it possible to experience our own sexuality apart from the ways in which culture and religion and ideology have organized our sexual selves? Or like asking, Can we experience the visual world as if we did not live in a culture in which the visual world is an almost endless object of visual depiction? Or for that matter, to relate it to a more traditional philosophical debate, it is like the question, Is there perceptual consciousness beyond the reach of our conceptual understanding?

What is at stake here is not psychological. The questions are ontological. What is language, really, such that, it seems, our understanding of language is entangled with the activity of representing that language in written form? But the questions are also in a way existential: *Is it for us a live possibility to engage with speech, to talk and listen, apart from the entanglement of speech with writing?* To do so would be like experiencing the body as if there'd never been historically elaborated gender roles, or experiencing the movement of dance as if there'd never been Fred Astaire, James Brown, or that boy in tenth grade who could do the Robot.

For now, this much is clear: linguists carry on as if a speaker's or a hearer's intuitions about grammaticality can be taken as data points and used to reverse engineer the nature of the underlying competence that is the knowledge of the language, a competence that is supposed to be independent of writing and culture. It is more likely, I believe, that our intuitions reflect the degree to which we have embodied what Harris calls a

scriptoralist conception of language, that is, a way of thinking about language *after* writing, or according to a model of what speech or language are that writing first makes available.[15] Take, as an example, the simple observation, noticed in passing above, that conventional alphabetic writing systems do not exhibit phrase structure in the way that they exhibit word order. That seems right. But is this a fact to which we have access independently of our knowledge of written language? Is our sense that "the" and "boy" go together to form a single unit a *writing-independent* fact about how we talk? Or is it rather that writing itself, and the writing doctrine, are the very source of the idea, so natural seeming to us, that speech is made up of units that may be combined and recombined?

THE WRITING PARADOX

Let us now, with preliminaries out of the way, return to the question of how or why we devised written language. That is, let's turn to the pseudohistorical question with which I began.

We have already considered what the simple view has to say about this. Written language is *just so useful*. As with the wheel and fire, the benefits of using it are sufficient to explain both how it came into existence and how it was maintained from generation to generation. We have gone far enough into the issue, however, to begin to appreciate why this can't be satisfactory as an account of why we first started writing, or trying to write, speech down. But now we must go further.

It's easy to see how we might apply our graphical know-how to the task of inscribing speech if we already thought of speech as made up of structural elements that can be combined and recombined in a rule-governed way. But to think of speech that

way is already to think of it, precisely, as something writable, that is to say, as articulated by writing. Indeed, if I am right, it is to think of speech and our capacity for speech in a way that may only have been first made available to us conceptually thanks to the existence of writing as a technology. But then it seems that we must already know how to write in order to invent writing in the first place. So writing was never invented. If we write now, we've always been writing.

In this way, we confront what I will call the Writing Paradox; as noted earlier (in chapter 1), it is comparable to Plato's paradox of the *Meno* or Augustine's paradox of *The Teacher*.

Let us pause to remember that there are other ways of thinking about speech than that which writing has made seem so obvious and natural. Speech is movement, after all. It is skillful, purposeful, situation-sensitive, social *movement*. Talking is something that we do with others, and in doing so, we move our mouths and our throats and we modulate our breathing and our rhythms, our posture and our orientation. Talking in this sense has more in common with free play with a ball, or perhaps, dancing, than it does with sentences printed on a page. How do we even get the idea of words, word order, phrases, and phrase structure out of that fluent exercise of task-oriented movement that is "language in the wild," as we might put it? Take, as another example, dancing: How do you write *that* down? Choreographers have tried and, so I would argue, have failed. Where would you even begin?[16]

Now you might be tempted to say that the difference between language and nonlinguistic movement is that language is, intrinsically and manifestly, articulate. It is structure made up out of parts; to be a language user is to be sensitive to this articulation, an articulation that shows up (as Humboldt argued) at two levels (phonological and syntactic, but also semantic).

But can't something similar be said about our bodies in action? Indeed, isn't the living animal body the very paradigm of something that articulates?

This much is clear: language is a moving flow of human activity. To write it down, we must conceive of it as structured and differentiated, but to do this is already to take up an attitude or stance to language that is tantamount to thinking of it as written or at least writable.

To understand the place of writing in our linguistic lives, to frame an adequate concept of language, we need to come to grips with this paradox. This is what I'll try to do in the rest of this chapter. My strategy will be roughly Augustinian or Platonic. I will try to show that there is a sense in which language has always been written; or rather, we language users have always been engaged in something that is the *moral equivalent of writing*. And so, for this reason, we never have to face off against speech—standing apart and wondering how we might ever *write it down*—in the way that the paradox requires. But there will be an even more far-reaching conclusion. Language is, as I will say, organized by writing; but writing is the achievement of art and philosophy.

But wait, how can it be the case that we have always been writing if, as we know, as a matter of fact, the application of graphical technology to speech is a datable and fairly recent event?

It will be helpful, as a way of better framing the problem, to recall the way that logicians think about formal language.

A formal language, the sort of systems that logicians work with, consists of a finite number of primitive or atomic symbols and a set of rules or procedures for determining, for any string of symbols, whether that string is also a symbol, whether it is, in the terminology of logicians, a well-formed formula. If

it is, then good; if it isn't, well then, it's prohibited by the rules. And so for meaning. There are assignments of meanings or "semantic value" to every primitive symbol, and there are rules for determining, given the meaning or semantic value of each symbol, what the meaning or semantic value of each well-formed formula is. If a sign lacks a proper assignment, or if the signs are combined illegally, then what you have is not so much meaningless language as nonlanguage.

A fair bit of philosophy of language and linguistics takes roughly this conception of language, originally framed for formal languages, for granted. Language is generated by the rules. And what is not generated by the rules is nonlanguage. Empirical research aims to make explicit the rules and representations, as Chomsky used to call them, that suffice to specify the language and that, also, therefore, can be thought of as telling you what it is you know when you know a language.[17]

Now consider the fact that actual languages, of the sort that we are using now, are, in at least one important respect, not at all like this. They are not rule *governed*, in the way I have just sketched; they are, rather, rule *using*, that is, users of the language deploy the rules to guide themselves, criticize the usage of others, adjudicate disputes, and in similar ways negotiate their dealings with others.[18] One of the distinctive features of true language is that it is always confronted by the live and immediate possibility of misunderstanding. And as a general rule, misunderstanding doesn't interrupt language, forcing us outside of it, as the logician or the linguist might think; for us, there is no outside, and misunderstanding is for us always an opportunity for more language, that is, for the distinctively linguistic activities of explaining, or clarifying, or elucidating, or justifying. Language users do not just carry on blindly, acting in accord with rules that govern them, occasionally misusing

words and finding themselves then ejected into the equivalent of linguistic outer space. Rather, language users, from the very start, as it were, use language to make meaning in the face of misunderstanding. We define terms; we challenge another's usage; we explain what a term or word means. In fact, as P. F. Strawson discussed in his book on logical theory, the range of evaluative reflection on language is very wide.[19] We find some bits of discourse *clear*, others *murky*, some *humorous*, others *dull*, and so on. There are many distinct domains of critical reflection on talking that unfold inside language: logic, rhetoric, style, wit, sophistication, and so on. Even very young children get this. One of the first uses of language that you see kids playing around with is that of asking after or offering definitions or explanations of meaning.

To be a language user, then, is perforce to be one who takes a stand on language, who cares about misusage and feels called on to offer corrections; it is to be one who copes with difference. This is why I say that language is a rule-using (or maybe even sometimes a rule-creating) activity as opposed to a rule-governed one. And this is why I say that to be a language user is, whatever else it is, to be someone who thinks about language.

To imagine speakers who just carried on, and never needed to reflect on what someone meant, or might have meant, would be to imagine something utterly unlike real human language. (Perhaps this is what the language of machines would be like.)

Tripping, arguing, adjudicating dispute, innovating, explaining, articulating, trying better to express—these are *ready-to-hand* modalities of ordinary, everyday language use. Criteria of correctness, questions about how to go on, or about what is or is not grammatical, dealing with misunderstanding, these are activities that we carry on, and that we fight about, inside of language, and they do not require us to shift, as the logician

might have it, to a language-external meta-activity of setting up the grammar.

Now Hubert Dreyfus has proposed that there is a sharp contrast between first-order engagements with tasks or activities and the interruption of such activities for purposes of reflection or self-monitoring.[20] When we are in the flow, we just act; reflection happens only when there is breakdown.

I agree with Dreyfus that we must be vigilant to ward off an intellectualism or a cognitivism that holds that human activity only rises to the level of action when it is accompanied by deliberate psychological acts of detached evaluation and contemplation.[21] But ironically, keeping the language case in mind, it is Dreyfus's view that conforms most perfectly to the artificiality of the logician's model. Dreyfus's opposition of flow and breakdown corresponds perfectly to the logician's conception of what is inside and what is outside the bounds of language. The use of language to adjudicate and regulate and indeed to reflect on language is one of language's fundamental *first-order* modes. To worry about language, to reflect on it, to take up the writerly attitude to language, is *not* to interrupt language, but to enact it. Language contains its own metatheory; or better, language contains, always, and from the start, the problem *how to go on?* as well as that of *what's going on?* Reflection on and argument about language, second order though they may be, are already contained within language as first-order phenomena.

It is helpful, I think, to compare the case of language with that of another style of skillful engagement with the world, namely, perception itself.

Wittgenstein, in the *Tractatus*, said that the eye is the limit of the visual field.[22] This is wrong: the adjustments of the eye, the need to adjust the eye, difficulties in adjusting the eye, are given

in the way that we see. To see is not, as it were, to be at the re-
ceiving end of a projection from the field; it is to be at play; the
visual field is a field of play. The perceiver, him- or herself, is in
the field of visual play.

Consider: we occupy cluttered environments. Columns,
people, furniture, stuff blocks your sight. But we only rarely ex-
perience the world as closed off by such impediments; they
don't prevent us from seeing, not any more than a rocky trail
stops you from wandering; we move our eyes, we move our
head, we move our body, just as we adjust our footing on the
trail to maintain our footing, and in this way, we keep the world
in touch. Which is not to say that we see through or around
obstacles. We can't do this. What we can do is preserve our ac-
cess even to what is not now in view. We visually experience
much more than is, in a projective sense, strictly visible.[23]

Euclid observed that you can't perceive a solid opaque object
from all sides at once. I am now reminding us that this inability
is not a disability; it is in fact bound up with the character of the
way that an object can show up for us visually. A perceptual
encounter that presented you with the object but in such a way
that none of its parts would be hidden would not be, could not
be, a form of visual encounter with it. That particular form of
fragility—that one side occludes another from view, that as you
move different aspects come in and go out of view—just be-
longs to the way of perceiving we call visual. It is constitutive of
the visual modality. Vision is manifestly fragile in this way.

The presence of the unseen parts of the things we see, like
the presence of the ground we stand on, is something we
negotiate.

And so with talking and speech. Speakers no more transmit
their thoughts than the environment transmits its image.
Talking, like seeing, is an ongoing transaction, a negotiation.

Misunderstanding, unclarity, vagueness: these are the very stuff of language, just as opacity and occlusion make for vision.

THE WRITERLY ATTITUDE

Now, to return to the paradox and to the pseudohistorical question of how and why we ever came up with written language.

The upshot of what I have been asking us to consider is this: to be a language user is (among other things) to be concerned with questions about language, and so language use requires, of speakers and hearers, that they seek to imagine or conceive of what they are doing when they speak. In this way, then, speech is always, in the normal course of events, concerned to write itself down, that is, to frame a model or image of itself, to create what Wittgenstein called a "perspicuous representation," which in a way is a kind of picture. Language calls for writing, for writing ourselves down. This is true of all languages, always, for it is, if you like, the normative engine of language itself. Language demands reflection, and reflection demands that we frame ways of thinking about language. What we call "written language," then, consists in the importation and application of extant graphical methods to this task. Written language is an important innovation, but the innovation is, as it were, only technical. All languages, whether they have writing systems or not, have the resources to take up the reflective attitude, the *writerly* attitude, to speech itself. Writing, in the modern sense—the use of graphical means to write speech down—is only one way of solving the problem that, in fact, preexists that device and arises out of the normative, that is to say, rule-using character, of language itself. Writing serves, finally, to offer a perspicuous representation of what we think that we are doing when we use language.

And this lets us resolve the paradox: we don't face the problem of inventing writing or discovering structure as if from the outside. We have always been writing language, for to be a speaker is to participate in the work of representing our activity of talking to ourselves, and that, finally, is what writing is.

We might put the point like this: the writerly attitude is a condition of speech itself; for speech, of its very nature, is concerned with writing itself (that is to say, modeling language as an activity) in response to the normative challenges that are internal to language. This is consistent with the claim that there is no writing without talking. But it also allows for the more intriguing discovery that, for reasons I have given, there is no talking without writing (or rather the writerly attitude).[24]

So writing and speech, while different, arrive together and are more closely connected than we appreciate. Of course, once we actually have a graphical technology of alphabetic writing, a whole new generative interaction and mutual influence of writing on speech and speech on writing gets started and can amplify and accelerate. For the existence of ways of representing or depicting how we talk (conventionally: *writing*) exerts an influence on how we talk, which in turn changes what we represent ourselves as doing when we talk; that is, it changes writing. Which in turn loops down and drives more change.

Speech is one thing, writing, or the writerly attitude to speech, the concern to represent speech, is another; but these become, in historical time and in culture, inextricably entangled. To understand the nature of their entanglement, we must appreciate the notional difference between the entangled strands, speech and writing. But it is an appreciation of the phenomenon of their entanglement that is, in a way, the important discovery.

If I am right, then it turns out that the invention of written language was ultimately an act in the service of philosophy

rather than in the service of more humdrum kinds of utility such as making it possible to record or send messages or to enable the development of science or bureaucracy. These are side effects. For it was an attempt to exhibit the structure of our language so that, in effect, we can know what we are doing when we talk. Writing has always been about writing ourselves. This has been a project, indeed one of the central projects, of philosophy all along, from Aristotle, through Frege and Wittgenstein, to Austin and Davidson.

Actually, this was also Socrates's project. It is often said that for Socrates philosophy was conversational, and here we think of Plato's early dialogues with their genuinely dialogic form. But in fact, Socrates was anything but a good conversationalist. Socrates was rather an interrogator, and the effect of his interrogations is not to explore ideas through talking, but to interrupt conversation. Socrates demanded that his interlocutors stop carrying on, stop acting out of habits of thought and talk, but that they subject these, their habits, to critical evaluation. In effect, if not in so many words, what Socrates demanded was that they shut up, indeed, that they stop acting, and that they start writing, that they start doing philosophy.

A Surprising Conclusion:
Art Is a Condition of Language

I have been arguing that our experience of language and our conception of its place in our lives are dependent on writing. This has an important negative upshot especially in connection with the status of work in so-called scientific linguistics. Linguistic judgments about grammaticality or well-formedness, and the attempt to frame principles, or rules, that shape our

linguistic competence, are all, as one might say, inside baseball. We are insiders, residents of the scriptoral world, and when we make judgments about language, we do so as participants, not observers. This makes linguistics prescriptive in its DNA, not descriptive, as every "scientific" linguist would insist. Nothing more perfectly illustrates the deforming influence of the prestige attached to the model of positive science than its ability to lead us to believe that we are dispassionate observers building theories on the basis of evidence, when in fact we are participants acting from activity-internal evaluations and implicit mastery of the relevant cultural norms.

Which is not to deny the facts! There are linguistic facts that find genuine expression in, for example, our judgments about phrase structure or grammaticality. But these are no more fixed data points than any other form of aesthetic response. They are starting points, rather, invitations better to articulate why we respond as we do to this thing that we have made or this act that we have performed. Linguistic reality has more to do with aesthetics than it does with psychology. Later in the book I will turn to the elaboration of the conception of the aesthetic that I am operating with here.

But there are vital positive upshots as well. I have been urging that *speech*, of its very nature, contains within itself, as one of its moments, anxiety about its own norms, standards, and, more generally, about what it is we are doing when we speak. We don't just use language; we use language to reflect on language, to represent language, to depict language, and we do so not as disinterested observers, but as speakers who find ourselves caught up in a normative landscape whose topological features are uncertain and disorienting. To be a language user is to be caught up in the *writerly attitude*, that is, in the task of

inventing writing as a means to make *us* more perspicuous to ourselves so that we may better cope with the challenge of carrying on.

Now this moment of language use is, as we have already considered, *philosophical*. We are lost. We reflect so that we might be found. We seek to represent ourselves to ourselves, so that we may understand ourselves, but also, so that we may free ourselves from all the ways in which mere habit and automaticity hold sway over us. The writerly attitude, which, as I have argued, precedes the novel use of graphical means to unveil our linguistic personalities to ourselves, is a philosophical attitude.

But this link between writing and philosophy points to a broader connection between art and philosophy. Notice that philosophy too is a *making* activity. Philosophy uses language and writing to put us on display to ourselves; or, as Wittgenstein put it, philosophy aims at the construction of perspicuous representations. Crucially, this is not, in Wittgenstein's writing, a mere metaphor. His concern from the start, although not always named as such, was with problems of *writing*; he sought to devise notations, graphical devices, with the purpose of elucidating, making explicit, putting on display, making perspicuous. Philosophy, in Wittgenstein's hands, is quite literally bent on the invention of writing, that is, on finding ways to use marks and mark-making to represent us to ourselves with the end in view of clearing up our confusions, enabling a better self-understanding. Just as the choreographer seeks to write the dancing body, so the philosopher seeks to write ourselves, the thinking, talking, linguistic body.

We have just noted that far from being a conversationalist, Socrates urged mere talking to stop so that we might start writing. But philosophical writing—now casting our eyes over the

centuries-long history of philosophical writing—is a battle-
ground; philosophers argue and criticize and analyze. What
they don't do, really, is reach agreement. But how could they?
What they aim at is not agreement, but persuasion, that is to
say, conversion. They seek to see the world anew. And this is an
aesthetic project.

Philosophical texts masquerade as treatises and posture with
argument, but in fact they are *scores*. We play our philosophical
scores and we write them so that others may play them and get
disorganized and maybe, we hope, reorganized by them too.[25]

6

THE AESTHETIC PREDICAMENT

Art is what makes life more interesting than art.

—ROBERT FILLIOU

The focus so far has been on art and the ways that art loops down and alters the habits and technologies that are its raw materials and its wellspring. But in fact, the entanglement runs deeper even than this. For the aesthetic predicament—or the *aesthetic blind*, as I will call it—is much more widespread and abiding than art and art-making; it is as basic and as original as the fact of consciousness itself. The aesthetic is a live possibility, an opportunity, and a problem, wherever we find ourselves. We, and the whole domain of our experience and our world, are no more scrutable than the artworks that we make. We are not fixed, stable, defined, and known; the very act of trying to bring ourselves, our consciousness, our worlds, into focus, reorganizes and changes us. We are an aesthetic phenomenon.

I return to these themes throughout,[1] but it is important—in order to light the way forward, and so that we know what to look out for—to say something more about this now.

From Perception to the Blind

You peer into a microscope. You see washed-out brightness. You adjust the eyepiece. Gradually something comes into focus. Take this as a model or metaphor for how to think of the basic problem of perceptual consciousness. Perceiving is the activity of bringing the world into focus. Many of the adjustments we make are below the threshold of consciousness or attention, most of them grounded in skill and habit, but also in style.

I take for granted here—but obviously this is something that we could argue about—that real seeing, or perception, isn't just a matter of patterns of optical information reaching the eyes and brain. Seeing, as I am supposing, is a kind of knowing and is an appreciation not just of how something looks, but of what it is. (I don't doubt that seeing depends on optical information reaching the eyes and brain, but it depends on much more than that.)

Among the skills and attitudes on which we rely for the actions and adjustments in which our perceiving consists are (1) *sensorimotor skills* (i.e., the general understanding of how one's own movements produce and modulate the sensory);[2] (2) *conceptual techniques* (practical knowledge of how to engage things, as well as intellectual knowledge about what things are);[3] and, finally, (3) general facts about, as I will put it, our *affective orientation*.[4] We are not neutral observers. We are affectively oriented to situations and things. Some things attract, absorb, and incite curiosity and desire, whereas others repel and resist. Every discrimination, every sensitivity, is a responsiveness to what matters. Every discernment is enfolded inside caring.

One of the mistakes that shapes our inherited ways of thinking about perception is the idea that perceiving is, basically, a matter of judgment. We suppose that when we see, we first de-

tect a mere something and then subsume it under concepts, categories, and values (attractive, repugnant, etc.).[5]

Here I work with a different idea. All this—the concepts and skills, attitudes, and valuations—is better thought of as *the means* by which we achieve direct access to the world around us. They are the adjustments in which perceiving consists. It is our competent negotiation and adjustment along these dimensions, and perhaps others too, as with the microscope, that lets there be anything there for us. They are the means by which we bring it all into focus. We don't first see the thing, or the situation, and then categorize it; our mastery of categories is a condition on the thing's, or the situation's, first showing up as what it is. Perception may be conceptual, in some ways and respects, but that does not mean that it is judgmental; it is not a predicative act. Think of our understandings as the techniques whereby we "pick up" what there is rather than rules for categorizing what we antecedently detect.[6]

Now all this—these adjustments, these perceptual operations of our live consciousness—belongs to the level of habit. Or to use the language of the previous chapters: they are first order. We spontaneously and effortlessly deploy these skills, techniques, and valuations to know the world, that is, to be *in relationship* with the world around us.

Now sometimes habit fails us. Sometimes we lack the categories, skills, background abilities, and affective orientations to make sense of or even to discern or individuate or care about what we encounter. Sometimes the world resists labeling and intelligibility. A good example would be the experience of unfamiliar speech, or strange writing. Here we meet no affordances. We also have this experience, in some ways, when we arrive in a new place, or enter into a novel situation. When this happens, we are thrown back on ourselves and we need actually

to make an effort to know where we are, what is going on, what matters. We need to labor to bring the world into focus.

This is the *aesthetic predicament* or the *aesthetic blind*. Aesthetic work, at the most basic level, its task and substance, is the effortful reorientation of ourselves—to borrow an image from Husserl[7]—so that we may know and see. Or we might say that it is the achievement of a perspicuous representation, as Wittgenstein put it.[8] (I come back to Husserl and Wittgenstein in chapter 10.) Aesthetics names the effortful movement from seeing to seeing differently, or from not seeing to seeing, or from not making sense to making sense.

Thought of in this way, the aesthetic blind is not so much the breakdown or disruption of ordinary first-order perceptual adjustments and knowing as it is a modality or moment thereof. This is a theme to which we will return (in chapter 11). The call for labor to bring the world into focus is an ever-present live possibility, and it is one that, in itself, is not strange. The ordinary, spontaneous, perceptual adjustments in which having the world in hand consists and the more difficult challenges of its aesthetic counterpart are entangled.

ART AND THE STAGING OF THE WORLD'S OBSCURITY

Now, let us ask, what is the connection between the aesthetic—so understood as an abiding possibility, but also the opportunity, or affordance, of our ordinary, habitual, perceptual lives—and art, or artistic practice?[9]

Art, or artistic practice, but also philosophy, or philosophical practice, are ways of more directly engaging with and investigating the aesthetic. In art and philosophy, we conjure opportunities to be stymied, to be incapacitated, to be confronted by the

nonintelligibility of the situation. The art object, in its purest form, is something that we do not recognize. We do not know what it is. Just as in philosophy we orchestrate situations in which we find that we do not know what to think or say.[10]

Consider this kind of case: You go to a gallery. The pictures that hang on the walls are unfamiliar. You know neither the artist nor the style. Often that sort of encounter is defeating. The works don't pop; nothing grabs your attention and fascinates you; they all kind of look the same. You may find that you are bored. Busy as you are, wrapped up with your life, you may find that you are inclined to keep moving on to the next gallery; or you turn your attention to the people you are with. This state of blankness and disconnection, of not knowing, or not seeing what is there for you to see, is one of great richness and possibility, even if it also challenging, maybe boring, maybe irritating. It is the basic *aesthetic blind*. You can't see. You can't even really want to see.

But suppose you rise to the challenge. Maybe the friend you are with motivates you because she knows the work and cares about it and directs your attention to this or that property of the paintings, maybe to do with what they depict, what they show and what they leave out, or with their history or origin, or their relation to history or ideas; or maybe she simply invites you to notice the way that the pictures were made, a fact about the application of paint, or the geometry or the color or whatever. Now you ask questions and look more closely. You don't exactly discover anything new. After all, it is not as though anything had been hidden from you on your first inspection. And as you do so, the pictures may, if you are lucky, transform themselves in real time as you make the effort to know them. Whereas before there was flatness and no structure, now there is obvious structure, and depth, and meaning.

By your own action, in these ways, you turn the works on, so to speak, and make them show themselves; you bring them to perception. You reorganize yourself by looking at them, and at the same time you reorganize them. You have now moved from not seeing to seeing, or from seeing to seeing differently. And it is this movement, this transformation and reorganization, in which the aesthetic consists.[11]

From this example, two thoughts suggest themselves. First, that part of what we might call the meaning of art, or its value, has to do with the ways that it lets us catch ourselves in the act of accomplishing the aesthetic, of coping with the aesthetic predicament, that is to say, with the ways that it lets us know ourselves as absorbed in this movement from not seeing to seeing, or seeing to seeing differently. And second, that it belongs to art's value that it lets us cultivate, develop, and refine the very ability to do this, to cope with the aesthetic, to reorganize ourselves so that we may see originally and be altered, in the face of the reality that it is, so to speak, a fact of life that sometimes we need to do so, that sometimes we find ourselves in the aesthetic blind.

An interesting question arises: If artworks are things that we do not know, do not recognize, do not know how to see, and if it is laborious and counterhabitual to do so, then what motivates us to engage them, to do this work? Why bother with art, let alone *like* it? I will call this the question of *aesthetic motivation*. What is the basis of aesthetic motivation? In a way, this whole book aims to answer this.[12]

But there is another, closely related question: *Why* does habit fail us?[13] Or what is it exactly that fails when habit fails? What are the sources of our inability to see? Now there is a straightforward answer. Sometimes we just don't have the knowledge, the skills, the orientations, to bring what is there

into focus. We don't know how to read. We don't have what it takes to make the necessary adjustments. We need to learn to see, after all; we need to learn to look and pay attention.

This is very much the case when it comes to artworks that, as we have already emphasized, are made to be obscure. An artwork is an occasion for fruitful inscrutability; it affords an opportunity for us to figure out how to make sense of the artwork itself. We need to reorganize ourselves so that the artwork can be there for us. And as we have already stated: this is one of the sources of art's very value: art demands that we move beyond the familiar, engrained ways of looking, thinking, acting, or more generally, *being*, that constrain us and, in so many ways, hold us captive. Art offers the opportunity not, surely, for a habit-free existence. But it does offer the opportunity for different patterns of organization.

But there is more to this question of habit's failure. Consider again, as an example, the fact that I might find that I can't see or make sense of particular foreign ways of talking or writing. Well, this is because they are strange to me, obviously; I don't know them, and maybe I have never cared about them before. In many contexts, it would be unreasonable to blame me for not knowing your language, for not being able to read your script or understand your words. You can't *blame* a person for their own illiteracy! Yes, but it is important to notice that the question of blame may not be in every case entirely out of place— even here. Consider that, sometimes anyway, there may be something, if not finally wrong, then at least ethically uncomfortable, about a person, a visitor, say, who is here among you but who does not share, has never made an effort to learn to share, your language. What this visitor can't see and do and understand here marks a kind of ethical remove between you, for it exposes, possibly, not just their distance, and not just their

difference, but also their indifference. Or consider the case of "the queer." Some people in the straight world can't see, or can't make sense of what they see, or can't tolerate what they seem to see, when they find themselves in this space. This is a very specific kind of aesthetic predicament or, we might even say, aesthetic failing, and it has everything to do with what we might also call ethical failings or, at least, ethical challenges.

This upshot—that perceiving has an ethical dimension—follows naturally from the starting point that in perception we work actively to achieve the world's presence. It is, finally, *constitutive habit* that governs how we find ourselves *able*, but also, *willing*, to try to bring the world into focus. Perceiving is bound up with who and what we are, with the very landscapes of personality and shared life. Aesthetic predicaments are obstacles to just carrying on; they are opportunities, potentially ethically loaded, to know the world differently.

This point also helps us appreciate that there is something very misleading about my microscope analogy. As if the world is like a microscope slide, and as if we are merely curious observers!

THE ARTWORK GETS IN THE WAY

The basic fact about the work of art is that it is a nonthing or a strange tool. It is something that we can't see or recognize; it is without label. It lacks a concept, as Kant might have said; there is therefore no knowing what it is, and so to see it we are, in a way, thrown back on ourselves, on the very question, What is it about our *ethos*—our habits, our way of being—that stands in our way? So the engagement with an artwork is an engagement with oneself, and also others, and the work of aesthetic engagement with an artwork requires a kind of unveiling of the self to

oneself that also tends, of its very nature, to alter us, to reorga-
nize us. Again, this is why, on my understanding, art and phi-
losophy are reorganizational practices, and this is why they offer
something like emancipation: they free us from the ways that
we just find ourselves, as a matter of fact, organized by habit, by
culture, by history, and even by biology.[14]

But now we must admit that, as a matter of fact, in our soci-
ety, most of our art encounters are precisely encounters with
objects that do in fact come prelabeled as artworks. We find
them in special art places—museums, theaters, galleries,
showrooms—and we approach them already looking forward
to the prospect of the special experience, the so-called aesthetic
experience, that they are able to cause in us. It is not surprising,
then, that we think of the aesthetic predicament or blind and its
challenges as posing something like a problem for judgment,
specifically, for aesthetic judgment. Here is the artwork: now
let us evaluate it and decide whether it is beautiful, or original,
whether it is important, or great, or serious; does it succeed, as
if we even know what this means for the work of art?

Now this is in fact something that we do—we look and argue
and wonder about the beauty, greatness, originality, power, and
so on, of artworks. But we are now in a position to see that this
activity, all these words and arguments, is a distraction from the
real work in which aesthetics consists. The real artwork is un-
known and invisible, not steadily or readily present to serve as a
topic. The real artwork, like the paintings on the wall in my gal-
lery example, has not yet found a way to show up. And so the real
work of aesthetics is prior to all acts of predication or judgment.
Aesthetic work, like perceptual adjustments more generally, is
the work that needs to be done prior to any possible judgments.
Aesthetic experience names the work of *achieving the object*,
work that is antecedent to any act of explicit evaluation of the

object. Aesthetics is not the task of evaluating the object. It is the task of achieving the object.

From this we can take away the conclusion that aesthetic encounters should not be assimilated to judgments about whether an x is beautiful or original or great. Those conversations are interesting, but they have little to do with the genuinely aesthetic challenge, which is something that comes before all that. Genuinely aesthetic experience is the work of reorganization in the face of the not-yet-known.

The real aesthetic values are not preference, beauty, greatness, originality, and the power to move us. The real aesthetic values, as with perception more generally, are prior to all that, the skills, attitudes, and basic affective orientations that let us bring what there is into view. Art participates in the aesthetic, but the aesthetic is a general feature of our lives together in the world.[15]

But things are actually more complicated still. For it turns out, as we will explore further in chapters 9 and 10,[16] that what we are doing when we try to *make judgments* about works— judgments like "this is/is not a great work"—is really just a kind of veiled way of working to see them more clearly, or to bring them into focus. Wittgenstein had this in mind when he said that in aesthetics what matters is not whether you like a work, but *why*: Why do you respond as you do? What are your reasons? And this in turn suggests that the work of aesthetics that you need to undertake is that of describing what you see, finding the words to say what you notice and find remarkable. The activity of doing this, attempting to survey and describe and evaluate work, is fragile, incomplete, tentative. But it is also productive in this sense: the act of thinking, looking, and talking about what you see changes what you know and see. After this labor, now you can, finally, see.

Indeed, this productivity is one of the most abiding features of the aesthetic. What is characteristic of the encounter with an artwork or any aesthetic encounter is that by looking, describing, thinking, and interrogating what is there, we make it and ourselves new; we reorganize it and ourselves.

We thus come back to the idea that we are entangled with art and, moreover, that we are ourselves, in a way, a kind of artwork. Which is to say that we are, for ourselves, like artworks, beings whose nature refuses to be known but whose being unfolds in the activity of working to know and see. Which is just to say that we are an aesthetic problem. We encounter this, surely, every time we try to do something as simple as "say what we see" or "say what we feel" or "say what we want." We have too much to say in answer to these questions, and we have no principled ways of deciding, once and for all, among the different possible answers. There are no tests we can run, no brain scans we can study, to get to the bottom of ourselves. We are aesthetic. We are works in progress.

This is surely one of the reasons—I offer this as an aside, but it is really central to my whole undertaking—why cognitive science (however construed: neuroscience, cognitive psychology, neurology, etc.) tends to remain not exactly immature, or unfinished, but really, in a way, not yet even begun. Which is not to say that there should not be cognitive science or that there cannot be. But it is to remind us that cognitive science—like art and philosophy—is an aesthetic domain.[17]

A further aside: these considerations also help us understand why it is not possible to know the aesthetic in the third person, why we can't reliably frame an understanding of the aesthetic qualities of an artwork on the basis of the testimony of another.[18] Aesthetic experience, such as it is, does not consist in coming to know, as it were, that a work has a property such as

beauty or that it carries a certain significance. If that were what the value of aesthetic understanding consisted in, then it would be possible for you to simply learn this by reading, or to be informed by some putative authority about which objects do and which objects do not have the aesthetic value in question. But this misunderstands the aesthetic, at least according to standpoint that I am developing here. Aesthetic experience, if this refers to anything all, refers to the temporally extended practice of engaging with oneself and one's environment with the goal of moving from not seeing to seeing, or from seeing to seeing differently. It is the experience itself, or the labor of achieving the object or the work, that is the key thing. Aesthetics is interested in the work of adjustment itself. As Dewey understood, our task is not to figure out what makes the object special. In itself, the object isn't special. Art works by affording us the opportunity to work ourselves over. This is what Dewey meant when he said that the art *is* experience.[19]

Which is not to deny—and this is very important—that what others say and think and write, indeed, the larger context of criticism that supplies the background to all of our encounters with works of art, does not and should not shape our own response. Of course it must. But "response" to an artwork is just the beginning of the aesthetic encounter, just the start of the aesthetic experience, which, in truth, consists in good measure in becoming a participant in the reflective work of criticism that began long before you showed up and will continue long after you leave. Aesthetic work is not something that we usually carry out by ourselves. We saw this in the gallery example: it is your friend who helps you see the work. But we are also typically accompanied by the voices of our teachers and parents and other authorities. To some extent, to engage an artwork is to engage these voices.

ACHIEVING THE OBJECT

The work of the aesthetic, as with perception more generally, is the labor of achieving the object.[20] Art and the aesthetic concern themselves with questions of beauty, genius, originality, and so on, only in a derivative way. The real values at work in aesthetic coping are antecedent to the making of such judgments.

To have liberated the aesthetic, in this way, from any but an accidental connection to art, let alone to beauty, lets us appreciate that aesthetics names the transformative work of operating with the values that we take for granted in sustaining our relationships to objects, people, and our world. The real work of aesthetics is precisely the adjustment of the values, and also skills, expectations, and understandings, thanks to which we can alone bring the world into focus.

Aesthetics, thought of in this way, is a general engagement with value, and so it is an ethical undertaking.[21] We have already noticed that aesthetics, like artistic and philosophical practice, is shot through with ethical significance. Negatively this is because ethical limitations, in both a narrow and a broader sense, may define the contours of the aesthetic predicaments in which we find ourselves (pertaining, for example, to foreign languages or to encounters with people who may present as queer). But also positively, because we remake ourselves and our worlds individually and together through our aesthetic engagement. We remake our ethos.

Now, if you were inclined to think that "aesthetic" has to do with what we like, or dislike, with preferences, or with what we find beautiful, or what gives us awe, or what is moving, as many philosophers say, then the idea that ethics is aesthetic might seem to trivialize ethical conflict and the urgency and importance of ethical dilemma.

But if you think of the aesthetic, as I have been explaining it here, as at once necessary, a basic moment in our lives as perceivers and thinkers, and if you appreciate, as I try to show in this book, that we transform ourselves, and also our communities, by means of artistic and philosophical practice, that is, through aesthetic engagement, then there is nothing in the least trivializing in seeing that ethics is grounded in the aesthetic.

The unifying thought here is that the aesthetic and the ethical are united in this: we enact values in bringing the world into focus; we change our values as we struggle to do so.[22]

The key, I think, is to allow for the possibility that ethical predicaments, like aesthetic ones, call for renewed looking, for closer attention, for generous, that is to say, maybe even loving curiosity. The ethical, as with the aesthetic, is an area of our lives where we find ourselves called upon to confront our own limitations; that is, the ways in which the ways that we find ourselves organized and resourced habitually are not enough for us to know, confidently, how to go on.

Neither argument nor empirical science can decide for us what we should do in the face of this onset of blindness or paralysis. Art and philosophy can. But not by giving us principles to decide, or on whose basis we might pass judgment—principles and arguments only stoke the aesthetic furnace—but rather by giving us opportunities to see differently, to know better, to enter into relationship with the objects, that is to say, the people and problems, that stand in our way.[23]

Here is an example, which I borrow from Iris Murdoch.[24] Mother-in-law has always viewed her son's choice of life partner as somehow beneath him. She has persisted in looking upon her with a critical and unloving eye. At some point, provoked by whatever eventualities, she has occasion to rethink her harsh picture of her daughter-in-law. She now comes to be able to

re-see her as the lively and supportive source of love and hap-
piness in her son's life that she is.

We can take this vignette, underdescribed as it is, as a kind
of paradigm example of the shape of a genuinely ethical situa-
tion. As I read Murdoch, this is precisely her insight. What's at
stake here is not so much the facts of the matter about
Daughter-in-law. These are almost too subtle to be weighed,
sorted, and judged. What's at stake, rather, is Mother-in-law,
and her consciousness, that is, the world as she knows it and
exists in it. At some point Mother-in-law is able to see Daughter-
in-law anew; she has performed the aesthetic movement from
not seeing to seeing, or from seeing to seeing differently. She
has achieved the object, and so she has reorganized herself and
remade her relationship with her daughter-in-law.

To think of the ethical in this way is to appreciate its funda-
mentally aesthetic and reorganizational character.

You might worry that ethics can't bottom out in the aesthetic
in this way. Mother-in-law's interest in seeing Daughter-in-law
differently is not idle and, as it were, for the sake of self-
transformation. She *owed* it to Daughter-in-law to look again.
And insofar as she persisted in viewing her with pinched and
ungenerous eyes, she is blameworthy, she is wrong, or bad. And
anyway, persons are not mere things that we, as it happens,
strive to get a clear view on.[25]

But this criticism loses its force once we give up the concep-
tion of perceiving itself as somehow predicative and divorced
from value, the very conception I have been urging us to reject
throughout this chapter.

Consider: Consciousness is not a beam of light that we shine
variously on this or that thing, lighting here an ashtray, there
one's beloved child, now a neighbor, now the congestion of ve-
hicles on the road before you. Perceptual awareness is better

thought of as something like a communion. In any case, it is bidirectional, genuinely relational, but also multimodal through and through. I don't *see* my daughter and *then*, having done so, *judge* her value and importance to me. The very way I experience her—the manner of her presence itself, the way she shows up— is the realization of her importance to me. Just as I don't identify the delicacy of the porcelain and then adjust my grip accordingly. It is in my sensitive touching that I achieve the porcelain's delicacy, that I come to know it, that is, to enter into relationship with it. To the variety of ways things can be present for us there correspond a variety of ways we actively, skillfully handle and respond to them.[26] Again, the things are not there for our detection, and then, after that, for our evaluation. We evaluate the things in detecting them; evaluating and detecting are entangled. We see the ones we love differently than we see the ones we don't care about. Values are antecedent to the encounter with the object, because they are embedded in and find expression in the relationship that is the encounter with the object. They are the means by which we (try to) achieve the object, or the person, and make it present.

To suggest, as I do, then, that the ethical is aesthetic is not to reduce the ethical to a matter of mere perceptual knowing. It is to admit that perceptual knowing is already ethical, for it is already the work of value.[27]

All this is consistent with the thought that there is something like an obligation, indeed, an ethical obligation, to know, or to see better, or to more fully realize our relationships. Mother-in-law was under an obligation to do better in her relationship to Daughter-in-law. But this obligation was not something imposed, as it were, from on high, or from outside the relationship itself. The obligation is just an expression of Mother-in-law's lively engagement with Daughter-in-law her-

self; or to generalize, obligations of this sort are internal to our engagements with the personal and worldly relationships that make up our living.

Let's compare this to a baseball player who is having trouble hitting. He experiments with his grip on the bat. He plays around with how to hold the bat—up high near his shoulders, or down low by his hips?—and he works with his stance and the different ways that he can use his footing to time his swing. The baseball player works on himself so that he may hit the ball, that is, be in relation with the ball (or maybe with the pitcher). It is good that he should do this. But not because there is a standpoint outside the very specific, personal, but also culturally embedded and so inherited life of baseball from the inside of which we can say that there is an ethical value in good hitting. The value of hitting has as its only ground the fact that one is, as it were, a baseball player, that that is one's life, and that one, therefore, cares about baseball. If there is any absolute here, it could only be this: it is good to have a life.

Knowing/seeing/achieving-the-other-in-relationship is one of life's basic processes. We enact ourselves in relation to others in the world, which is just to say that sometimes we fail to do so, and that we always run that risk. Actively working to perceive better, more truly, this is what "just carrying on our lives" consists in.

It is important to remember that Mother-in-law does not stand apart from Daughter-in-law; Daughter-in-law is not a theoretical object for Mother-in-law's consideration. Mother-in-law is already wrapped up in exchange and cohabitation with her; they are involved. And not as a result of her own choosing. She didn't pick Daughter-in-law out of all the people there are to be an object of interest and pursuit, just as she didn't pick her own son out from among the many and decide to love him. Again, knowing

here means something more like communion and exchange. An even better example, although loaded in all sorts of ways: Mother-in-law no more chooses Daughter-in-law than Baby chooses the mother who gives birth to her; but every baby *must* cope with the reality of that birthing process and must deal with its aftermath, even if none of us ever remember any of that.

In comparison, art can seem flimsy and optional. Is it better to see and understand a work of art than not to see it? Is there some obligation to know an artwork, to engage it and deal with it? It is surely the case that with art, but usually not with our families and other important personal relationships, we can just walk away. Nothing compels us to spelunk our way into the dark place where we can finally face up to the challenge of the unknowability of the art thing. Mother-in-law's need to deal with Daughter-in-law, and to deal with herself so that she may deal with Daughter-in-law, is more pressing, with much more at stake.

That's true. But here it is useful to remember that artworks, like good jokes, are interventions that frequently have the power to startle us and command our attention, and when they do so, it is because they, too, like our most personal relationships, work with the very fabric and material armatures of our lives. We can evade art, just as we evade "working on" our relationships. It is an evasion nonetheless. This brings out the ethical basis of aesthetic motivation, just as we have been bringing the aesthetic character of the ethical into view.

PLAYING PHILOSOPHY

In *Strange Tools*, I argued that philosophy and art are two different species of the common genus *reorganizational practice*. Their aim is to free us from the ways that we unreflectively find

ourselves stuck being. The philosopher challenges you not to stand by your guns, but to question what you take for granted when you reflect, for example, on freedom, morality, consciousness, or free will. What the philosopher establishes in their labors are not truths or theses, but rather *scores*, scores for thinking with. This is why we don't study philosophy by learning lists of claims; nor do we particularly worry about discarding the false ones from consideration. In philosophy, it is never about the bottom line, even when that's what philosophers seem most dearly to care about. As Dewey understood, in philosophy there is never a take-home nugget, or portable finding, that can be applied and put to use here or there, as there is in science and math.[28] The philosophy lives for us like a musical score that we—students and colleagues, a community—can either play or refuse to play, or wish that we could figure out how to play, or, alternatively, wish that we could find a way to stop playing. And when a philosopher is committed to their work, it's because they feel the value of breaking free of constraining habits that playing the score affords them.

To say this is not to deny that philosophy is a rational enterprise, that it deals with ideas and substantive problems or that it deploys argument and analysis to get to the bottom of things. No, the really striking thing about philosophy—as modeled and exemplified in Plato's early dialogues—is that the hardest work consists not so much in getting answers, but in finding and, as it were, licensing questions. This is why philosophy books usually begin with the litany of past mistakes. They've got to convince the reader that there is really a need for some further contribution, that there are problems here worth paying attention to. Another striking thing about philosophical work is that we don't measure its richness and success by, as it were, whether it offers a stable and settled solution to whatever

problems it concerns itself with. This is because no philosophical work has ever done that—not because philosophers are wrongheaded, tendentious, obtuse, unwilling to compromise, or indifferent to truth, but because philosophical problems, like everything in the domain of the aesthetic, are immune to decisive argument. Waismann appreciated this. "No philosophical argument ends with a QED," he wrote.[29] Philosophical problems are something else altogether. They are opportunities for us to reorganize ourselves, to try to see what we already know *differently*, to change ourselves.

Philosophy, like art, is an answer to *the call of the blind*, to the inability to know how to carry on, and the blind is a live hazard of everyday life. Our lives are, for this reason, shaped and reshaped by art, philosophy, and the aesthetic. There can be no serious engagement with ourselves—whether in natural science, cognitive science, or whatever—that tries to sidestep this awesome and potentially liberating fact: that we are ourselves aesthetic phenomena who are always in the midst of becoming.

7

FRAGILE BODIES

Writing free verse is like playing tennis with the net down.
—ROBERT FROST

HERE WE ARE, IN TEAM COLORS!

Descartes's great ambition was to free himself from tradition, to bracket books and language and erudition so that he might, as it were, from the ground up, reconstitute his own understanding of the world, and that he might do so authentically, in the first person. It is ironic that he has done so much to shape *our* philosophical and literary traditions. The first thing that we require our students to read are the reflections of Descartes in which he eschews the value of what can be learned in books.

But what if every image in your mind is recycled from the things that we have seen and thought about together? What if your thoughts and feelings are present for your consciousness only in the partially articulated way that language makes possible? Factor out all the books and traditions, sedimentations (Husserl's word) and entanglements, and what you are left with is not pure consciousness, or the true self, but only a shell corresponding to the place where the self—one might almost say, *our* self—was meant to be.

Vico, the passionate anti-Cartesian, seems to have understood this. What we know best is the social world we have made together. Vico's autobiography, which is in marked counterpoint to Descartes's autobiographical *Discourse on Method*, is written in the third person, and consists mainly in the recounting of a life led. It is a telling of people met, books read, conversations had. Such a story, it is tempting to say, is told *from the outside*. But it might be better to read it as poking fun at the ridiculous ambition of trying to remain what one is while, at the same time, bracketing one's actual worldly life.[1]

Vico's discovery is the antithesis of that of Descartes. For Descartes, what I can know best, and with greatest certainty, is my pure subjectivity. Vico's idea is that what I know best, and with the greatest certainty, is what I make or do. And I make or do almost nothing by myself. I am a being that becomes what it is in the dynamic of my participation in the world around me. And *that world*, crucially, is not the world of geometry; it is the world that is itself only available to me or us thanks to tradition, thanks to entanglement, thanks to language, and poetry, and the fact that I rework and recycle and reuse the resources we all share to make our own way of being. Just as texts are only intelligible to me if I can read, so the whole unlimited mass of meaningful relationships that define our lives together is only available thanks to my incorporation of the language and also the attitudes and styles dominant in the household where I am brought up, as well as in the schools and on the AM radio stations and TV screens, in the bathrooms and playgrounds and subways that mark out the places where each of us begins.

To appreciate that consciousness itself is participation in a tradition in which there is custom, erudition, and poetry is to be in a position to discover a new importance for the body, although it is unlikely Vico went this far. For it is a condition on

the ready intelligibility of the world that I, you, we *can*—Can
read. Can talk. Can see. Can understand. Can notice. Can eat.
Can cope. Now the suite of can-dos, know-hows, and skills, and
also the corresponding failures, and can't-make-its, and maybe
sometimes also humiliations, is something that we bear, not as
Cartesian egos, disembodied, and only truly disclosed in the
absence of the weight of the world's teachings, but precisely as
belonging bodily and culturally to that world, as active in it.
Vichian Egos, unlike their Cartesian counterparts, are like the
players on a baseball team. Look at us! There we stand, all
dressed up, in team colors. We don't just have bodies, as we
might have vessels to travel about in—even Descartes under-
stood that. Nor are we identical to our *mere bodies*, unless by
that we mean only that we are identical to the be-capped and
muscle-popping, chewing, spitting, spike-wearing ballplayers
that we are. The bodies that we are are not *mere bodies*—not
merely extended matter, or whatever—they are the players, and
they are only players because they come equipped to play. They
can play. They care about playing. They want to play. The base-
ball player's eyes see that the runner is taking an extended lead
off first base. The shortstop snaps like a rubber band when the
ball is hit, running, fielding, throwing, soft hands scooping up
and then ridding themselves of the ball. This player's body is
geared into its world, knowingly, affectively, competently. The
player's mind is not something behind, or underneath, or ex-
pressed in, or thanks to the body. The body manifests a kind of
implicit comprehension that Merleau-Ponty called "motricity"
or "motor-intentionality."

So Descartes was wrong about the body—it is already ori-
ented to the world in a knowing, competent, intelligent way;
the body is a mental phenomenon—but he was also wrong
about the mind—it is not something that shows up a zone apart

from the place where the body resides; a mind without a body is like a baseball player who has never played the game. Just as baseball thoughts happen on the field of play and in relation to the in-game choices we face, the same is true of thoughts more generally; they are actions in the worldly field.

Merleau-Ponty held that the body is a schema of movement, that is, a dynamic structure defined by what it can and also by what it cannot do. But, as we have already appreciated, motor intentionality isn't just a matter of the ways that we move. We are bodily geared into the world in other ways. Desire, lust, curiosity, interest, but also revulsion, contempt, and maybe most of all fear. The human body is *oriented*, we might say, just as we speak of sexual orientation. This orientation—in relation to the meaningful world—is not something more basic than mind, or beneath it or before it. This is mind at work.[2]

To have a body, a specific, educated, formed, competent body, is to have an orientation. It is for certain things to be salient, to capture attention, to solicit response, to afford opportunities, and for others to close off possibilities and to present insurmountable obstacles. If the world is a song, then the body is the range of ways that we can knowingly, that is, skillfully, respond to the music in movement and play. We are our bodies! Even though we are not, merely, our bodies.

I would not say that it is the body that *determines* the orientation, in the sense that it brings it about; we cannot explain, as it were, *why* people are oriented differently in the world, or why they in a sense occupy different worlds, simply by reference to physical differences in their bodies. The animate, competent body *is* the orientation, rather than its cause; it is our potential for opening up a world, and the world is just that which is made available by an orientation, that is, by the body. This is a point of importance, conceptually and politically. Let me explain.

It is obvious, I think, that people have very different ranges of experience and that these differences may track, in pretty transparent ways, bodily differences, that is, differences in body schema and also differences in what is sometimes called body image, namely, differences in the ways that we look, and also differences in the ways that we come to experience what we are that have to do with attitudes to how we look. The bustling night spot, packed with people leaning on small tables, might seem cozy to some, but positively unsafe to a person with fragile legs and difficulty walking. One and the same roadside diner might afford a White traveler a place of shelter but present itself to a Black traveler as a place too unwelcoming to enter. It is tempting to say, then, that the different bodies of the disabled person or the Black person determine the different worlds, difference suites of saliences, different affordances, different emotional realities. This thought gets something right: different bodies have different possibilities, different can-dos and can'ts (including prohibitions, etc.), different freedoms and constraints, and thus different affective orientations, and so different worlds.

But this characterization is too simple; it leaves out the fact that the disabled and the nondisabled, White people and Black people, men and women, also share a world, even if it is also true that the world they share is full of occlusions, projections, discontinuities, and differences. But just as what shows up beyond the horizon of sight *shows up* as *out of view* or *too far away to see*, so socially significant differences show up sometimes as invisible, or as objects of indifference; they may show up in the modality of neglect.

To have a body is to navigate horizons of possibility—I can walk now, but maybe not next year; I can drink this now, but if I drink too much, I'll be sick later. But also distinctively social

possibilities; a body is a structure in a social possibility space. And pairs like Black/White, woman/man, disabled/nondisabled pick out, at least typically, opponent processes. Each term has its meaning usually in relation to the other. To join the world, then, as a little child, and to come to learn terms such as these, is not merely to learn to categorize entities according to whether they have this or that property. It is to learn, even if only implicitly, something deep and important, and also terrible, about the very shape of reality. So, for example, a young White child may have literally no conception of Blackness, and so her attitudes and postures, her security, is not, as it were, founded on *her* opinions about race. But if the child is "normal," if she is intelligent, if she is sensitive, she is liable to a "learn" that her normal—her comfort, her safety—is opposed, somehow, to Blackness, which may become, for her, a kind of fluctuating otherness. In this way, the child becomes, as a matter of course, a product of something that we might call racism; her "normalcy," her cognitive power, almost necessitates this; she comes to "know" that race matters, that color matters because, after all, it does. She comes to understand, and if you like, to own, the overlaid horizons of Black and White life. But she may also, and thanks to the operation of the very same sensitivities, come to incorporate seeds of resistance.

It may be that Merleau-Ponty himself tended to take for granted that there is one, normal, standard body, a body like his, the body of the nondisabled European man, that he imagined that the body's organization in and relation to the world is, roughly, the same for everyone, always, over time. This would lead naturally to the further assumption that *the* body explains *the* structure of human consciousness and *the* world.

But again, this would be mistake. Whatever Merleau-Ponty thought, what is important to appreciate is that the order of

explanation goes the other way. Yes, the body belongs to the ways that we enact our consciousness by enacting our selves and our worlds. But it is not antecedent to consciousness, available as a resource in terms of which we might hope to ground or explain consciousness, not anymore than the piano is antecedent to the music we make with it. We do use the piano to make music, of course, but the piano is, very literally, a machine for making music, one whose existence presupposes a musical culture. Likewise with the body. The body is the fruit of consciousness, its very embodiment or materialization, and not something "natural" before all that.

Here is another, often noticed, fact about the body: it is visible. If you can see me, you can see my body. The body is exposed. It is revealing. My body reveals, typically, *what* I am: that I am Black or White, young or old, man or woman, disabled or nondisabled, or that I am not determinately any of these things, or, as we might put it, that I am determinately neither/nor. These are the sorts of things that we can see, or at least, that we take ourselves to be able to see.

This observation is in the vicinity of what was perhaps my first, most personal, and most authentic philosophical thought. I wondered, as a thirteen-year-old, at the transformative power of *other people*. The fact of the presence of another person— even an unacknowledged stranger on a train—fundamentally reconfigures the situation in which you find yourself. You may be sitting there reading, or sipping a drink. But how it feels to be there, the very quality of the air around you, is changed, if there are other people there too. To be seen, to be open to the view of another, is to be active and activated; it is almost as if the presence of others sends a charge through the air and animates the very space in which you find yourself. If this phenomenon does not impress you, it might be because we are so

accustomed to others, or rather, because the presence of others is in fact the normal default, that we continue to abide in a social space, a space in which we are visible and assessable, even when we are alone.

Frantz Fanon, in his 1952 book *Black Skin, White Masks*, describes a particularly exemplary experience, what he tries to think of at the time as a "passing sting." He is in France; a little boy sees him on the street: "*Maman*, look, a Negro; I'm scared!" The wound is not made better when the mother scolds her child—"Ssh! You'll make him angry"—and then apologizes to the man—"Don't pay attention to him, Monsieur. He doesn't realize that you are as civilized as we are."[3] To be seen this way, to be identified, labeled, recognized as a certain kind of being, Fanon understands, is to be altered and made different from what one might otherwise be, or at least to be threatened with such destructive alteration. Even the body schema is affected. Fanon writes, "In the white world, the man of color encounters difficulty elaborating his body schema. The image of one's body is solely negating. It's an image in the third person. All around the body reigns an atmosphere of certain uncertainty." He explains, "Beneath the body schema I had created a historical-racial schema. The data I used were provided not by 'remnants of feelings and notions of tactile, kinesthetic, vestibular, or visual nature,' but by the Other, the white man, who had woven me out of a thousand details, anecdotes, and stories."[4] To be subject to being seen in this way is to be injured; it is to experience oneself as made up by others, or, even worse, made into a mere object: "I came into this world anxious to uncover the meaning of things, my soul desirous to be at the origin of the world, and here I am an object among other objects."[5] He describes the pain and gives it expression:

My body was returned to me spread-eagled, disjointed, re-done, draped in mourning on this white winter's day. The Negro is an animal, the Negro is bad, the Negro is wicked, the Negro is ugly; look, a Negro; the Negro is trembling, the Negro is trembling because he's cold, the small boy is trembling because he's afraid of the Negro, the Negro is trembling with cold, the cold that chills the bones, the lovely little boy is trembling because he thinks the Negro is trembling with rage, the little white boy runs to his mother's arms: "*Maman*, the Negro's going to eat me."[6]

Fanon speaks here of something particular and concrete, something devastating and historically specific, about his experience, and also the experience of many Black people. He describes what he calls a "suffocating reification," less a process whereby the self is achieved in a social space, than one by which the very possibility of selfhood is apparently denied. I do not ignore this point or neglect its brutal specificity when I urge, nevertheless, that the phenomenon he describes may be more general: Fanon shows how body schema and body image—what we can do and be and the image that we have of ourselves as we take ourselves to be seen by others, our selves as agencies and our selves as mere objects—interpenetrate. And so I and you and we become, for ourselves, in Fanon's words—but Vico might have thought this—something "woven out of a thousand details, anecdotes, and stories."

A Fragile, Dense, Intersubjective Skein

I wrote above of the ready intelligibility of the world. But here's the thing: the world is all this. It is a fragile, dense, intersubjective skein. A simple example. I look at the tomato. I see its facing

side, but I have a sense of the presence of the sides I can't see. They are out of view, and so in that sense they are absent, but they are present to me even so; I have a distinctly visual sense of their presence. This is because they *are* there for me, I have *access* to them; indeed, I have access to them *now* even as they are manifestly out of view now. I understand, for example, that by the merest movement of my head or eyes what is now hidden can be brought into view. My visual power consists in the fact that I have skillful, visual access, now, to more than is now strictly visible. This relation is sustained by what I can do, by my sensorimotor skills—my implicit understanding that I modulate my sensory relation to what is there by moving—but also by other forms of conceptual and practical understanding (e.g., knowing what something is, what it is for, and being familiar with how to handle it effectively, and finally by my interest in, or concern for, e.g., tomatoes).

But there is so much more to be said about the varieties of the tomato's presence. Let's make a start: What I see is something that others can see, too, and their relationship to the tomato is similarly partial, dynamic, and enacted. So the tomato, this thing, is an object of our shared world whose live meaning is being worked out, and maybe being worked out differently, by each of us, or by all of us. The tomato, simple as it is, is thus a grand stage; it implicates a field of possibilities, hidings, and disclosures. To see the tomato, to achieve access to this thing, is to act knowingly in light of the varieties of ways of achieving access that there are, on my part here, now, but also before, and later, and on your part, now, then, in the future. I can only have the tomato because we—all the different We's—can all have the encounter. The simple, straightforward, pseudoatomic character of my episode presupposes all the other experiences and possibilities and ways of making contact. So the dense fabric of

our visible world includes, or implicates, these abilities and enabling conditions on our engagement. Likewise implicated are the way that these—these enabling conditions, these skills, abilities, motivations—are themselves contingent and vulnerable. Walking implicates the possibilities of tripping, and engaging tomatoes implicates the many different ways in which we can fail to do this.

In general, the world swells as we learn. We extend our reach—our body schema—by learning new skills, by gaining new techniques or technologies, new tools, but also new languages—and there is no reason why we can't lose them too. People get old. They lose their sharpness. Things they once could do without thinking are now a challenge. Even the words that were always there, ready-to-hand, for one to use, may now evade one and leave one quiet. In these ways, horizons open and close, widen and narrow. But this also happens at more conceptual levels. You learn something—about history, or about architecture, or about music, or about people—and now you are able to understand, or recognize, or hear, or empathize, in ways that you never could before. The botanist can see what I cannot see.[7] The chess player can recognize positions on the chess board that I cannot. But I can become a botanist or a chess player. I can open up new horizons. And remember, these are not only horizons of knowledge and understanding, but horizons of caring and concern, curiosity and arousal. Significance waxes and wanes.

You show up for me, too, in my horizon, and so does he, and she, and they, and people who are very far from me. They are all there, and they are all there, for me, as occupying, like me, dynamic access to the fragile, dense, dynamic skein of what there is. I can see that the side of the tomato that is hidden to me is open to you. It's present to you; or, its possible presence to you

is part of what is concealed in its hiddenness from me. My seeing is thus a sensitivity to your seeing, or to your not being able to see either, or to your not being able to see at all. The hidden parts of the tomato are present to me not only visually but as features of the landscape opened up by a multiplicity of abilities and disabilities, knowledges and histories. What shows up for me has hidden sides and multiple meanings, and it has within itself the possibility of disclosing these hidden parts. But it also carries the significances that it will always have for others, including *other* others who have access to more or less or different kinds of things than I do, because of their different bodies and backgrounds and capacities and incapacities and histories. *Everything that there is is surrounded livingly by the range of all that is possible, not only to me, but to everything and every sentient being that ever was.*

And the whole thing is set in motion by the dynamism of our own reflection.

Let me explain: We find it easy to think that there are, or were, naïve or innocent cultures, cultures untouched, as it were, by the knowledge that their culture is arbitrary, that there are people who may come along who do things differently, and who might even find their way revolting. Continuing in the same vein, we imagine that the collision of cultures in this way becomes a moment of the greatest existential import. Think of what is so richly imagined in Terence Malick's *The New World*: specific people, unanticipated, and for the very first time, see something unimaginable, what we know to be ships appearing on the horizon and moving closer until they discharge men of a very different nature. Once there is the live reality of plurality, you can't recapture the innocence and naïveté you knew before the discovery.

But what if this supposed naïveté is itself a fantasy? In this book I challenge the illusion of human, first-order organized

activity and habit—*just* seeing, *mere* talking, *spontaneous* dancing—unencumbered by knowledge, worries, second-guesses, or doubts. What if human consciousness, by its very nature, has pluralism built in, as it were, to its very structure, which is, after all, a structure of fragile, overlapping, crisscrossing, always changing horizons?[8]

This whole question of naïveté now pops out as one of our central themes. The fact of our entanglement is tantamount to the idea that it is impossible for a human to be naïve, not really. To be a language user, as I have argued, is to be sensitive to the ways that language poses problems and so to the need for means for handling and negotiating these problems. To be capable of seeing is to be sensitive to all the ways in which seeing poses problems; you need to move and shift, peer and squint, and, really, work to achieve access to what there is. And what we see, and what we take ourselves to be doing, when we see, this is shaped by pictoriality; so our visual lives require a sensitivity to a larger, finally art-entangled, picture culture. Dancing, likewise, however free and untutored, is shaped by dance art, that is, by Capital-D Dance, as we saw in chapter 3; so every dancer is doing something that always is, and is not, art. The same thing can be said about storytelling. Storytelling is at once a cognitive technology, a habitual way of keeping track, organizing events, and making sense. But storytelling can also be a way of emancipating ourselves from storytelling, that is, from the habits of thought and talk, the ways that we find ourselves organized, on which ordinary first-order storytelling depends. Thanks to the entanglement that defines us, it turns out that every story is always both, at least potentially, art and technology, tool for organization, strange tool for disrupting organization. The up-shot of these considerations: we are not naïve, we have never been naïve, naïveté is incompatible with the shape of our mental lives itself. No experience is so simple as not to have hidden

aspects and suggested meanings whose hiddenness or merely-suggested-ness belong to the full, manifest character of the experience.[9] The recognition that worlds have thick *styles* in this sense was something Hegel gets at when he recognizes the modal complexity of even the most simple experience, for example, this is red, for if it is red, it isn't some other color, it can't be both, but it might not always be this way, or have always been this way, or be so under different conditions, and at different times.[10] The atomic fact is no atom at all, but a wrinkle in a heaving flow of implications and significances.

THE SOCIAL SIGNIFICANCE OF THE BODY

What does all this have to do with the body? The body, knowing, skillful, limited, insightful, social, is not a given, prior to and at the foundation of the worlds we build. The body is itself of the world, one of its significances, a feature of its topography. But what of biology? What of the relation between biology's body and the worldly phenomenon of the experiential body? Do not the facts of biology—the hard facts of heredity and genetics, physiology, disease, and aging—constrain and limit the body's and the world's style? Does not our natural biology make us what we truly are, as it were, transwordly, transculturally, transhistorically?

Now obviously, there are not *two* bodies—that of biology proper, and that which takes form for us in our living, namely the worldly body. The worldly body is biological too, just as a baseball player is not only a strapping youth, but also an organism, and sometimes a patient. Our biological being is not the foundation of our worldly being if by this one means that we can explain why our worldly life is what it is in terms of the biological facts. At the same time, it is a mistake to think that we are not, truly, in ourselves, biological.

This is yet another instance of the phenomenon of the entanglement, and our understanding of the entanglement as a structural fact of our existence gives us resources to make sense of the way that we are biological, even if we are not merely, or only, biological. We took this up in chapter 5, in relation to talking and writing. Talking, they say, is natural. Writing, they say, is cultural. But writing, I objected, is something that we make in the face of talking; it is a response to the need to represent to ourselves what we are doing when we talk, and it is also something without which there would be no talking. Writing doesn't leave talking as it finds it. We talk differently in a writing world. Just as we see differently in a picture world, and dance differently in a Dance world (as we investigated in chapters 4 and 3).

So, we might say, we *live* differently in a *lifeworld* (where "live" here is meant to refer to our living as an organic, biological process, and where "lifeworld" refers to that thick, intersubjective skein of meaning). Indeed, this idea—that the human being has been amplified, reorganized, and made something new as a result of culture—is, as mentioned in chapter 2, by now a common idea in biology and in cognitive science.[11] For example, it is a familiar observation that the human body is altered, even transformed, by cultural life. Diet gives a ready-to-hand example of this. People are bigger and stronger today, on average, than they were even a few hundred years ago, let alone a few thousand, before the onset of organized agriculture. Our bodies have been changed through the centuries as new opportunities provide contexts in which we can adapt to new foodstuffs; our biochemistries have been altered by the new conditions of our social organization. We also have allergies and diseases (e.g., diabetes) that would have been uncommon in our species-past, and this is connected to such facts as that we drink, we smoke, we live more sedentary lives in comparison to our ancestors.

Or consider that human beings live almost everywhere on the globe, and this despite our relatively poor adaptation to many environments where we in fact thrive. Our species thrives biologically, indeed, it dominates, because of the ways that we are organized socially, for example, the ways that we exceed collectively what any of us can do on our own.[12] This a bio-cultural phenomenon, and it points in the direction of the fact that we are cultural by nature, or that our biology is entangled with our culture.

But as I have already stressed, my focus in this book is a different, more radical kind of entanglement. What these stock examples of the interplay between culture and biology leave untouched is the fact that the biology itself has a human face and is a problem for us. We are organisms; we are—this is the animal condition—organized, at the cellular and at the organismic level. From this point of view (*our* point of view), culture itself is just more organization, more control, more habit; it is merely an alteration of the pregiven environment or landscape to which we must adapt ourselves and in relation to which we are able to scaffold ourselves. But this is not all we are. Human beings also resist habit and control. And we make ourselves something new by grappling with the constraints upon us. This is at work in our lives as dancers, as speakers, as perceivers.

We can get a better sense of how this phenomenon plays out here in relation to biology and the worldly body by turning to an example, the familiar and important topic of gender and its relation to sex.

Sex—I mean the familiar, physical concomitants—matters to us; it is something that literally preoccupies us and organizes us, from monthly hormonal cycles, to patterns of sexual arousal, to hair and musculature, to the properties of genitalia. Sex and all its processes are principles of organization that both consti-

tute us and also, and this is critical, *make trouble for us*, to borrow Butler's apt phrase.[13] Sex is something that we need to deal with, just as, as we have been exploring, talking and seeing and dancing are something that we need to deal with.

Gender, with all its processes, I propose, belongs to the sex repertoire, that is, to our familiar and in that sense established ways of coping with sex; gender is our way of doing sex. Just as we create writing and write ourselves down to manage our being as speakers, so we create models of ourselves as sexed and think about ourselves in relation to these models to manage our sexual being. This is what gender is. Gender is different from sex. But gender is a recognition of and (a frequently anxious) response to sex. Genders are the models of sexual selves that we make, and thereby come to embody, in order to cope. But that is not all. Gender norms, as they are called, are scripts or templates for how to be; they are, we might say, *scores*. We play these scores. Gender is enacted (or, in Butler's phrase, performed). That is, we enact, and so become, the body, or person, of the gender (just as we enact ourselves as dancers, speakers, etc.).

Crucially, the facts of our gendered lives do not "reduce to" or "bottom out" in sexual facts (about, e.g., menstruation, pregnancy, body hair, body size, genitalia). But nor do they float free of them.[14] The facts of our gendered lives have, at the same time, *everything* to do with these facts, for gender is something that we do knowingly in the face of them.

In chapter 4 I asked what painting as an art has to do with pictures. I answered, everything and nothing. Nothing, because works of art are never just pictures. But everything, because it is the preeminence of pictures in our lives that gives painting pictures as an art its whole point. I made the same move in connection with Dance and dancing (in chapter 3). What do they have to do with each other? Everything and nothing. Now here

we can say the same thing about the relation between gender and sex: Gender has both nothing and everything to do with sex. It has nothing to do with it because, well, gender is neither identical to nor determined by sex. How could it be? How can any feature of biology control or govern how we enact ourselves, our processual lives? How could the biology of vision determine, for example, the place of pictures in our lives?

At the same time, gender has *everything* to do with sex, for it is motivated by our real and troubled relation to our own bodies; our bodies organize us and try (as it were) to hold us captive. We frame for ourselves gender pictures of what we are, pictures that then loop down and remake us in their image.[15]

It is the entanglement of gender and sex that best explains the feminist dictum, sometimes attributed to de Beauvoir, that gender is the social significance of sex. "One is not born, but rather becomes, a woman," she wrote.[16] This should not be taken to mean that sex and gender have nothing to do with each other because sex is natural and prior, a biological given, whereas gender is "constructed." Rather, it should be taken to mean that gender is something like the unfolding of our sexual lives, or our lives with sex. Which is another way of saying: gender and sex are entangled, as art and life are entangled. Indeed, from this standpoint, there is something at least potentially art-like (or performance-art-like) about gender.[17]

The crucial point about entanglement is that we have *two* things bound together in one knot; they are distinct, but they can't be disentangled. You'd have to go back to Eden, that is, to a never-truly-existing imaginary prehistory, to find sex before it was made and remade by gender pictures of what we are in relation to sex—just as you'd have go back to Eden to find vision unaffected by pictoriality (as discussed in chapter 4), or speech unaffected by the writerly attitude (as discussed in chapter 5), or

dancing without the influence of choreography (as discussed in chapter 3). This is the truth, I believe, in the idea that sex, as Butler has argued, is already gendered. It is not just that we see sex through the lens of gender, as Thomas Laqueur has proposed.[18] The point, rather, is that sex, of its very nature, is a fact about us that demands that we struggle to find a lens through which to view it; it presents challenges. *Gender is the form this grappling with the existential reality of sex takes.*

These considerations pertain, it seems to me, to sex in the other sense as well, that is, to *having sex* or sexual intercourse. Our ancient ancestors had to negotiate sex, just as we do; they presumably had orgasms and these orgasms may have been, typically anyway, pleasurable. They also had sex without orgasm and encountered impotence. They sexed, just as we do; and crucially, their sexing, just like ours, was not only a biological given, but a social and relational task, one that was colored, or stained (to use J. Reid Miller's word), by the sorts of attitudes and values that accompany all responsive dealings (e.g., love, anger, boredom, jealousy, fear, excitement, worry).

I agree with Butler. Gender does not stand to sex, as she explains, as culture stands to nature, for sex is already gendered. According to Butler, "Gender is also the discursive/cultural means by which 'sexed nature' or 'a natural sex' is produced and established as 'prediscursive,' prior to culture, a politically neutral surface on which culture acts." And she goes on to ask, "How, then, does gender need to be reformulated to encompass the power relations that produce the effect of a prediscursive sex and so conceal that very operation of discursive production?"[19]

But I would put the point like this: Our world is and always has been a gendered world. (Just as it has always been a pictorial world, a written world, and a choreographed world.) That is, from "the beginning" we have been seeking to represent

ourselves to ourselves as creatures who sex. We do this by en-
acting what we are doing when we are sexing. And this
enacting—these models, or scripts, these *scores*—loop down
and alter the phenomena of which they pretend to be the mere
representation. And what drives this process is finally the need
to break free, the desire for ecstasy.

What I admire in Butler's view is its dynamism and its appre-
ciation of the "discursiveness" of the whole shebang, which for
me has to do with its aesthetic character. Sex is a problem for us;
it is, if you like, a question, not an answer, not something that we
can ever quite take for granted. Sex is a dispute. That it seems to
us, we philosophers, or maybe *we* more generally, as if we can
take sex for granted (as a "prediscursive prior") stems from yet
another "surreptitious substitution" of sex, as we come to define
it through the model of gender, that is, as something merely bio-
logical, for the problematic reality it is for us originally.

Gender grapples with the existential reality of sex. Gender is
the way that sex is given, or what makes it the case that sex is
never just given. For this reason, gender concepts (e.g., "man"
and "woman") will elude definition. Not because they are am-
biguous, or because their meaning systematically varies from
context to context, as has been argued, but rather because gen-
der concepts are insistently provisional.[20] Gender and gender
concepts are always in the midst of becoming. In this they are
like art and philosophy themselves, but also, as I have argued,
like visual experience and dancing and talk.[21]

"THE DREAM OF ETHICALLY NEUTRAL
EMBODIMENT"

Is sexism built into the very idea of being a woman?[22] That's
what some thinkers believe: you are a woman if you have a
certain anatomy and so are apt to play a certain role in sexual

reproduction and if you are on that basis subordinated or viewed as deserving of social subordination. Womanhood and patriarchy are connected.[23]

This might seem extreme. Not only does it threaten to exclude a lot of women from its scope—for example, women who can't or don't raise children, or women who don't have, or are presumed not to have, "female anatomy"—but it defines "woman" in such a way that any fight for true gender equality would, in one fell swoop, be a fight to get rid of women![24]

But actually many thinkers who take such an approach seriously offer it up not, as it were, to explain, or ground, or elucidate, the essence of womanhood, but to bring out precisely the ways in which there is no such thing, that what it is to be a woman is problematic and political and, in a way, up for grabs.[25]

I agree with that. Gender is aesthetic. We can no more analyze, finally and once and for all, what a man is, or a woman, than we can give a one-size-fits-all account of beauty or of the significance of an artwork. Which doesn't mean that it isn't true that the concept of woman, say, is bound up with sexism and patriarchy. That might be right, and that might be worth saying. It might be beneficial, politically or emotionally, or whatever, to bring this out into the open. But that won't be, it *can't* be, the end of the conversation. It's the only the beginning. And part of what we effect through pursuing the conversation—this is the hallmark of the aesthetic—is a reorganization of what "woman" means or can mean or might mean.

With this in mind, let us ask, Are we free to give up using gender as a way of seeing people, experiencing and categorizing them, and ourselves? Can we (*should* we?) free ourselves from gender?[26]

Consider the discovery, or the invention, that it is possible to be a woman with a penis, or that, because one is really a woman, one needs to have done with the penis, or that one can

be a straight woman who loves a man who has a vagina. These are, in the frame of this book, aesthetic accomplishments of the first order, that is, they are more-or-less radical reorganizations of what and how we know the world around us. By the same token, we can appreciate that gender nonconforming people (so-called) are (among all the other things they may be) revolutionaries whose actions and inventions and self-actualizations are emancipatory, not just for themselves, but for everyone who might feel puzzled, stymied, disoriented, fascinated, curious, and enthralled in the face of this apparently new way of enacting oneself in the world that we share. The revolution that they bring about is, in my sense, an *aesthetic* one (even if it is also revolutionary in other ways too).

I hope by now that the reader will trust that in speaking here of aesthetic accomplishment I am not diminishing or trivializing the stories, life-journeys, the injuries, or the self-understandings of trans people. Aesthetics, as I am developing it in this book, is existential. Nor am I in any way trying to remove the whole issue from the arena of justice and human rights.

But there is more to be said: people reject, rethink, remake, reshape, and reconfigure gender in novel ways—this is an option, there is a *need* for this—precisely because gender and sex *matter*. And they matter because we are, in fact, ourselves, entanglements of gender, beings woven out of the many ways that we are known to ourselves through our encounters with others and ideas about what we are supposed to be. Here's what we can't do: no one can just decide, as it were on the basis of morality, or politics, or theory, to stop caring about and placing value on facts about, for example, *mere anatomy* (genitalia, hair, skin, shape, size, etc.). And that is so, even when it can seem that it is mandatory that we do so, even if we are convinced that it is morally unacceptable to let facts about a person's mere body

govern how we see them or experience ourselves. Why? Because—and this is to pick up again on a theme in J. Reid Miller—we are, as I'll put, *dynamically embodied*.[27] Our bodies are not mere vessels for the containment of our personalities, our agencies, or our disembodied souls. Our embodiment is the very manner of our coactivity with, emplacement in, and experience of the world. And this lived body is made and remade through our situated involvement with other people; through the ways that we experience ourselves with them and through their gaze; we are woven and put together, in Fanon's image, "out of a thousand details, anecdotes, and stories." We are entangled; we are processes of becoming; we are products of resistance to the conditions in which we find ourselves.

To imagine ourselves unencumbered with the self-understandings nourished in the face of shared models, scripts, pictures, but also shared prejudices and bigotries, is really to imagine the absence of that ongoing drama that a person is. It would be like imagining music made in the absence of a musical culture, with all its conventions, familiar strategies, and styles. Music shorn of its responsiveness to all that baggage would not be music. Like music, we are temporally extended inventions and interventions of style (an idea that I explore more in the next chapter).

So getting rid of gender, on the grounds that it is a kind of falsification, bigoted overlay, or untruth, is, thought of a certain way, at least, no more a live option for us than it would be a live option for a composer to try to make music outside of time, tradition, legacies of instrumentation, and history, as if there had never been music before.[28]

But crucially: there is growth, change, even revolution, in music. Musical revolution is made from the inside by, as it were, using what is familiar to undo expectations thus to motivate

new curiosities and new expectations. And so, in the same way, there can be change, growth, and revolution, too, when it comes to our identities. We can't just stop caring about anatomy, in ourselves, or in others. But we can, through what I think of as aesthetic work, come to change how we experience and live our anatomy and ourselves.[29]

The hard thing is for us to acknowledge that we embody, that we have already incorporated, that we are entangled with, so much that some of us now want to reject; as Miller argues, we are ourselves inheritances however much we may dream of "an ethically neutral embodiment." This is what he means, I think, when he writes that we—men and women, transmen and transwomen, Black men and Black women—are a "historical instantiation of an irreducible, necessary, and mythic logic that fashions a synthetic arrangement of subjectivity, materiality, and value."[30] Or, as Augustine would have it, our sin is original.

We are not all artists. We are not all revolutionaries. We are not all trans. Many of us carry on, much of the time, by and large untroubled by all the adjustments that we have to undertake to enact ourselves. And so we need to be reminded that all of us are makers caught up in the making of ourselves. And our making happens always in relation to ideas, images, scores, and models, of what it is to be a person of a certain kind, and there is never only one way to do that. We either put on the coat of stereotype, or drape it across our laps, carry it over shoulders; we turn it inside out, or take it to the tailor's for alteration, or maybe we throw it away. Ignoring it is not an option.

EXISTENTIAL STYLE

How should a person be?

For years and years I asked it of everyone I met. I was
always watching to see what they were going to do in any
situation, so I could do it too. I was always listening to their
answers, so if I liked them, I could make them my answers
too. I noticed the way people dressed, the way they treated
their lovers—in everyone, there was something to envy.
You can admire anyone for being themselves. It's hard not
to, when everyone's so good at it. But when you think
of them all together like that, how can you choose?

—SHEILA HETI

Art pervades our lives. We are not all artists, not in the voca-
tional sense. But we all operate in a space of significance held
open by art. Pictorial art makes visuality possible. Choreogra-
phy makes dance possible, and graphical representations of
ourselves (that special kind of drawing we call writing) make
language possible. In the previous chapter, we began to appre-
ciate that the body itself is an aesthetic phenomenon, that we
are, as I will now try to explain, the mobilization and realiza-
tion of style.

Recall Hollander's idea: how you experience your own dressed body is shaped in part by your familiarity with representations of the dressed body in the history of painting.[1] But this means that when you look at yourself in the mirror, or even more so, when you make choices about how to dress yourself, you are making a move in an art space and you are driving entanglement: what you have seen—not only other dressed people, and their pictures, but *artistic representations* of other dressed people—influences what you feel and do, what presents itself to you as choices, all of which leads, in turn, to your production of new raw material for art making. You are not an artist. But you are living and participating in an art project. Just as you can be funny without being a comedian, so you can do art's work without being an artist.

Now Hollander was adamant that her concern was with dress and the body, and precisely *not* with *fashion* or *style*, that is, haute couture and the like.[2] But what she may not have considered is that style in this narrower sense that we associate with the fashion industry or the fashion world, or maybe with pop music, is just a special case of a more general, a thicker, more existential phenomenon of style. And it is this latter phenomenon that it is art's true business to handle and explore. Some artists, perhaps none more so than Warhol, have made precisely popular style and fashion, as these show up in the everyday world of commerce, but also in our culture's celebration of celebrity, into the very stuff of their work. But when I say that art works with and aims at problems of style, I don't mean to make a narrow point about Warhol and a moment in twentieth-century art. I mean something more abiding. Art has always worked with style. Art is a place where style flashes and blinks and shines and does so communicatively, and always according to the very same rhetoric and logic that it exhibits in other areas

of our lives (e.g., fashion, pop music, etc.). And what explains this fact, and simultaneously helps us understand the sources of art's importance in our lives, is the fact that *style is an organizing principle of all human life.*

In this chapter we pick up the threads of our discussion of style toward the end of chapter 4. What is style and what is its relation to art and nature? We will learn that it is thanks to style, a quintessentially aesthetic phenomenon, that human life refuses to present itself as a stable object for natural science.

STYLE, AGAIN

Human beings are not merely creatures of habit; we are creatures of style. To say this is to say something more than that we leave behind identifying markers in everything that we do, or that there are norms or regularities of a statistical nature that are unique to each of us, or to groups of us, or to groups of us at a particular time. We don't merely *have* styles, the way that we have fingerprints. We *inhabit* our styles; we *enact* them.[3] To have a style, then, is to inhabit a visible way of doing something. There are multiple parts to this important idea.

First, styles are *visible*, or rather, perceptible; that is, they manifest themselves in what we do in such a way that they are available to others as something for them to recognize. Your distinctive way of writing, walking, holding your place in the room, shines forth. I imagine that I am in a room with colleagues; each of them engages the company with his or her eyes, tone of voice, and posture, in a recognizable way.

Second, and closely related to this first point, style is not merely perceptible; it is also intelligible. Computers may be able to mine data to detect all manner of patterns that the human eye can't see; they discover hidden meanings. But style

is not hidden. It is manifest, even if it is not quite a phenomenon of the surface either. And it is always meaningful. To say that style is intelligible is to say that it is a currency of significance that is available to others, and also to ourselves. Part of this is that style puts us in relationship with each other, not unlike the way that different songs on an album may in a way work together to define each other. But further, we *get* each other's styles; and our sensitivity to styles is one of the key ways in which we are intelligible to each other. We read each other because we have *style eyes*, that is, the eyes to see.

I said before that styles are visible and immediately recognizable; they are also, and this is crucial, imitable. We copy each other mercilessly. We truly are an imitating animal, as Aristotle observed, and our tendency to copy is a driving interest in and concern for style; what we imitate is style.[4]

The third point is that, as I have said, we *inhabit* style. This has different aspects. Style is spontaneous; it just shows itself in the ways that we do what we do; it finds habitual expression. We have no direct choice over style. A person's style can evolve, to be sure, and one can choose, for example by pursuing an education, to change certain feature of one's style. But you don't choose your style, or if you do, then you choose it in the peculiar sense in which you choose a dialect of your own language.

Fourth, we are typically aware of style, because it is the lens, and the filter, through which we make skillful contact with the world around us, in action, perception, word, or thought. And this means, crucially, that we are sensitive to our own styles. I don't mean that we are self-conscious in the ordinary sense of this phrase in which we are, say, aware of our tics and mannerisms and posture and other traits by which others recognize us. But our styles—our basic manners of being active in the world—are enacted by us, and they are enacted by us in a space

of significance for others, and so they are present to us, too, as the ways that we find ourselves presenting ourselves to others. To have a style is perforce to be in relation with others and to have a socially amplified self-conception.

Styles may sometimes be aspirational, but aspiration is enough to put them into operation. This may be the thing with dialects. You have a sense of what sounds like the right way to talk, and this then shapes how you do talk. You become what you think you are or are supposed to be. This is also how we become men and women, nonbinary, and so on. This is also how we become professionals, punk rockers, citizens, and such like.

A final point is that insofar as we perform or express ourselves stylistically, and insofar as style shows up wherever *we* do, then we are ourselves always open to, and, really, alive to criticism. Vico spoke of the New Criticism as the fundamental method in philosophy. Husserl's term was "phenomenology," for the attempt to reorient ourselves to ourselves and each other. But the term that I have favored is "aesthetic." Style marks the domain of the human, and this is also the zone of aesthetic criticism.

Style is an aesthetic problem, it should be stressed, both for producers and consumers (and we are always both producers and consumers of style). To perceive style, and to fail to perceive style, or to enact a style, and to fail to do that, are aesthetic matters, aesthetic accomplishments and failures. Again, I remind the reader: to say that these are aesthetic matters is not to say that they pertain to what we like to see, or what pleases us, or feels right, or goes together. These are aesthetic matters because they present us with opportunities for new seeing, for cultivating sensitivity, and for transforming ourselves in the act of bringing difference, likeness, kinship, opposition, contrast,

and concord into view. These are aesthetic matters because they are a certain kind of problem for us and because we need to do a characteristic kind of work to bring them and our responses to them into view.

But expressions of style are also, or can be, as we have considered, *art* matters. The basic work of art, as I have argued, here and in *Strange Tools*, is to unveil us to ourselves and to do so in ways that enable us to change, to reorganize, to become something different. Art is an ecstatic undertaking with an emancipatory goal. Technology enslaves us. Art works to set us free.

Now style, as I am understanding it here, participates in an art-like dialectic. Style shines in our lives; it is our avatar, our profile picture, the visible face of our image and our schema. Style is the arc that describes what we are, but that also stands there, for others to see, and for us to see, as something that we can actualize more perfectly, or differently, or that we can now finally try to reject. Style and life are entangled, and it is this entanglement—an expression of our fundamental self-consciousness—that makes human beings always something becoming and unfixed, even to themselves.

Style is the sine qua non of human activity. It is not possible for a human to have no style. It is certainly possible, though, as Wollheim noticed, for an artist to fail to achieve a distinctive style, to remain indistinguishable, or invisible, that is, to fail to probe problems of style effectively or deeply. But this is not a case of no style; it is a case of no individual style, which really just means that the artist's style does not *engage* style, or mess with it, or play with it, in the ways that artists aim at doing.[5]

Art and philosophy are the expression, in the sphere of human vocational life, of our productive, everyday, that is to say, nonvocational engagement with style, that is, with our human

engagement with the ways that we are each of us flashing out together and in response to each other, like fireflies—showing, displaying, perceiving, receiving, and performing, all our lives. We make patterns and we are influenced by the patterns that we make and see. Just as you don't need to be a philosopher to reflect philosophically on your own thoughts, so you don't need to be an artist to work, as an artist would, with skillful activity, doing, making, and expressing. Indeed, as I have argued, the ability to think philosophically, or artistically, that is, reflectively, about one's thinking and doing, is bound up with what it is to think and do. The artistic attitude, or the philosophical attitude, is embedded in the natural attitude.

Husserl, to whom the phrase "the natural attitude" is due, appreciated this. Philosophy aims at epoché, at the bracketing of the assumptions of ordinary life. But to reorient oneself to one's lifeworld in this way is not to embrace skepticism, or to give up the world, or to lose it, according to Husserl. After all, the bracketing happens during "vocational time." We do it, as it were, on the clock. After work, we get to go home and be with our families and resume our domestic concerns and our more general carings.

But Husserl also appreciated that the philosophical exercise of bracketing that occupies us philosophers 9 to 5—our cultivation in ourselves of the aesthetic contemplation of our ordinary commitments, assumptions, feelings, attitudes, values— ultimately very radically transforms (reorganizes) that lifeworld and our attitude toward it. You can continue to care about the things that you love and value. But things can never be quite the same again. Their look will have been altered. For things will now show up to you as being objects and qualities to which it is possible for you to have a very different attitude. The possibility of precisely this kind of detachment and reorientation must

now always remain alive in things. The horizon has acquired, in a way, a new dimensionality.

Where I break with Husserl's profound and beautiful insight is in my insistence on entanglement. And this means that the reorganization of the fabric of experience thanks to the dawning of *the aesthetic attitude*—a term that I now use to encompass both the philosophical and the artistic attitudes—is not something that happens finally, all at once, as it were, thanks to the philosophical work of a single twentieth-century person. No, a human life is a series of epochés, and aesthetic reflection, as I now use this term, is built into the structure of lived experience. We have been making art and philosophy—creating models of ourselves, or perspicuous representations (in Wittgenstein's phrase) whereby to understand ourselves—from the very beginning. And one of the forms that this making work takes is participating in the vibrant and irreducible processes of style in human action and perception.

IDENTITY IS STYLE

Now we come to the crux:

The vital identities that we label man/woman, Black/White, young/old, disabled/nondisabled, and so on are *unities of style.*

To have an identity of one sort or another—and of course we have many identities—is to *inhabit visible, intelligible ways of being and acting,* to use my earlier formula. We have identities because we are active bodies expressing ourselves habitually in the face of others and in the glare of the ways that they know us, and against the background of a history. Style is the most general modality of human being.

Style pops out. We can very often confidently recognize who or what someone is by the way that they look and act. People

organize themselves *stylistically*; they show themselves and assert themselves in voice, gait, appearance, posture, and attitude, in dress, in music, in accent, indeed, in body.

At the same time, style is nothing like a universal or a defining essence. It is not something occult or interior, not DNA, not distinctive feeling; it is rather the arc of coherence that organizes what a person does (including their feelings). And of course, importantly, not every New Yorker talks like a New Yorker, and not every Black person "acts Black." Style is always aesthetic. Styles are norms whose very existence makes them *questionable*.

It is precisely the apparent "superficiality" of style that makes it so well suited to excavating the worldly (and political) significance of human identities. Styles are both real and, in a sense, imagined; visible but also visibly vanishing and always merely contextual. Style is never really just skin deep, even when it is always there, on the surface, for us to try to see. The race of a person, for example, is something that you can see, sometimes, and that can find expression in the way that the person *is*, and in the way that they function. Not that it must, or always does. It takes real judgment to get this right. We are in the zone of a kind of connoisseurship, where sensitivity to the subtlest shades of meaning, attitude, and reference is required.[6]

It's crucial that styles are overt, manifest, recognizable, that they are visible, available, intelligible. We can discern them and read them, and to be unable to do so is to be closed, cut off, unknowing. What we read, what we notice, when we perceive style is who or what a person is. The person is the expression of a style; that's what it is to *have* a style. And the style finds expression not only in how a person walks and talks, and eats and dresses, but also in how they themselves know and respond to the world.

One of the chief functions of education, formal or informal, is to give us an eye for style. This is a point Vico might have made. Whereas Descartes, with his scientific method, strove to reduce all inquiry to something like geometrical proof, Vico insisted on the distinctive kind of ingenuity or wit that is cultivated in the play of children, on the one hand, and in the engagement with literature, rhetoric, poetry, and painting, on the other. Erudition gives us an eye for style, and crucially style, as we have considered, is ubiquitous in human life (in no way confined to the worlds of art and fashion).

We enact style. Style names our fluid, evolving, and yet distinctive manners of being in the world—ways of being that are themselves visible tokens available to others and immediately reflected back to us as images, models, options, and problems. From the beginning, we respond to the ways that we find ourselves reflected in others. Recall Fanon's thought that we are woven "out of a thousand details, anecdotes, and stories," but all given in the voices of other people; but it is in those voices of others that we come to put together our own voice.

Where there is style, as already mentioned, there is also the possibility of imitation. Ways of carrying oneself, mannerisms, talk, gesture, and attitude spread among people like contagions. But what makes imitation special in our lives is style. Humans imitate by glomming onto and playing with style. Kids don't just learn to talk; they learn to talk in this or that characteristic way, to swing at the baseball not as well as, but in the style of their favorite player. And when they learn to talk and play, they also learn how to mimic an attitude and an outlook.[7]

Consider this question: Why do some people have a New York accent? You might think, well, because they grew up in New York, and so they talk the way other people in New York talk.

Obviously that's right, but it doesn't go deep enough. There isn't one way that New Yorkers talk, and anyway, your typical New Yorker is not confined only to the speech of other New Yorkers, or only to the speech of parents and family and friends.[8] Books, music, TV, radio, the movies, the Internet, not to mention the people to be met in stores, at work, or at school, or on the subway or at the ballpark, will provide access to different manners of speech.

I once heard of two Dutch sisters living in London. I think the older girl was thirteen when they moved to London. The younger girl was eleven. In adulthood, the younger girl spoke with a North London accent, like a native. The older child came to speak with a clearly identifiable Dutch accent.

It is almost as if they each chose, the older child to preserve one identity, the younger to adopt a new one. And crucially, with the choice, with the identification, came a way of being, or at least a way of talking, that is to say, a style.

But this can't be right. Styles are existential possibilities, but, as already emphasized, we don't get to choose our styles, as if from a style menu. My characteristic gestures and timings, the way that I show up as myself for others, are not things that I can decide on, no matter how much I wish that I could; and it isn't up to me, or anyone, to adopt one or another identity, racial or otherwise. As a comparison, consider: a musician is born at a historical juncture; this fact governs the possible meanings that the musician's musical actions can have; it governs how the musician can listen, make, and imagine. There is no musical existence, and, indeed, there is no human existence, outside the field of stylistic realities.

In the same way, we just find ourselves in medias res, in full view of others, modulating our visible selves as the situation demands; but we didn't create the situation, we inherited it, or

better, we just find ourselves in it. And so likewise for the body
and its meaning. We are saddled with ourselves and our bodies.
Which is not to say that I can't change my body in a million
different ways; dress and adornment, cosmetic surgery, diet,
and exercise are ways that we alter our bodies. But what we only
ever partially control, finally, is the larger condition, context, or
history that gives my body/self the meaning that it can have,
just as with the musician.

So we don't choose our identities; we can neither adopt
them, nor choose to reject them; we don't choose our styles.
And so, of the two Dutch children, perhaps the best we can say
is that each girl found herself inclined to take, or perhaps com-
pelled to take, a different path and, as a result, each of them
authentically became a different kind of person.

And yet, the connection between style, identity, and agency
is not entirely severed. Plessner said that you can't cry or laugh
on purpose, but only an animal who can do things on purpose
can cry or laugh.[9] This seems true of styles as well. There is
something incoherent about the idea that one might inhabit
one's styles, one's identities, on purpose. But it is only because
we can do things on purpose that we have styles. Wild animals
don't have styles, even if they have distinctive or idiosyncratic
ways of doing things. Style belongs only to those whose expe-
riential lives are organized by style. Style, however mandatory,
however forced, requires participation and agency, even when
it doesn't require or even allow for genuine consent.

So back to our question: Why do (some) New Yorkers talk
like New Yorkers? The answer, roughly, is that they talk the ways
that they implicitly understand people like them are supposed
to talk. And the same goes, I think, for other familiar categories
of identity, like gay/straight, Black/White, and so on.[10]

The thing is, to have an identity isn't just to *be* a certain way, or of a certain kind; it is, at least to some degree, to think of oneself as being a certain kind of person, and so it is to have a motivation, as it were, naturally and without any pretense, to act and talk and behave in ways that one takes to be characteristic of that kind of person who one takes oneself to be.[11]

This idea that identity concepts are intrinsically normative, that they are like templates or scripts, and that they loop down and provide tools for self-understanding for those who fall under them, is due to Hacking.[12] He calls concepts like these—New Yorker, man, professor—looping concepts. Looping concepts give us a clear instance of the phenomenon at the heart of our investigation, namely, *entanglement*. But we discover here a new upshot: that looping concepts denote styles; they are style markers. Indeed, this is the prime mechanism or substance of their looping. In earlier chapters, we explored the idea that vision has styles, and that sensory modalities are styles of skillful access to what there is. But now we come to see that style, an aesthetic notion through and through, takes its rightful place at the very heart of our investigation, indeed, at the heart of any investigation of human being.

"Style" has been a bad word; it is associated with fashion, and fashion, for its part, is grounded in commercialism and capitalism. Art historians think of style as a relic of an old-fashioned and somewhat benighted way of thinking about art as the province of connoisseurs and collectors rather than historians proper. My view is that style has been neglected and poorly understood, but that it is a central and critical aspect of human life, key to making sense of our minds and our worlds.

Now style is not biological, at least not according to any worked-out acceptation of this word. Style is aesthetic. Not in

the sense that it has to do with fashion and *what we like*. But in the sense that style happens in the space in between objectivity and subjectivity; style denies proof, but welcomes insight, wit, and ingenuity. Argument and persuasion, disagreement and the impossibility of resolution, are always at home where there is style. Human beings make style. Indeed, really, we *are* movements in style, or processes in style space. This is why we cannot think of a human being as fixed, exhausted by a nature. And this is why, if we are to understand ourselves, we must be artists and philosophers.[13]

AFTERTHOUGHTS ON ARTIFICIAL INTELLIGENCE

By now, as we all know, computers have bested human beings in games like chess and go and are fast establishing themselves in all manner of pattern recognition tasks (e.g., medical diagnostics). Computers can compose music in the style of different artists; ordinary listeners cannot tell that the works are not human made. As I sit here and write these words, machine learning algorithms (e.g., GPT-3) are able to produce prose and other forms of text (poetry, etc.) that may frequently be indistinguishable from the writing of actual live human beings.[14] What is striking about these new systems is that they acquire their training by reinforcement learning; that is, they start out behaving randomly and they receive rewards for "right moves," which cause them, through changes in the weighting of connections, to be more likely to make those moves again.[15] That operation, reiterated again and again, given a sufficiently rich database for learning, is all that is required for the system to "figure out" how to carry on in the relevant domain. They do this without ever having had a the-

ory of chess or go or whatever programmed into them. What they do, in a very tangible sense, exceeds their programming and the knowledge of their programmers.

It's worth reminding ourselves that the tasks the system is trained on are our tasks; that the corrections provided to the system so that the system can reorganize its connection strengths are supplied by our intervention. It is also worth remembering that the surprise and novelty, the *value*, of the computer's contributions—machine learning has *revolutionized* human go and chess, for example—are also ours. For all their competence and power, computers are, in a way, slaves to the schemes of organization and performance that we have devised for them. As a young man, Galileo discovered a basic physical principle by watching the pendular motion of a chandelier hanging in a church. And so we are learning about ourselves and what we do by looking at what the things we have made can accomplish.

Now, it might be objected: a computer is no chandelier, and everything that we have said about the computer could be said, more or less, about human beings. Human beings too acquire their wide range of cognitive competences—from the playing of go to the writing of books—precisely by being "trained up"; that's what education is, after all. So humans too, in a sense, are also slaves to the standards, patterns, expectations, and finally values and demands of the culture into which they find themselves born.

But with this difference. Computers, not being alive, have no dogs in any races. They don't give a damn. Things don't matter to them, or *show up*. In fact, they don't really do anything. In particular, they don't play chess or go, or offer diagnoses. We wind them up and turn them on. They don't even follow rules, not any more than an hourglass does; rather, the hourglass is built so that the

movement of the grains of sand usefully track time's movement; we use it to track time, it doesn't track anything.

But doesn't the fact that computers can at least simulate our genius show that our genius isn't what we took it to be? That we are not so special? Well, yes and no. We are not so special, but in a special way. This is what we need to understand.

A comparison will help. Suppose we were to discover that many of our favorite paintings by Vermeer were not in fact painted by him at all, but were painted, rather, by an unnamed member of his household (by his daughter, say, as has actually been argued by Benjamin Binstock in a fascinating 2009 book[16]). In the face of such information, we *might* come to conclude that many of our favorite Vermeers were not Vermeers after all. And we might come to celebrate the discovery of a new artist, a woman, the secret talent, we might even say, behind the more celebrated Vermeer's success. But there is another option: we might rethink what it is to *be* a Vermeer, or to be *by* Vermeer. Perhaps what makes something a Vermeer is not, as it were, the question of who made it, or rather, so as not to beg the question of what this phrase "who made it?" means, the question of whose hand worked the canvas. An artwork's relationship to its author is not the same as that of a footprint to the foot that made it. A work of art is not a *relic*; the piece of Jesus's shroud stored in the church reliquary has whatever significance it has *only* because it is supposed to be a piece of his shroud.[17] To learn that it is not what it has been claimed to be would be to learn that it possesses none of the value attributed to it. But paintings are not like this, or at least they needn't be. It might be the case that no one can make a mark with the quality of Johannes Vermeer. But it might also be that the meaning of the work—the work that it performs, the way that it lands in the art space—is less tied to the manner of its own material

production than that. Again, it *could* turn out that biographical records confirm that it was the daughter, and not the father, who was the prime mover in the family's artistic project. We can imagine that he was her "front man," or beard, so that works made by a woman could be sold for their proper value in a sexist culture. But let's assume, for the sake of argument, that she was in fact his apprentice, and that, as his apprentice, she worked with him and for him so as to execute his characteristic artistic vision. To learn this then would not be to learn that her paintings were not really Vermeer's, and certainly not evidence that they were fake, or fraudulent, or wrongly valued as if they were by the master himself.

I propose that we look at computer "agency" and "creativity" in the same way. Just as Vermeer (hypothetically) harnessed his daughter to the yoke of his project, we harness computers to our projects. Just as, we imagine, Vermeer's daughter could have come to influence the work of her father, so we can allow that machine systems might even come to transform the way that we work, and even the way that we understand a domain of work or creativity (e.g., go).[18] But it is only under a false conception of agency and authority, something like the relic conception, that this would lead us to rethink who's doing what.

Crucially, the fact that we might not be able tell if something was written by a human being or a program is a matter of no theoretical consequence.[19] First of all, if the piece of writing has value, it has value thanks to the work that it does in the space of our ideas and concerns. Second, who or what generated the work does not, as a general rule, and for reasons we have been considering, confer authorship, the entrenchment of the relic conception notwithstanding.[20]

But there is a possibility that we haven't yet considered. What if it comes to pass that machines, trained up on the whole

'vast corpus of human culture, come to design novels and movies and poems and songs that live, for us, at the cutting edge of what matters? What if machines become the artists of the future (as well as the journalists and physicians, etc.)?

This *cannot* happen, but not because it might not come to pass that AI systems will be set to the task of writing novels and movies, and not because what makes a novel and a movie special is that they are the product of the human hand. Remember Duchamp's *Fountain*. The human hand has nothing to do with it.[21] But more to the point, the *thing itself,* the made product, has not exactly *nothing* to do with its artistic value, but as good as nothing. *An artwork is not a thing.* An artwork is communicative action aiming at ecstasy. It is at once responsive to a history and a felt need and a sensitivity to the situation in which art-maker and audience find themselves. A work of art is like a joke. If a joke is funny and significant, then this can only be because it taps into human concerns, upsets them, or knocks them loose in a significant way. If a joke is funny, if we *get* it, then it is ours, it is *of us. How it was made has nothing to do, or at best very little to do, with its status or its meaning.* In particular, it matters not if the jokes were found written on an ancient scroll, or were delivered by aliens from outer space, or "generated" by a machine learning system trained up on a comprehensive world database. And so with art. If something is an artwork, then it is, by that very fact, a human product (method of production be damned). For it is an artwork not as a result of its origins, or thanks to its intrinsic properties, or even thanks to its mere effects on us—remember, a good commercial on TV can make you cry, and nothing has a bigger effect on people than pornography and propaganda, even though these are not typically art—but only thanks to what it lets *us* do. The point is not well captured by a slogan such as

"something is art only relative to a population." But that is true. Art is contextual and interactive.

But if we are looking for a mark of the human, a feature that draws a red line between human and computer, we need look no farther than the body and style. Computers don't have bodies, and they don't have styles.

Remember, we *inhabit* style, and we inhabit it, we know it, precisely as *our* shared self-picture, as our way of showing up, at least potentially, for others. Style is not just the "tell" that lets you know that I am the responsible party ("that's *his* signature"); style is the self-conception that I deploy to govern my own becoming. It is the law to which I subjugate myself. Style expresses itself in the things that I do that are just below the threshold of my consciously doing them at all, in my posture, my gait, my look and smile, in my body. Only a creature with a body can have a style, for style is the phenomenon of embodiment par excellence. And only a creature with a world can have a body, for the body is our concrete presence, as players, in the world, a world whose meanings are in turn opened up by what we can bodily do and undertake.

Style is an expression of the fact that a human never merely acts. Our actions are venturings into a social space where what we do resonates with social meaning. A movement or a gesture or a deed of any kind can be a carrier of style only if it has a significance for the agent that exceeds the practical demands of the task or situation. What we do acquires style only insofar as we are sensitive to what we do *as* perceptible to others and, as such, as at least a potential mode of communication and exchange with them. Consider, then: people deeply blind from birth do not participate in a certain visual modality of stylistic display; they gesture and use their faces expressively, and of course these expressions are visible; but they do not typically

monitor this fact about themselves with an eye, as it were, to their distinctively visual quality. This is why it is sometimes possible to tell that people are blind just by seeing their gestures.[22] Blind people do not enter into this particular stylistic space.[23] This point is quite general. A beginner at the piano, however adept she may be, has not yet entered into style, for she is not yet in a position to comprehend what she is doing as another might comprehend it. Of course, that is precisely what she is learning. Style is born of a loop of distributed self-consciousness, and it depends on skill.

Computers, even the not-yet-existent deep learning juggernauts of the future, do not prevent the looping and entanglement that makes human life what it is. Nor do they hijack it for their own purposes either. They have no purposes, after all. But more to the point, they seek no self-understanding and do nothing, therefore, to enact the ways that they represent themselves as being. Computers, however vitally important these may become as technological extensions of our work, never enter into human being.

Ironically, this line of argument does support, in a way, the basic claims of artificial intelligence. No, machines will never be intelligent, or rather, they won't be intelligent until they cease to be machines and become not machines, but anxious strivers for coping in a precarious and all-too familiar social world. But what does turn out to be the case is that we, we human beings, although we are not machines, are every bit the product of human making activity. We are artificial intelligence.

9

TOWARD AN AESTHETICS FOR THE ENTANGLEMENT

Literature and philosophy are two rivers that run together
for certain stretches.

—ATTRIBUTED TO STANLEY CAVELL
(BY HILARY PUTNAM)

UNCOVERING THE QUESTIONS

Experience is an aesthetic problem for us. This may be what
Merleau-Ponty had in mind when he wrote, "Nothing is more
difficult than knowing precisely *what we see*."[1] For trying to de-
scribe your experience, or fix it, trying to think it or define it, is
not something that we can complete, or manage definitely. We
could no more give a complete description or account of a work
of art, something fragile and still happening, an object of
reflection.

What do you see *now*? If you think that's an easy or straight-
forward question, it's because you've never really tried to an-
swer it. Unless you have already decided beforehand what is to
count as relevant to notice or mention, that is, unless you have
predetermined what matters, the question barely even makes
sense.

We can't fix our experience, in words or thought, because it is not fixed. It is a process, or activity, of encounter, and response, and more encounter, mixed in with reflection, self-discovery, and surprise. Experience is not a datum. It is a happening. And crucially, it is *our* happening, our becoming, our being at home in, caught up with, overcome by, and made up again in, the situations in which we find ourselves. To let all this—our total subsumption in where we are—be an object to our own reflection, this requires something like a method, or at least a very considerable *reorientation*. This is the demand of aesthetics.

And crucially, it is a problem that art itself takes on. For works of art are both objects to experience and opportunities for us to catch ourselves in the act of experiencing. Art engages human experience. Art works with human experience. Art changes human experience. Art's history, properly, like philosophy's, is a history of making and remaking, not just things, but contexts, ranges of significance, worlds. And so it is a way of making and remaking ourselves.

This makes us, we human beings, into something made, in a sense, and indeed, into something made *by us*. We are an artificial intelligence. We are an art problem. The decisive fact about any work of art is that it is what it is, it is there to be known; *nothing is hidden* (to use Wittgenstein's phrase).[2] The discovery, the disclosure, the articulation itself, arises out of gaining a new understanding of what has been exposed to view all along rather than in the discovery of new information.[3]

The same is true, then, with the study of ourselves. What we need is an integrated response to ourselves. Information about the nervous system, or about the genome, supplies more pieces of the puzzle that we face; it never supplies answers. The puzzle itself—what we take ourselves to be trying

to answer—is always changing. That's finally where our interest lies: not in answers, not in data masquerading as insight, but in the questions that, as James Baldwin suggests, have been occluded by the answers.[4]

When our object is ourselves, we face the added complication that we are not only the object of inquiry, and not only the interpreter, but also the maker. We are the results of our own making and remaking through, precisely, such activities as investigating ourselves. Insofar as we are products of our own doing, and insofar as aesthetic inquiry into ourselves alters how we do things, and thus changes us, then the very act of investigating ourselves is a constructive act of production. It is not surprising, then, that philosophical, neuroscientific, even biological theories of the human find themselves unable quite adequately to stabilize their own subject matter.

Human being, I am trying to convince you, is an aesthetic phenomenon. If we are to understand ourselves—not only what it is to be a dancer, but what it is to *see* and to *talk*, to *feel*— we need to undertake an aesthetic investigation of ourselves.

In this chapter, building on the discussion of chapter 6, I try to explain further the conception of the aesthetic needed to do justice to these strong claims.

Moving beyond the Trigger Conception

"Aesthetic matters," in common parlance, are matters of taste or preference. Empirical psychology (or its cousins cognitive science, cognitive neuroscience, and neuropsychology) is often taken to be the overarching category under which aesthetic phenomena are to be ranged. When people talk of the importance of "aesthetics," for example when buying a car, or a house, or clothes, they have in mind the value they attach to how these

items look or otherwise appear as opposed to their mere functionality, efficiency, or suitability for this or that purpose.

What does *art* have to do with the aesthetic from the standpoint of this conventional conception? The connection is supposed to be very tight—as we have already explored in chapter 6—but it is almost always misconstrued along the lines of what I call the *trigger conception*. According to the trigger conception, artworks are stimuli that trigger a special kind of episode in consciousness, namely, aesthetic experience. Artworks are special because they are specially designed to generate aesthetic response.[5]

The trigger conception is wrong at both ends. Aesthetic experiences are not triggered in us. And artworks are not triggers. Artworks do not trigger aesthetic experiences, because, in the relevant sense, there are not really aesthetic experiences. That is, aesthetic experiences are not episodes in consciousness—like a ringing in one's ears—that start and stop anchored in exposure to a stimulus.

Here are some considerations to support this claim:

1. *Your aesthetic experience of a painting, say, is not identical to the perceptual experience of the painting.* For one thing, the aesthetic experience needn't stop when you look away (to read the wall text, for example, or to talk with a friend about the painting, or to take notes on what you were looking at, or to look at other paintings in the same gallery). For another, you can perceive the painting and fail to have any aesthetic response whatsoever. Seeing is one thing. Aesthetic experience something else. The same goes for art in other modalities.

 Some works of art, for example those of Charles Atlas, or some work in electronic music, may deliberately target

perceptual/neurological effects. Even in these cases, it
seems dubious that the sensory impact *is* the aesthetic
experience, rather than an opportunity for it.

2. You might think that if the experience isn't perceptual,
 then it must be cognitive or emotional, or bodily, or
 empathetic, or motor, or whatever. But a striking feature
 of aesthetic experience is that although it is never one or
 the other of these *exhaustively*, it is, typically, all of these.
 Experiences of art are thickly, densely multimodal: they
 are emotional and perceptual, cognitive, bodily, cultural,
 and biological; they are personal but also shared.

3. Suppose that you read a poem or go to the theater. You
 can use a stopwatch to time how long this takes, that is,
 how long it takes to read the poem, or how much time
 you spend watching the play. But you will not thereby
 have measured the duration of your aesthetic experi-
 ence. How long *does* your aesthetic experience last? For
 as long as the play lasted? For as long as you think about
 it? Whenever you think about it? These questions don't
 quite make sense, which shows that aesthetic experi-
 ences are not creatures of time like headaches.

 Which is not to say that they have no temporality.
 My suggestion is that aesthetic experiences are less
 like headaches, or perceptual episodes, and more like
 patterns of curiosity, interest, or caring. An aesthetic
 experience isn't the sort of thing that happens once and
 for all at a moment in time, but for the same reason that
 one's concern for a political cause, or affection for a
 person, or commitment to a relationship, doesn't
 happen once and for all at a moment in time. Which is
 not to say that our commitments, interests, and caring
 can't change or that they are outside of time.

4. Nor are responses to an artwork singular or stable. This is important. Initial responses—finding something absorbing, or boring, or wonderful, or meaningless, "liking it," whatever—tend to be changeable. You can't point to a single effect, a single response, the occurrence of which we might try to explain. (It is sometimes said that an initial response is accurate in the sense that it predicts one's final, settled response. But there is no such a thing.)

5. Aesthetic experience varies, as we have just considered, but it does so, typically, in the setting of *conversation* and *criticism*. We bring artworks into focus through shared thought and talk and through shared culture. Aesthetic experience, insofar as it is a unitary phenomenon at all, is essentially a critical or discursive one—that is, it unfurls in a space of thought and talk, a space of criticism, as Kant and McDowell might have put it[6]—and so, in an important sense, it is not private or individual. (Note, to say that it is a critical phenomenon is not to say that it is exclusively or even predominantly *intellectual*.)

6. Finding the words to articulate your aesthetic response is itself a *creative* act, and maybe also an emotional one; it is not something that can ever be simply taken for granted, nor is it something that we typically do on our own, individually, in one-on-one response to an artwork, thought of as a sort of atomic stimulus. We strive to have aesthetic experience, and we do so always already as members of a culture, and, in particular, as members of an art culture.

7. Finally, aesthetic experiences don't come for free, just for the price of admission to the gallery or theater or whatever. We may fail to frame any response to the work

of art. We may even fail to perceive it, even as we look at it or seem perceptually to take it in. It can be difficult to do this, and sometimes we need to make an effort. We need to care. We cannot care always, and we cannot care about everything. And sometimes we need to be taught to be able to care (by the artwork itself, for example, or by our friends, or by critics).

In sum, the trigger conception takes for granted an unrealistic conception of aesthetic experience, and also of the kind of critical *work* or engagement, with one's values, among other things, that art itself demands. Let us reflect on this richer conception of what the artwork affords and what our aesthetic experience of the artwork can accomplish.

THE AESTHETIC POTENTIAL
OF EVERYDAY LIFE

Aesthetic experience is not confined to art. We have discussed this already in chapter 6. The world is replete with aesthetic opportunities and conflicts.[7] There are occasions for aesthetic response and engagement everywhere. But although it is true that there is aesthetic value to be found just about everywhere and that the world is rich in opportunities for aesthetic work, even outside the domain of art, the deep fact about aesthetics and everyday life—and the fact that gives the aesthetic its importance—is that many people are, not always, but a lot of the time, not only indifferent to, but even, in certain respects, *blind to*, all but the most immediately practical features of what there is around them.

This is true even when we are actually in an art setting. Have you sometimes seen people in museums race through galleries,

maybe on their way to a specific location, or to the café? Or
maybe because they are wrapped up in a conversation? This
image gives a good idea, I think, of the aesthetic standpoint of
everyday life. Whatever the *aesthetic potential* of the everyday,
most of us have our eyes to the ground. We do not regard what is
there before us. If we do see it, in an optical sense, we can't really
see it in the sense of understanding it or engaging it. Not because
there is anything wrong with us, or defective, but because that's
the nature of the beast: it takes *work* to perceive, and, as we have
already noticed, you don't get aesthetic rewards just for the price
of admission to the gallery, or to everyday life.

Yogi Berra once said, "You can see a lot by observing." The
joke is that observation is not easy; it requires effort and curios-
ity; it requires looking and interrogation; it requires thought. It
requires a kind of labor. Typically it also requires other people;
that is, the natural setting for most robust aesthetic encounters
with what there is around you (an artwork, or a sunset) is social.
A friend calls your attention to the variety of shades of green
among the foliage and remarks on this having to do with the age
of the leaves and the onset of spring, and *voila!* now these dif-
ferent shades are salient to you; or someone mentions the can-
vas tarp forming the covering of the vintage VW bus, and now
you can see it too, and appreciate what a difference it makes to
the overall character of the vehicle. To learn to see is to learn to
take an interest in things, and the world is full of different fami-
lies of things to take an interest in.

So yes, there are opportunities for aesthetic response ev-
erywhere. Aesthetic response is not confined to art. *But,* it is
also true, as we considered earlier, that art has a special tie to
the aesthetic, and precisely not that supposed by the trigger
conception. Art *targets* the aesthetic; it works with it and
makes it a problem. By this I mean: artworks stage occasions
for that distinctive passage from not seeing to seeing, or from

seeing to seeing differently, that is the very hallmark of the aesthetic. And they typically do something else, too. Artworks afford an opportunity for us to *catch ourselves in the act* of doing just that, of bringing the world itself, or the artwork, into focus for consciousness. Art makes the aesthetic an opportunity for investigation and at the same time it makes *us* such an opportunity; aesthetic experience holds out the possibility of self-discovery. Artworks are not mere triggers. They stage us.

Aesthetic Work: Productive and Fragile

I turn now to two remarkable aspects of aesthetic work, or criticism, that have been poorly or only partially understood (both of which have been touched on earlier, in chapter 6).

First, aesthetic work, or criticism, as I shall call the activity of energetically engaging with objects of aesthetic potential, or in the face of the aesthetic blind, is *productive*. Aesthetic work does not leave us as it finds us.

Let us return to my gallery example: you go to an art gallery and you look at works of art in an unfamiliar style by an artist whom you don't know. It happens, sometimes, in a situation like this, that a work of art strikes you as flat or opaque. You don't get it. It is incomprehensible. But you don't give up. You look harder; maybe you recall another similar object that you've seen. You read the title of the piece and that gives you an idea. You overhear someone in the gallery make a comment about the piece—about how it was made. Or perhaps you are with a friend and you talk with each other about what is there in the work. Something remarkable can now occur. The piece opens up to you; it discloses its face to you; you can see into it now and appreciate its structure. The piece now is present to you as meaningful.

What brings about this change in you, this new understanding? Not merely familiarity, but rather *aesthetic work*—you look and think and talk. You describe. And in doing so, you reorganize yourself, or you get reorganized, and you reorganize the work; it gets reorganized. You can see what you didn't see before, and you can see what you saw before in new ways.

How does aesthetic work change your experience? And precisely what is it that changes? I suspect only this: aesthetic work gives you, as I have already hinted, a new understanding, an understanding that consists not in the discovery of something new—again, to use Wittgenstein's phrase, *nothing is hidden*—but in appreciating the ways in which what is open to view fits together or rises to meaningfulness.

Whatever we say about this, it is remarkable not only that the understanding or reorganization occurs, but also that the art setting, the gallery in this example, provided us an opportunity for this to happen, or for us to do this. Art lets us catch ourselves in the act of bringing the world into focus for consciousness, and this is surely one of the sources of art's value.

In this way, aesthetic work changes us. I think that it does something like this on larger time scales as well. To give a personal example, I can remember the very first time I heard *Never Mind the Bollocks* by the Sex Pistols. I must have been in the eighth grade, and I was in the school library. My friend Michael Astor had brought in the record and we listened to it together in a cubicle. I remember thinking it was a joke. A titillating joke, but a joke nonetheless. What I heard was not music, not in the way that Led Zeppelin, the Rolling Stones, Diana Ross, Mahler, and Beethoven were, to me, recognizably music. What is truly remarkable is that now, today, not only to my ears, but, as it were, to the ears of the musical culture at large, the Sex Pistols sound almost classical, in the sense that they fit perfectly into a

musical lineage with clear antecedents and borrowings and an obvious effect on what came later. Today it can be difficult even to recognize the ways in which these songs seemed, then, utterly outside the bounds of the known.

So aesthetic response has a history.[8] Whatever other sources of value art has, one of its sources is that it affords an opportunity for aesthetic work, and aesthetic work changes us. These changes in us in turn make it necessary for artists to make new kinds of work. And so on. Art changes us, which drives art to change, which in turn changes us more, and on and on. We have a history, it turns out, in part because of the fact that there is an art history.

Back to the gallery example: it also serves to remind us that art's demands on us are not fixed, in two different ways.

First, as we have already noticed, they are not fixed during the original encounter itself; that is, the initial response to what you see or hear or meet is no more than an opportunity, in the best case, for aesthetic work, that is, for the kind of thoughtful observation and interrogation that will change our responses. Aesthetic work—looking, arguing, feeling, criticism, conversation—is always liable to rejigger our sense of what is right, or of what the work demands. Our initial responses are starting points; they are not conclusions. This is true for our experience of artworks, but also for our experience of aesthetic matters in other areas. A gardener or decorator, for example, can enable me to see a garden or a house, respectively, in new ways.

Second, as we have already considered, art's demands may vary over larger time scales (the life of a person, the life of a community, the larger history of a culture, etc.).

It is worth remarking that it is just this basic unfixed character of aesthetic response, or experience, that provides the biggest reason why empirical approaches to aesthetics have been,

by and large, such a failure.[9] Psychologists and neuroscientists interested in art take for granted that the aesthetic response is a fixed data point and they try to understand its causes and conditions. Why do people like x? Or why don't people like y? Or what happens in us, or to us, when the aesthetic experience occurs? But what people like, and why they like it, and what makes up our aesthetic evaluation, changes through caring; it changes through reflection, through conversation, through criticism, as well as through the historical cultural counterpart of these, that is, through shared practices of reflecting on, discussing, or evaluating artworks or other aesthetic problems or dilemmas, and also through education.

It isn't just that what we like shifts and changes. The point, rather, is that, as already mentioned above, aesthetic response unfurls in the setting of engaged thought and talk, and active looking, that is, in the setting of criticism. And criticism itself—engagement with the demands of art, with the task of trying to find the words to say what we see and to articulate our aesthetic response—is *genuinely creative*. It is also not something that we can understand at the brain level. It has much more to do with friendship, education, culture, and so on. We make aesthetic experience. It doesn't happen in us.

This is no less true when we take as our examples simpler, more basic responses, such as our responses to bodily sensations, tastes, and so on. The cat scratches me. The tattoo artist cuts into me with her instruments. Even if we suppose, for the sake of argument, that these events are exactly alike as to their sensory quality, the aesthetic meaning of these episodes does not supervene on these sensory qualities, nor is it fixed once and for all by, as it were, the bodily phenomenon.

So, to repeat: criticism—active looking, thought and talk about art, or other domains, mere description—is *productive*.

I turn, now, to a second feature of criticism that is both cru-
cial and, I think, poorly understood. Indeed, it hasn't even been
named before. Criticism, or aesthetic work, is *fragile*.

By the fragility of aesthetic work or criticism I have in
mind, in the first place, the fact that it is internal to the aes-
thetic standpoint that, no matter how powerfully I feel the
force of my aesthetic commitment, I also always appreciate
that nothing can compel the agreement of others. It isn't just
that aesthetic disagreement is undecidable; it is undecidable
on its face.

Here I extend Kant's famous insight. Kant realized that the
domain of the aesthetic is constituted, in part at least, by the
operation of two antagonistic principles. First, that aesthetic
disagreement is real and substantial—that we make our aes-
thetic claims in "the universal voice." Second, that aesthetic
response is, in the end, a matter of feeling, that this is a domain
in which there can be no deciding who's right or wrong, no
means of arbitrating dispute.[10]

Consider this thought experiment: suppose there were a
people whose putative aesthetic judgments were held by them
to be the sort of judgments for which demonstration or settled
agreement were possible, who believed that this was an area in
which it was possible to be, flatly, right or wrong. From Kant's
point of view, the mistake of these people is basically epistemo-
logical, or maybe intellectual. They think aesthetics is like geom-
etry or other areas in which positive knowledge can be attained.
And in this they are mistaken.

It is a consequence of what I am calling fragility, however,
that these dogmatists do not even manage to have genuinely
aesthetic responses at all. They are blind to the nature of the
aesthetic itself, rather than merely being overconfident about
the independent validity of their aesthetic responses. The

openness and undecidability of the aesthetic is, if you like, its *very modality*.

Fragility is familiar in other areas of life and thought, as well, as we have considered earlier. When we talk, for example, we always run the risk of being misunderstood, and so we need to stand ready, always, to rephrase, reformulate, rearticulate, and so on. To be a speaker is to be open to the demands of linguistic reparation and repair.[11] Something similar operates in the domain of perception: no object can be perceived in its entirety from all sides at once, and everything that you see blocks what is behind it from view. Seeing enables and disables. To see, then, is to be sensitive to the ways that we encounter the world only partially and thanks to active negotiation or exploration.

A language that admitted no communication breakdown within language would be like a visual perception in which everything was visible from all points of view at once. These would be language or perception missing the essential aspect of fragility, and these would be unrecognizable as language or perception in the sense that we know. (Perhaps this is what computer language or machine vision would be like.)

But there is a second way in which the distinctive fragility of criticism shows itself. This is the fact, as we have already considered, that our own individual aesthetic responses are not fixed or stable. They are not fixed or stable because they change over time. You may like a poem the first time you read it but grow to dislike it, and vice versa, as we have already considered. But aesthetic responses may be unfixed and unstable in a still further sense as well. It can take work—aesthetic work, the work of looking, thinking, and talking—even for one's *own* aesthetic evaluations and responses to start to come into focus for oneself. Far from its being the case that aesthetic experiences are conscious events triggered inside us, we need to enact our aesthetic

experiences, and we do so not only over time, with others, against a historical background, but sometimes also with the greatest of effort. We need to achieve aesthetic response.

And crucially, and this really is the point about fragility, it belongs to our first-person appreciation of our own aesthetic responses that this is the case. We appreciate our own aesthetic responses as changeable and unfixed and as, finally, something more like opportunities.

NOT FOR THE PRICE OF ADMISSION

Art has a special tie to the aesthetic, as we have seen. But more surprisingly, philosophy does too. A philosophical problem is a puzzle arising from the apparent incompatibility of different things that we find ourselves confidently believing. Wittgenstein put it like this: A philosophical problem has the form: I don't know my way about.[12] Not for lack of information, or because of empirical error, but rather because we are disoriented and cannot see our way clear to recognizing the resolution of the conflict. What is required, typically, is a reorientation of the problem, a rethinking of the very meaning of what one supposedly knows, a new analysis of what is already in front of one's nose. What is required is a new *understanding* that consists, in effect, in seeing things differently, or in seeing anew what was in plain view all along.

Philosophical problems are aesthetic opportunities. We don't get answers, or settled conclusions, at the end of our researches, but we do come to see things differently; things are brought into a new focus. The process of argumentation and investigation is itself transformative, and so productive, even if it is, also, always, fragile. It may be rigorous, even if it never allows for anything like proof or demonstration. It may be

persuasive, even if never compelling. It may be rational, even if it is also sensitive to the different pulls that we feel to say this or affirm that. These general characterizations fit perfectly the shape of the standard philosophical chestnuts such as the problem of free will (how to recognize the compatibility of our apparent freedom with our understanding of the causal connectedness of physical phenomena), or, more generally, when we try to reconcile what science teaches us about physical reality with our everyday, commonsense conception of the world around us.

It will be helpful to consider an example, although not a very recent one, in more detail.[13] Take the case of number. The mathematician and philosopher Gottlob Frege argues that statements of number are, as he puts it, statements about concepts.[14] A statement such as "the king's carriage is drawn by four horses," Frege claims, is not a statement *about* the king's carriage, or about its horses, or about their number. It is not a statement about the king's carriage, because, after all, there is nothing *four* about the king's carriage. Nor is it a statement about the horses. The horses are not all four, the way they are all brown, say. Nor is it a statement about the collection of the horses, since these are no more intrinsically four than they are, say, sixteen (given that there are sixteen legs) or eight (since there are eight eyes). No, what we are talking about when we talk about the number of horses drawing the king's carriage is the concept "is a horse that draws the king's carriage," and what we are saying when we say that there are four is that this concept is true of four and only four unique individuals. Frege integrates this analysis: first, with the availability of a new notation for rendering, that is to say, for *graphically displaying* this analysis and making it explicit (the predicate calculus, or, as he called it, the concept-script or *Begriffsschrift*); second, with a more

general analysis of existence and quantification; and third, with
an independent argument that arithmetic can be derived from
basic principles of logic.[15]

It is beyond dispute that Frege's proposal is a substantive one,
that there are reasons for accepting it. Frege himself believed that
it is just a fact about the nature of the relevant thoughts that they
have the structure that they have and that it is just a fact about
us that we are able to apprehend these thoughts and their struc-
ture. We have a "logical source of knowledge," as he wrote.[16]
When we render statements of number in the concept-script, we
are making explicit what is implicit in our ordinary thought and
talk, in our ordinary patterns of reasoning.

What is striking, and what is, really, I think, no less obvious
than the fact of the substantive character of Frege's claim, is this:
it admits of no freestanding proof. Frege's considerations may
be persuasive, but they are not dispositive; he cannot compel
our agreement about what, in the end, after all, is a claim about
us, that is, about what *we* mean, how *we* intend, how *we* under-
stand *our* own thought and talk. Frege's analysis is not itself
mathematics but rather belongs to the prose that supports and
motivates mathematical work still to be done.[17]

Frege's analysis, the fruit of philosophical work, is itself, then,
a creature of the *in-between*—in between the subjective and the
objective—which is where aesthetics resides. We can see this
when we consider how silly it might seem to hold—as Frege
may himself have been tempted to believe—that the facts of
philosophical analysis are of the same general status as facts
about, say, analysis in chemistry. It would be equally silly to
hold, as Frege well understood, that these are just psychological
facts about how minds work.

So what is Frege's subject matter, really? What is his field of
investigation? What is a philosophical analysis an analysis *of*?

The answer, I would propose, is this: Frege's true subject, the ground of his research, is the way that we find ourselves organized (in the relevant domain), that is, by the shared *habits* of thought and talk about numbers that antecedently organize us; Frege's insight was into the organization and structure of our habits of thought and talk, where this includes whatever we ourselves make of the relevant norms. Frege is inviting us to reflect on and assess how and why we talk as we do, and he invites us to do so from *the inside* of this activity of thinking about talking. He is targeting a domain in which we live and act, as it were, naïvely and with confidence, and he urges us to reflect, from the inside, on the kinds of principles, reasons, ideas, feelings, and so on, that move us.

I am trying to convince you that Frege's work, like all important philosophical work, is, as we can now appreciate, straightforwardly aesthetic, in my sense of this term. The field of his aesthetic concern is a *practical structure*. He is working to give us an overview, a "perspicuous representation," of *ourselves*, of ourselves insofar as we are inside, embedded within, and owners of a range of habits, skills, attitudes, and beliefs that we find ourselves antecedently saddled with. There can be no activity- or standpoint-independent way of deciding any of this, for what is at stake is nothing other than our antecedent commitments. Frege is offering us a new way of understanding or positioning ourselves in relation to a practical structure in which we already find ourselves.

Frege, like Wittgenstein, and also like Socrates, begins precisely where art also always begins, namely, with the ways that we find ourselves organized, with our habits, in this or that domain of lives. Not because art is necessarily *about* any of this, but because it is just this—the ways that we find ourselves dis-

posed to do and make and act and talk and think and see—that provide art's raw materials. Recall our previous case studies:

Painting. People make pictures; they use pictures. We have been doing so for millennia, much as we have been talking, thinking, and dancing for millennia. We are participants in a picture-based economy of exchange. Pictures are tools for showing, a technology of display. We use them for all manner of purposes. For example, we use them to show something that we want to sell, or to record what happened, and so on. Crucially, artists who make pictures are not merely participating in this economy of show and display. They are not simply carrying on this *show business*, as I call it.[18] They are not really making pictures at all; they are making art *out of pictures*, that is, out of the fact that we are organized by pictures, that pictures occupy an existentially organizing place in our lives. Painting as an art puts all this on display and does so in ways that give us resources, finally, for making new kinds of pictures and for thinking about the place of pictures in our lives in new ways. Painting starts with habits, with the ways that we find ourselves organized by pictures, and then it reorganizes us.

Choreography. People dance. Dancing is an organized activity. It is an activity built out of habits. Choreography, the art of dance, however, is not just more dancing. Choreography puts dancing on the stage. It puts the fact that we are dancers, that we are organized by dancing, on the stage. It puts us on the stage. It offers a representation of ourselves dancing. Think of this as writing ourselves down, or as the introduction of a perspicuous representation, like a new notation (e.g., the concept-script). And this representation of ourselves changes us, for it gives us new resources for thinking about what we are doing when we dance, and so finally new ways of dancing. You dance

differently in a world in which there is choreography. Choreography loops down and changes the dancing of which it is the representation.

Philosophical work, of the sort undertaken by Frege, is aesthetic in exactly the ways that choreography and painting are. It is an investigation of our organization, our antecedent residence in a system of habits and skills, activities and tendencies. Aesthetic experience is an engagement, from the inside, with all of this. Aesthetic work is fragile and productive because it is, precisely, the work of reorganizing ourselves. And this is also the source of its in-between, neither fully objective nor fully subjective, character.

THE VICO/DREYFUS PARADOX

I no more wrote than read that book which is the self I am.
—DELMORE SCHWARTZ

Art, and in its own way, philosophy, are making activities. One might say that both are oriented toward *making* paintings, compositions, texts, performances, whatever, that serve as Wittgensteinian "perspicuous representations" of ourselves and that serve, also, to reorient or reorganize us.[19]

But we are also ourselves *made* through this very same making activity. This is entanglement. The second order, as it were, transforms the first order and thus drives the need for new attempts at the second order. Art and philosophy are never finished. And neither are we. We are the unfolding result of this evolution. Note, this is *not* the sort of cultural evolution envisioned by anthropologists and biologists, mentioned in chapter 2, who argue that where biological evolution by natural selection gives way, cultural evolution takes over. The thing that

such an account gets wrong is its necessary assimilation of art and philosophy to mere culture. As if these were just further ways in which we find ourselves organized. Art and philosophy are *not* that. They are themselves precisely modes of investigation of, and actions of resistance to, the ways that we find ourselves organized. They are reorganizational practices.[20] Or rather, if we try to reframe this point in a way that takes the standpoint of entanglement for granted, *culture* itself, given its entanglement with art, can never be itself alone a phenomenon of the first order; entanglement remakes culture as itself always a site of rivalry between mere technology, with its regimentations, and art, with its emancipations.

But let us now focus on the dual significance of *making*: we are makers and we are transformed and so, in that sense, made again by our own making activity.

Here we can follow Vico, who starts, as we noticed in an earlier chapter, with the rich and, as it were, homely observation that a builder has a special kind of knowledge of their building. So too for an artist. They have a special knowledge of their drawings, for each mark on the page is their mark, the trace, the effect, the residue of their movements. There can be no mysteries here. In contrast, for Vico, it is hard to escape mystery when we are confronted by that which we do not make and which we therefore do not know, as it were, from the inside. The natural world, for example, is finally incomprehensible to us precisely because we are not responsible for it; it is due to the work of God. But the things that are made by us—whether buildings and clothing and roadways, or social institutions and human customs—these we can know, and indeed, we can know them with the Creator's authority, for we are very truly their creator.

This is a fascinating suggestion. It is an almost ironic inversion of Descartes' view that what a person knows best is the

private passages of their own consciousness.[21] It is not what we cogitate that we know best; for Vico, it is what we *do*. And importantly, what we do includes culture itself, which is something that we make primarily in the setting of our social lives with others. From Vico's standpoint, natural science is the stranger's work; you need science when you encounter that which you have not created. But you don't need, and can hardly use, the scientific attitude when you are a trusted familiar, at home amid the stuff of your own manufacture.

Now, in one respect this is pretty unconvincing. True, the builder doesn't need the methods of science, such as those laid out by Descartes in his *Discourse on Method*, to know what he or she has built. But these methods may be exactly what we do need to understand, for example, whether the structure we have built is stable or trustworthy, whether it will withstand strong winds, for example.

To this there is, I think, a plausible Vichian response. Yes, science can serve in a supporting role to test and constrain building activity. But the building activity itself is *ours*, and this is a domain where there is no need and no room for science to intervene. And this point is a productive one: it explains, in particular, why, as a matter of fact, science can't assert its authority in the domain of the human (advertising to the contrary notwithstanding).

But there is a deeper objection to Vico. So much of what we do is skillful and habitual, as we have stressed all along. But this means that so often we act precisely *without* self-monitoring, or at least without self-deliberation. Indeed, according to Dreyfus, we are at our best when we act beyond the reach of our own thoughtful control, when we have so embodied skill and expertise that we can just let it all happen.[22] As my tai chi teacher

sometimes says about martial arts, by the time you get to the T in "think," it's too late. From this standpoint, we achieve true mastery when we stand to what we make and do in an attitude of *non*-thought. It is almost as if it is not *me* who does the things I do—a Merleau-Pontyan refrain—but rather my body, or some anonymous person I embody. It is my fingers who know how to find the f-key on the keyboard, not me, just as it is the batter's exquisitely trained body that lets him make contact with the ball that was thrown so fast that he cannot even see it. Real creation, real creativity, from this standpoint, happens when we cede agency and let our impersonal skillfulness take over. To be a creator is to be a locus of attunement and entrainment, captured by the demands of the task. It is this capture—engagement in what the task requires—that is at once the source of mastery and that also stands in the way of understanding or knowing what we do when we do it.

So Vico may have had things backward. The creator's relation to the world is so immediate, so practical, so spontaneous and habitual, as to deny room for, or need for, anything like investigation, science, or knowledge. It is not the maker, or the doer, but the dispassionate observer, the theorist, who has a better chance of really comprehending what we are doing precisely then when we are expert makers and creators.

Who's right, Vico or Dreyfus? On the one hand: we have a special and intimate relation to our own creation, to our own actions and doings, our makings; we have a kind of epistemic authority in relation to these. This cannot be denied. But on the other hand: nor can it be denied that sometimes the very source of our *author*-ity is a kind of letting go, a surrender to habit and skills, that makes our works, in a way, mysterious even to ourselves. Creation is a kind of miracle.

We face a paradox of sorts: let's call it *the Vico/Dreyfus paradox*. On the one hand, the author is best positioned to know what he or she writes. And yet, on the other hand, a good author is one who knows how to let the book happen, let the book write itself. But then the author is not best positioned to know the book.

It would seem that we need to give up either the Vichian idea that we have a special knowledge of our own works or the Dreyfusian claim that expertise requires a loss of agency.

But actually, the solution comes when we recognize *the entanglement* of reflection, on the one hand, and doing, on the other.

Critically, in opposition to Dreyfus, engagement does not exclude reflection. Even the most experienced hiker stumbles. But to stumble is not to stop hiking, or to interrupt it. Stumbling and needing to pay attention to what you do are not interruptions of our skillful engagement, but natural moments or aspects of it. Which opens up the possibility that Dreyfus and Vico are in a way each half right. We *do* have a special relation to our own creative action. But not because it is transparent to reflection. Rather, because it is uniquely a *concern* for reflection. But skillful engagement—mastery, creativity—is large enough to comprehend this concern-ful character.

To know what we do when we do it, or to know ourselves in the process of becoming, is not easy. But it is not impossible either. We live in the entanglement, and we are, thus, to echo Heidegger, always already problems to ourselves. But this challenge—the problem of bringing ourselves into focus for reflection—is, as we have already realized, *the* aesthetic problem. We *can* know ourselves in the act of being and doing, and we can know what we do, what we make. But neither Vico's creative authority nor the detached standpoint of science is

what secures this knowledge. What we need is to adopt precisely a distinct standpoint, namely, the aesthetic standpoint. What is needed is a reorientation to ourselves, to our being and doing. It is this reorientation, and the resulting *rehabituating*, or really, emancipation, that is the *work* of art. This is the aesthetic problem.

10

REORIENTING
OURSELVES

Where do we find ourselves? In a series, of which we do
not know the extremes, and believe that it has none. We
wake, and find ourselves on a stair: there are stairs below
us, which we seem to have ascended; there are stairs above
us, many a one, which go upward and out of sight. But
the Genius which, according to the old belief, stands at
the door by which we enter, and gives us the lethe to
drink, that we may tell no tales, mixed the cup strongly,
and we cannot shake off the lethargy now at noon-day.

—RALPH WALDO EMERSON

HUSSERL'S BRACKETING

"Reorientation" is Husserl's term, and it will be helpful to turn
our attention, briefly, to his handling of this critical idea. Hus-
serl's conception of the philosophical standpoint, or that
standpoint made available through the distinctive activity of
philosophical reflection that Husserl called the *epoché* (= brack-
eting), is thoroughly aesthetic in the sense developed here.
This is a point that he remarked on in different places, but

seems to have come to downplay, perhaps because he failed to appreciate its significance.[1]

Husserl begins with the lifeworld. This is the known milieu that we take for granted; it is pregiven, as he puts it; we can think of it as the place where we find ourselves before we pose questions and do natural science; it is the ordinary world that we know *before* we take up physics or philosophy. We are residents in the lifeworld. It is the very context of our lives. Husserl writes,

> The life-world, for us who wakingly live in it, is always already there, existing in advance for us, the "ground" of all praxis whether theoretical or extratheoretical. The world is pregiven to us, the waking, always somehow practically interested subjects, not occasionally but always and necessarily as the universal field of all actual and possible praxis, as horizon. To live is always to live-in-certainty-of-the-world. Waking life is being awake to the world, being constantly and directly "conscious" of the world and of oneself as living in the world, actually experiencing [*erleben*] and actually effecting the ontic certainty of the world.[2]

Science is an activity taken up by us; it is a vocation, one among others. In this sense, natural science is itself a phenomenon of the lifeworld rather than, as it were, a way of getting outside that everyday familiar world so as to get a truer account of reality. We are in the lifeworld when we do science. So the idea that science might undercut our confidence in the reality of the lifeworld is, for Husserl, a nonstarter. Indeed, the very distinction between reality and illusion, truth and falsehood, subjective and objective, these are drawn inside the lifeworld and presuppose it; they have no application to the lifeworld (or to "reality") itself.[3]

But the lifeworld itself—ordinary, pregiven, unproblematic—can be made a problem too. We are both of the world, and in it, as one of the things there are, and also, crucially, as Husserl would have it, as conditions of the world's possibility; after all, the world is the domain of what is there *for us*. Can we come to understand the ways human living enables and sustains the lifeworld as what it is: ordinary, pregiven, unproblematic? How might this be possible? How can we foreground that which is, inevitably, the open-ended, infinitely variegated, and always unquestioned *background* of our lives? How can we make *ourselves*, we who are at once objects in the world and at the same time always conditions of its very possibility, into objects of investigation? The project of answering these questions can seem impossible, comparable to trying to catch yourself seeing yourself in the mirror: you *can* see yourself in the mirror, but when you do so, you see yourself in reflection from the outside merely as a thing. What you can't manage, ever, is to see, as it were, your *seeing yourself* itself.

But it is possible to bracket the lifeworld, Husserl thought. Not because we can actually remove ourselves from it—we cannot—or because there is life before it, or outside of it; there is not. But what we can do is *reorient* ourselves to it, or, rather, within it. Husserl uses the vocational metaphor again.[4] I am partial to my own children; I am interested in them. It is possible, however, at least in principle—for example, if I am asked to serve as a referee in some sporting contest that they are participating in—for me to view them impartially and disinterestedly. When I call my own son out at a close play at the plate (in a baseball game), I am not viewing my son as my son but rather as the player whose action at the plate needs to be decided. I don't lose my affection for him; I don't cease to be his father; but insofar as I don the umpire's cap and take on that job, I am

able to reorient myself and indeed to remove myself even from that which I love most dearly. And when the game is over, I take off my umpire's hat and resume my more enduring commitment, itself another vocation, as father to my boy. Similarly, when we bracket the world in reflection, that is, when we undertake the epoché, what we demand of ourselves is not that we actually cease to care about, or believe in, or even take for granted the lifeworld around us and beneath us, but rather that we adopt a standpoint, or assume an attitude, as if we do those things, only provisionally, only for "vocational time."

To adopt such a disinterested and detached standpoint is to take up an aesthetic stance. Detachment, disinterestedness, and reflection are hallmarks of the aesthetic attitude, as Kant correctly believed. And so philosophy, as Husserl practiced it, is in this way an aesthetic activity.[5]

But Husserl appreciated something else too: aesthetic reorientation, or the standpoint of transcendental subjectivity, does not leave us as it finds us. The standpoint may be adopted in "vocational time"; when our workday is over, we return to our ordinary engagements, partialities, and investments. But crucially, everything has been altered nonetheless. For once you realize that it is possible to take up a reoriented relation to the world that we take for granted, then *that fact*, the possibility of reorientation, the possibility of detachment, must henceforth show up as one of the world's facts, aspects, or horizons. The reorientation, as he puts it, brings with it a "a significant transformation." He writes,

> As a phenomenologist I can, of course, at any time to go back into the natural attitude, back to the straightforward pursuit of my theoretical or other life-interests; I can, as before, be active as a father, a citizen, an official, as a "good European,"

etc., that is, as a human being in my human community, in my world. As before—*and yet not quite as before*. For I can never again achieve the old naïveté. I can only understand it. My transcendental insights and purposes have become merely inactive, but they continue to be my own.[6]

In this way, we change the world by taking up a philosophical, that is to say, an aesthetic attitude to it. In this way, Husserl anticipates our basic phenomenon: the entanglement.

WITTGENSTEIN ON ART AND PHILOSOPHY

The approach I take here to aesthetics, and to philosophy, has roots in my reading of Wittgenstein's philosophical writing, and I would like to offer a brief discussion of Wittgenstein on art and philosophy.

Wittgenstein wrote fairly little about art.[7] He had more to say about aesthetic inquiry. "In aesthetics the question is not 'Do you like it?' but 'Why do you like it?'"[8] And he explained, "Aesthetics is descriptive. What it does is to *draw one's attention* to certain features, to place things side by side so as to exhibit these features."[9] The aim of aesthetic inquiry is to bring more clearly into view that which is hidden in plain sight, that is to say, that which is not hidden at all. And its method consists, basically, in making "peculiar kinds of comparisons."[10]

Wittgenstein's conception of the aesthetic is squarely in the lineage of Kant. For Wittgenstein, as for Kant, the work of aesthetics consists in finding the words to say what one sees and so to explain or justify one's response. For Wittgenstein and Kant, aesthetics happens in a space of criticism, a space where there is the lively possibility of disagreement and where disagreements are heartfelt and important.

This might seem a somewhat thin picture of aesthetics if not for two important facts (which have already loomed large in my discussion).

First, for Wittgenstein, as for us, aesthetic engagement—or criticism—is dynamic and productive; in my terms, it reorganizes us. "Our attention is drawn to a certain feature, and from that point forward we see that feature."[11] Finding the words to say it, describing what you see, making comparisons, all this changes what you see, or how you see; it effects a passage from not seeing to seeing, or from seeing to seeing differently.

Crucially, aesthetic judgments (reactions, responses, feelings) are not fixed and stable; they are not mere data points recording the power of the work to bring about causal effects in us. They are, rather, ways in which we initiate the looking, interrogating, comparing, noticing, and reminding, in which aesthetic inquiry consists. And the end of criticism is not the explanation of the data with which we began, but rather their alteration. Again, criticism aims at reorganizing.

When discussing these and related matters, Wittgenstein rails against the idea that aesthetics, in his full-blooded sense of thoughtful, critical encounter and engagement, could be a topic for empirical psychology or brain science. For Wittgenstein, the propositions that works of art are triggers for self-contained aesthetic responses and that aesthetics should target these effects/reactions represent a fundamental error.[12] We are not interested in what causally influences us when we ask, for example, *why* we judge a work as we do. Aesthetics doesn't name an experimental domain, but something more like an *attentional* discipline.[13] In aesthetics we offer descriptions, we call attention to details, we make comparisons, and in this way, we bring what we see into focus, for ourselves, but also for others. In this way, we teach another to see what we

see. Wittgenstein explains, "I very often draw your attention to certain differences. . . . What I am doing is also persuasion. If someone says: 'There is not a difference,' and I say: 'There is a difference' I am persuading, I am saying 'I don't want you to look at it like that.'"[14]

For Wittgenstein, the aim of aesthetic inquiry is to bring what is in plain sight into view. We engage in criticism—we describe what is there, we make comparisons—and in so doing, we make it possible to take in or notice or perceive what is there all along. Criticism makes the work perspicuous (surveyable), and in this sense, it opens up the object of aesthetic attention to us.

Second, philosophy itself is aesthetic (and dynamic and productive) in this very sense: philosophy aims at reorganization through description. The point is not that philosophy is *about* aesthetics—that would be silly. The problem of free will, or the mind/body problem(s), these are not problems about art or visual perception. The point rather is that philosophy's trouble spaces—and here we might mention free will or mind and body—show up as aesthetic problems. Not in the sense of having to do with looks, or beauty, or preferences, or art. They are *not* aesthetic in that sense. They are aesthetic in the thicker sense that I have been trying to articulate throughout this book: a problem is aesthetic when all its elements are there, before you, open to view, and yet you don't understand how they fit together, and yet you can't really *see* how things hang together. The problem we face when we face an aesthetic problem is seeing what is there before us, and the aesthetic work we do aims at bringing what is there into focus.

Now for Wittgenstein, philosophical problems are aesthetic in exactly this sense. We lack, as Wittgenstein would have it, a perspicuous overview of some problem, or field, or area, or conceptual landscape. Through description and argument, through

careful looking and thinking and paying attention, we try to achieve a clear view of them, as we might try to command a clear view of a work of art. Philosophy aims at just that sort of understanding that consists, in this way, in appreciating connections and noticing differences. Philosophy aims, then, at aesthetic integration and understanding.

Philosophy and aesthetics are bound together, for Wittgenstein; what unites them is the idea of the perspicuous representation. As he writes,

> A main source of our failure to understand is that we do not *command a clear view* of the use of our words.—Our grammar is lacking in this sort of perspicuity. A perspicuous representation produces just that understanding which consists in "seeing connexions." Hence the importance of finding and inventing *intermediate cases.*
>
> The concept of a perspicuous representation is of fundamental significance for us. It earmarks the form of account we give, the way we look at things. (Is this a "Weltanschauung"?)[15]

Philosophy therefore aims at the making perspicuous, at the presentation, or display, of our ways of talking and thinking, of the domains in which we find ourselves at sea. Wittgenstein compared language to a city that has grown complicated through decades and lacks any plan. A philosophical problem, he also wrote, as we have noticed already, has the form "I don't know my way about," that is to say, "I am lost."[16] What is required is that we figure out where we are. We need a map, or a clear representation of the concept-scape where we find ourselves. So philosophy, like art, aims at making perspicuous, at presenting, at showing.

I suspect that most readers of Wittgenstein have been inclined to think that the idea of a perspicuous representation functions

as a metaphor in his thought, as if working through a philosophical problem were like climbing a great height and achieving a summit from which one can get a clear view of the land below. I have already challenged this (in chapter 5). For Wittgenstein, philosophy was a making activity, specifically, a graphical one. It is worthwhile, returning to this theme, to emphasize that in conceiving of philosophy as aiming at the making of perspicuous representations, Wittgenstein was, very clearly, framing a conception of philosophy that brings it close to art itself. Indeed, we may say, for Wittgenstein, philosophy—all philosophy, not just his philosophy—is always, of needs be, graphical philosophy. Philosophy, that is, aims at the invention of the means to represent that which puzzles us to ourselves. Philosophy seeks the ways to write down, or lay out, or sketch or show, that which is confusing to us, thereby to offer us release.

This vision of philosophy is already in evidence in Wittgenstein's early work. The *Tractatus* can be read as a commentary on the invented notations of Frege and Russell.[17] Like Frege and Russell, Wittgenstein believed that language conceals the true structure of thought and logical relations. That there *is* an underlying logic—that language "is in order just as it is"—is a fixed point, for Wittgenstein, for that logical order is itself a condition on sense making and understanding.[18] But the fact that language superficially violates that concealed logic is the source of the most fundamental confusions. To avoid these, Wittgenstein urged, we need not a more perfect language—there is no such thing—but rather a way of writing our language down (a notation or *Zeichensprache*, a *Begriffsschrift* or concept-script, as Frege had called it) that more perfectly exhibits that already present underlying conformity to logical syntax and logical grammar. We need, that is, a better, more perspicuous, way of representing our language and ourselves, to ourselves, and for ourselves.

Now in some ways Wittgenstein pressed beyond this idea in his later works. He famously came to be suspicious of the idea that there might be a logical syntax in the sense in which we know this in the work of logicians, and he tended to replace talk of notations with a new focus on language games, which, in turn, brought to the fore the ways in which language is grounded in activity, embedded in context, shaped by interest and situation.[19] But these advancements shouldn't be overemphasized. In the *Tractatus*, Wittgenstein had stressed that "colloquial language is a part of the human organism and is not less complicated than it."[20] And in the later work, no less than the earlier, his focus is on making language—or everything that is involved with language, that is, thought, logical relationships, puzzlements and confusions—perspicuous. Philosophy's task remains, for Wittgenstein, from start to finish, the task of writing ourselves. The problem is not language. The problem, rather, is with our picture of language, our way of representing it to ourselves, or rather, with limitations in our ways of representing *us*, and our lives with language, to ourselves. We fail to represent what we are doing, our language-ing, to ourselves. Consequently, philosophy's job was and became, for Wittgenstein, to invent better ways of writing, better ways of representing ourselves, to ourselves. ("Better" not in any final, all-things-considered sense, but only in relation to our immediate felt needs and concerns.)

And crucially, for Wittgenstein—and here he goes beyond Kant—this is an aesthetic enterprise, not only in the sense that what is required is that we, first, take up an aesthetic attitude to the sources of our puzzlement—an attitude like that which we take to works of art, or that artists might take up to the world—but also that we, second, take up, as we have seen, what we might call an artistic, that is, a maker's attitude. In the *Tractatus*,

Wittgenstein sought concretely to fabricate better ways of
writing, which is to say, better ways of depicting or showing or
displaying ourselves. But notice: this way of characterizing
Wittgenstein's idea of philosophical work also serves perfectly
to capture that of art as well. Works of art are not merely pic-
tures or stories, for example; they are moves in a practice of
making perspicuous, of displaying, of unveiling, of bringing out
and setting forth.

Philosophy, like art, is creative work. Philosophical work,
like aesthetic work, is a domain in which we turn not to the
world, and not inward, but to the ways in which we find our-
selves organized. Philosophy and art have the power to reorga-
nize us.

THE SEEPAGE PROBLEM

Out of the crooked timber of humanity, no straight
thing was ever made.

—KANT

A DYNAMIC LOCUS OF ENTANGLEMENT

The inability of science to explain consciousness and life is
not an isolated theoretical shortcoming, argues the philoso-
pher Thomas Nagel, but one that "invades our understanding
of the entire cosmos and its history."[1] For it belongs to that
"comprehensive, speculative world picture that is reached by
extrapolation from some of the discoveries of biology, chem-
istry, and physics," that it *ought* to be possible to give a unified
scientific account of *everything in the universe*, including us.[2]
The fact that such a unified account is not available, that we
have yet even to limn its broad outlines, indicates, for Nagel,
that there is something incomplete, inadequate, or mistaken
about our very starting point. We've baked materialism into
our science at the lowest level, and as a result, our science can
make no room for mind and life. What is needed, Nagel pro-
poses, is a do-over, something like Reductive Materialism, but
sans the materialism; that is, we need a reductionist account
of everything, but one that is founded on nonmaterialist

building blocks (and, as he also claims, perhaps teleological
first principles).

In this book I offer a very different approach. Science is in
good order just as it is. The problem, rather, is that we have not
yet come to grips with the fact that we ourselves are not a fitting
subject for this thing that we do called science. We are a dynamic
locus of entanglement. We are a problem to ourselves. We are
the one thing that admits no fixed points of any kind.

To say this is not to demote science or derogate from its impor-
tance. It is only to acknowledge that there are genuine questions,
important ones, that it is not science's business to answer. I agree
with Collingwood when he writes that "natural science, consid-
ered as a department or form of human thought, is a going con-
cern, able to raise its own problems and to solve them by its own
methods, and to criticize the solutions it has offered by applying
its own criteria: in other words . . . natural science is not a tissue of
fancies or fabrications, mythology or tautology, but is a search for
truth, and a search that does not go unrewarded."[3]

But crucially, as Collingwood continues, "natural science is
not, as the positivists imagined, the *only* department or form of
human thought about which this can be said, and is not even a
self-contained and self-sufficient form of thought, but depends
for its very existence upon some other form of thought which
is different from it and cannot be reduced to it."[4]

What might this other form of thought be? My answer—and
here I part company with Collingwood—is twofold. First, science
depends for its very existence on *non*-scientific understanding,
that is, our extrascientific as well as our prescientific concerns,
projects, and values. Galileo, Newton, and Einstein were people
with the frailties and ambitions common to all people. Even when
facts of daily life do not enter as premises into the theoretical argu-
ments of scientists, it can hardly be forgotten that science is a
human undertaking, a kind of work, a vocation, as Husserl put it.

And of course it *is* sometimes the case that facts about perception and the perceiver—about measurement, for example—do need to be registered as premises in scientific argument. We encounter this self-reflection in relativity and quantum theory. And we see it in a more practical way in the fact that real science depends on the use of real equipment, bought and sold, and subject to its own performance limitations. Every scientific paper contains a methods section, and for good reason.

But second, as I have been urging throughout this book, the standpoint of the pre- and nonscientific, that of the *ordinary*, of Husserl's lifeworld, is neither authentically naïve nor, as it were, theoretically unbiased. Where there is body, perception, language, sex, race, and dancing, there is also philosophy and art. And so really, then, it is philosophy and art, or what joins these, what they share—*the aesthetic attitude*—that supports, enables, and sustains science; and so we can say, echoing Collingwood's words, that science depends upon the form of thought that is art and philosophy; art and philosophy are different from science and cannot be reduced to it.

SCIENCE AS TECHNE

It is possible to hold these two thoughts together and at the same time:

> *biology, chemistry, and physics are effective and, indeed, distinctive, ways of working toward truth and gaining knowledge about how things really are, how they work, what there is,*

and

> *natural science, thought of as comprising biology, chemistry, and physics, is not the only way of rising to truth and understanding; art and philosophy are other such ways.*

I have insisted that art and philosophy are distinct from sci-
ence and not reducible to it. But this doesn't mean that these
distinct domains are entirely independent of each other or that
they are utterly unconnected. In fact, they are *entangled*, and
indeed, in exactly the sense that I have been working to unfold
and elaborate in this book. Art and philosophy are entangled
with life and science. And this has broad implications for our
understanding of science and nature, and for why it is that there
can be a natural science, but, finally, no science of us (at least no
physics-like science). Let me try to explain.

Science, it hardly needs saying, is not a magical method that
supplies an open window through which we catch a glimpse of
Reality. It is, rather, an organized discipline of theory-making
and knowledge-collecting. We pose questions and seek an-
swers. A scientist is not like a sailor adrift at sea, discovering
willy-nilly that there is an island here, or high seas thataway. A
scientist is like a competent navigator, using their maps and
equipment, sextants, compasses, and the like, to arrive at
sought-after quarry. The navigator may be wildly mistaken—as
Columbus was, say, when he arrived in what he thought was
India—but their work, composed step by step on the basis of
choice, data, hypothesis, expectation, aspiration, and hope—is
anything but idle or haphazard. Far from being a transparent
openness to the world, science lets you learn about the world
by turning your attention away from it, and to your own model
of the domain in question. The scientist learns about what is
going on around them by keeping their heads in their instru-
ments and books.[5]

To think that the world of our everyday life is somehow an
unreality, and that what is true is the stuff revealed by scientific
theory, may be a crude mistake, but it is one to which many of
us have sometimes fallen prey. It is comparable to the mis-

guided idea that since a soldier targets his weapon by looking through the scope, it is the image in the scope that is his true target, and that the enemy combatants, say, and the warlike movement of troops all around, are mere figments. Which is of course not to deny for a second that the scope lets us see better, at least for certain purposes, for example, more accurately and farther. Here the contrast is not between appearance and reality, or illusion and truth, but between different techniques of active access to our situations and to what there is. It would be an equally egregious, but somehow contrary, error to hold that our "natural attitude" to the lifeworld is itself a species of the theoretical attitude. For neither the houses on Elm Street, nor my neighbor's feelings, nor "the Gods of Homer" are merely posited theoretical entities as, say, quarks or strings are.[6] Such a view flattens and distorts, as I would put it, the plurality of different ways that we have of achieving access, of making what there is present.[7] Crucially, there *are* different attitudes and different ways of knowing. And this last point is consistent, too, with the observation that, as Quine believed, there is a truth in pragmatism, namely, that science is an extension of life, the pursuit of its practical aims, but by different, indeed, specialized means.

But the critical point, for now, is that science is an activity. It is something that people do. I don't mean this merely formally, merely registering a grammatical fact; I mean this concretely, that is, in a more anthropological sense. Science, like business, or government, or agriculture, is an activity and an undertaking; it is, as Collingwood put it, a "going concern." And crucially, as I said before, it is an organized and, we might add, normative activity; that is, it operates with standards and a concern to cleave to standards that it is also necessary, sometimes, on the fly, to reevaluate. Science is a techne.

Not so philosophy and art. These are not techne; that is, these are not skillful or disciplined modes of work with settled criteria of success and operative norms. Scientists ask questions and produce answers. Philosophers and artists, in contrast, raze answers in the quest for concealed questions (to repurpose the epigraph from James Baldwin given in chapter 2). Scientists know what their answers mean, and they are agreed, almost always, in what counts as evidence for or against them. Success and failure are terms with straightforward meaning when we are in the domain of science. This is not the case with artworks or philosophical products, which are willfully and, sometimes at least, *fruitfully* obfuscatory.[8]

Design, like science, but unlike art or philosophy, *is* a techne. The thing about design, at least as I use the term, to encompass craft and technology, is that it relies on a clear view of its task, which in turn means it can take for granted measures of success and failure.[9] Engineers working on the iPhone, for example, can clearly enumerate their goals (light, small, user-friendly, "sexy," handheld devices for communication, pictures, multimedia), as well as the constraints under which they operate (e.g., cost, availability of materials, the feasibility of production, competitors). Innovation may strike like a creative blast—as when someone realized that you could integrate the music playing device (iPod) and the smart phone—but when it comes to design, we remain ensconced in the zone of prefabricated intelligibility. We come up with solutions to prearticulated problems.

So art and design are worlds apart. And yet, there is no art without design. We might say that art is a reaction to design, an attempt to disrupt its certainties and to put into play what it holds constant. After all, art makes art *out of* design, which is just to say, out of our embedded, function-oriented lives. But

art also *influences* what design looks like, and even shapes the imagination and the self-understanding of designers. Designers design in a world that is opened up by art. So, just as there is no art without design, there is no design without art. Art and design are, as I have been arguing, entangled. This is why it is sometimes impossible to decide, of a work of design, whether it is art, or whether it is design. (Architecture thrives in this place of entanglement.)

And as with art and design, so, critically, we now come to appreciate, with philosophy and science. Kuhn contrasts normal and revolutionary science.[10] Revolutionary science is paradigm shifting, an activity of reevaluation, reassessment, indeed, reinvention. But that's just to say that revolutionary science is something rather like philosophy. And this reminds us of a point that is easily missed: philosophy and science may be different departments, different faculties at universities, supported by different funders, and making use of different journals and societies for the promulgation of work. But really, the entanglement of science and philosophy is such that science and philosophy denote different *moments* or aspects of our one living project. Philosophy *happens* inside science, because science needs philosophy, as philosophy needs science. They are two, but they have become as one. They are *entangled*.

The Seepage Problem

Part of the impetus to write this book stems from an anxiety, in me, induced by recognition of the fact that it can seem as though we have failed, again and again, to get a rigorous and robust science of the mind off the ground. This is Nagel's point, and I agree. There has never been, in psychology, any discovery or breakthrough comparable to Watson and Crick's discovery

of the structure of the DNA molecule. Psychology has done an amazing job collecting facts and data, but it has never quite established foundational principles. And so human being, consciousness, subjectivity, value remain open questions, even mysterious, even now, after so long, as Nagel was right to emphasize. Why? The problem is not that psychology is young and immature, or, for that matter, that *natural science* is itself just achieving its full adulthood. The problem is deeper than that, and more interesting, or so I have been urging: human being is an aesthetic phenomenon; it is not, in any sense that we can take for granted, a natural phenomenon. And human concepts are creatures of entanglement. When it comes to perception, consciousness, love, sex, memory, the body, there are no fixed points, no settled places to begin or ways to move forward. Here is another way to put the problem: in the would-be sciences of the human, in contrast with physics, say, we never quite know how to stabilize the subject matter.

But now I have been insisting that physics too is entangled. Which shouldn't be a surprise. Concepts of the physical world such as *object, space, time, force*—these are *our* concepts too, excavated, as Husserl might have said, from the fertile soil of our lifeworld. But then, we must ask, what stops the aesthetic character of the human from seeping into natural science and doing damage there? What allows physics, unlike psychology, to be positive?

Now, there is *seepage,* and there is its mere possibility; the former may be dangerous, at least for the amenability of a question to natural scientific treatment; the latter is harmless, and in fact necessary; indeed, it is a condition of the very possibility of science.

To appreciate this, let's stay with Collingwood's characterization of science as a "going concern," that is, as like a profitable

and well-run business or operation.[11] This is an instructive meta-
phor. For one thing, it puts us in mind of the concrete, anthro-
pological, lived reality of science as a human undertaking. For
another, it lets us appreciate that there is nothing made-up or
"conventional" or merely relative or subjective about the fact of
its success. We know exactly what we mean when we say that a
business is successful, just as we know exactly what we mean
when we say that science works. Science delivers understanding
and actionable information. Science cures diseases and sends
people to the moon, and so on. But the success of a business,
here and now, is no guarantee of future success; indeed, the very
possibility of success, it would seem, depends on risk-taking and
the possibility of failure. And so with science.

Now science does work, and it works not despite the fact
that it is grounded in human life, which is problematic and the
stuff of aesthetics and philosophy, but thanks to this fact. Con-
sider that science is, actually, in continuous negotiation with its
own philosophical origins. I don't have in mind primarily facts
about the explicit thoughts and attitudes of scientists, or the
sociology of science itself; nor do I have in mind such historical
considerations as that natural science in fact took shape as, if
you like, a philosophical subculture, and that "scientific
method," if there really is such a thing, is a philosophical
method.[12] Nor even that science has conceptions of its own
history, written down in textbooks, that typically frame the
work of science against a background of a theory *of theory* as
something that has evolved, perhaps thanks to revolutions, out
of past theory. I mean something much more straightforward.
Scientists actually do philosophy, even if they do not typically
call it by this name, and even if they do so only exceptionally.
Einstein's reflections on simultaneity in special relativity are phi-
losophy; indeed, as Wittgenstein noticed, they are grammatical

investigations, that is, explorations of what it makes sense to say about, in this case, simultaneity. Debates about the interpretation of quantum mechanics, and about the unification of quantum mechanics and general relativity, have a broadly philosophical, that is to say, aesthetic shape (in my sense of "aesthetic"). Similarly, it is hard to see the study of time in cosmology and such questions as whether the Big Bang might not in truth have been a Big Bounce, as distinct from philosophical investigation.[13] Here is another example: String Theory raises the prospects of a "postempirical" science, which is perhaps philosophy by another name.

Now the interesting thing about examples such as these is that the philosophy arises *inside* the science and *for* the science. This is why I say that science is in negotiation with its own fragile origins in the human effort to make sense and understand. But what is equally interesting and important to stress is that the quasi-philosophical, interpretive character of some problems in physics does nothing at all to diminish physics overall, or to threaten, as it were, such established findings as, for example, that gold atoms have a given atomic number. This latter claim is true, and there is no standpoint *outside of science* from which we can offer meaningful criticism of such utterly secure facts and findings. For example, it would be nonsense to argue that gold doesn't really have the atomic number 79, because, after all, science is a particular cultural phenomenon. That's just a non sequitur, like arguing, on similar grounds, that a song isn't really in the key of A-minor.

It is helpful to think of physics as oscillating between two poles. The first pole is techne; when physics is at this pole, it is a domain of clear questions and answers, a zone of unproblematic intelligibility. The other pole is philosophy, or art, the zone of the aesthetic attitude, where the good questions are the ones

that are never quite decidable. When the seepage is great, you get a movement to the philosophy pole. This is where we might wonder about the emergence of time, or such questions as whether the Big Bang was not in fact a Big Bounce. But when we are concerning ourselves with the atomic weight of atoms of gold, or iron, we swing toward the other pole. Here interpretative questions get no purchase. The point is that physics is always related, more or less, to one pole or the other. Now crucially this entanglement of physics and philosophy inside physics is like the entanglement of art and design inside design. In and of itself, this entanglement does nothing at all to impugn the truth of scientific findings; and in the absence of such entanglement, there would be no science at all.

DREYFUS AND ROBUST REALISM

Some argue that if science is embedded in culture and entangled with art and philosophy, if it is a human activity, then this undermines science's claims to be genuine knowledge. At best, science is no better than religion, just another practice with its own arbitrary ontology.

But why say this? Just the opposite is true. In order to hit the target with my bow and arrow, I need to do something, to take aim and concentrate. The fact that I am an embodied person, embedded in a culturally rich situation, is no obstacle to my sometimes succeeding. In fact, it is that embedding that supplies me not only with the physical means—the bow and the arrow, and the training—but also with the motivation to hit the target in the first place. Science and perception too are similarly human activities that aim at secure knowledge of the world.

Human life supplies not only our targets, but the whole skein of meaningful connections and involvements thanks to which

questions and targets and bows and arrows and doings of any kind are even intelligible. But there's nothing relative, subjective, merely conventional, or fictional in the least about whether I manage to hit the target. Dreyfus, whose development of related ideas is my focus in the next pages, gives the example of the hammer and the wood and iron it is made from.[14] The former is a cultural object, but the latter, the wood and the iron, these have a nature independent of the way that they are deployed by us. We can hit the cognitive target and come to understand this nature, or we can fail to. Our drive to do so reflects something about us. Questions about wood and iron, these are our questions, after all. But whether we manage to hit the target, once again, this has to do with what we accomplish in relation to the physical world itself.

It is possible, then, according to Dreyfus, to appreciate that science is a human undertaking while at the same time endorsing what he and Charles Taylor call a "robust realism" about the natural world, for example, such things as gold, iron, wood, and so on. Let's look more closely at this view.

Dreyfus proposes that what he calls "skillful coping" is our basic, ground-level, primordial orientation to the world. We achieve uprightness in gravity not by thought, nor by analysis, not thanks to language, or culture, but by a kind of bodily mastery, a responsiveness to gravity itself. This, then, is the paradigm of human expertise and thriving across the board. The competent human being is one who is oriented in such a way to the world that the world, as it were, makes the hard decisions for them. We don't have to *think* about where to stand when we are talking; we spontaneously find ourselves drawn to the right spot, and so throughout our lives. Skillful coping is the achievement of *optimal grip*, and this in very diverse areas of our lives. The chess player, the one who is truly a master, that is, lets the

board speak; the situation on the board solicits the next move. Building on Heidegger, as well as Merleau-Ponty, for Dreyfus the basic modality of the way that the world shows up is its unthought readiness-to-hand.

An interesting thing about this skillful-coping orientation to the world is that it defies explicitness and articulation; it is a zone of feeling rather than thought, one in which we are guided, in what we do, by a *felt-sense* for what is right,[15] or by a primitive sense of fit,[16] or by a sense of tension that is released as we approach the optimal. And it is this fact that explains, for Dreyfus, why there are limits on what can be accomplished by a science of the human. Human affairs are situational; they are contextual; and so they resist being made explicit or set forth. To do so would be to distort and alter our primordial relation of engagement.

Thought, as well as *perceptual consciousness* of objects, these are achieved, for Dreyfus, by interruption of our skillful coping, our merely felt tendency to optimal grip, and by the achievement of a "detached attitude" to the world and our situation. What happens when you detach is that, in Heidegger's phrases, you *de-world* or *de-contextualize*.[17] You loosen the dependence between what things are and the context in which you and they are embedded. Detachment disrupts what Husserl called the lifeworld, but it opens up a zone of presence, that is to say, the universe thought of as a zone of entities and also processes, about which we can take up a scientific attitude.

For Dreyfus, Putnam's and Kripke's analysis of reference and the meaning of "natural kind" terms is a resource for explaining how our social practices and cultural embedding can support realism.[18] Thought and talk about water, say, may be guided by our culturally determined and, as it were, accidental *conception* (or stereotype) of what water is—for example, that it is the

liquid that flows from taps, fills reservoirs, has a certain look and taste, and so on. But this conception, however much it governs how we think and talk, serves only to narrow in on and pinpoint the reference of what we are talking about. Once we have actually fixed reference—once we've zeroed in on water itself, in the form of an actual sample—then we can leave it to the world, to reality, to fix the nature of the real object of our thought and talk. We are talking about H_2O even if we've never heard of H_2O, and even if, in fact, we have yet to discover the molecular structure of water, or because we are ignorant of such discoveries. Again, there would be no *interest* in water, no water-thoughts or water-talk, no *problem* of the nature of water, and no theories about water, if not for us human beings. But water's nature is independent of us.

Such a view not only reconciles the fact that science is human with a realistic account of science, but it does so in a way that may also explain why we have been *un*able to achieve scientific results when it comes to the human domain. Unlike water, we ourselves resist explanation, *for we resist being made present-to-hand or merely occurrent.*

A striking feature of Dreyfus's account—I am not sure whether this criticism would extend to Heidegger and Merleau-Ponty—is that it may fail to make room for the phenomenon of entanglement, and with important consequences.

Confining our attention to the supposed ground level, Dreyfus tends to neglect the inescapably fragile character of the world's presence, as well as that of our skillful engagement with it. There is no optimal grip, not really. Or rather, the optimal grip is a problem, an ideal maybe, but always only something ever partially achieved. The most skilled player bumbles, finds themself needing to wonder what the situation on the board solicits; and the most experienced hiker may fall. These are not

breakdowns, disruptions to ground-level flow and skillful coping, but are themselves just varieties of such coping. They are little thoughtful moments, Husserlian mini-epochés, which punctuate our ordinary engaged lives. We are already entangled at the ground level.

Which does not mean that we do not respond to the world, or that we do not achieve, if you like, an "openness" to it. But it does mean that even in our everyday lives we do not escape the aesthetic, the need to do the work of looking and even striving to bring what there is into focus (to make what there is be there). And the same is true, or a variant of the same point is true, for science. Science too will be a blending of "access" and "occurrence." We don't *see* quarks, true, but this doesn't imply that we have no real access to them. As a comparison, we don't *see* the emotions of another person, but we are surely directly aware of them. They are not posits, but features of the landscape that immediately show up for us. They are ready-to-hand. But theoretical entities are sometimes like this too. We can have genuine access—for example, by relying on them—to merely theoretical entities.

Dreyfus is right, with Heidegger, to emphasize the difference between readiness-to-hand ("access") and presence-to-hand ("occurrence"). But these are not stable zones of difference, but problematic tendencies that always require negotiation and that exist only in the setting of entanglement and fragility. Everything shows up not as one or the other but as, rather, a kind of shuddering fluctuation of readiness-to-hand and mere presence. The hammer is never only ready-to-hand, and correspondingly, the electrons in the hammer, no less than the wood or metal it is made out of, are never only entirely hypothetical. This is really just to reformulate what I have been insisting all along: that there is no such thing, finally, as an unself-conscious,

merely habitual, first-order activity (whether of looking, walking, dancing, talking, whatever). And this is because of entanglement. The second order resides within the first order as one of its live possibilities, rather like the tonic of its harmonic variations. Which does not mean that we are hyperintellectual slaves to reflection. What it means is that thought and action, mind and life, are entangled. Thoughtfulness is one of our *engaged* modes of orientation to the world and is not the child of detachment. And crucially, the *shuddering fluctuations* of what there is—things now show up this way, now that way—is our basic, our problematic, situation.

HOMO PHILOSOPHICO-AESTHETICUS

Dreyfus's "robust realism" seems to play on our readiness too sharply to segregate the zone of the unproblematic operations of immediate intelligibility from that of detached reflection. The first zone gives us the *world*; the second zone opens us up to scientific reflection on a mind-independent *universe*.

But what happens when these zones collapse toward each other as a consequence of entanglement? Or better, what happens when we acknowledge that each zone is a kind of thematic variation on the other, and that our situation can't be segregated in this way into distinct zones at all, again because of entanglement? What happens when we allow that our predicament is, finally, aesthetic?

Under these conditions, we don't lose the availability of different stances—the engaged and the detached, the thoughtless/habitual in opposition to the thoughtful/deliberate—we just need to accept their basic fragility and also, then, the fact that our reflective project of differentiating them itself resists fixity; to make these distinctions about our different modes of

being in the world is to participate in a kind of aesthetico-philosophical exercise.

This criticism extends, I think, to Putnam and Kripke as well. The idea that we can segregate in a definitive way "what we are talking about" from our contingent, and maybe quite messy and unsystematic, concepts, ideas, images, and stereotypes about what we mean, is dogmatic. The problem with the idea that our names for substances like water attach to them directly, rather like tags, is that there is no such tagging, there are no tags, and the samples that we use to explain what we mean belong, not to the domain of reference, but to our language itself.[19] We can *say* that there is no possible world in which water isn't H_2O—whereas there are possible worlds in which water isn't the liquid that flows in our rivers and lakes, etc.—but this is just to outline our own normative commitments; it is not, as it were, an insight into reality.

So much for "robust realism," or what Putnam called "natural realism." But crucially, none of this adds up to a good reason to *deny* the reality of anything, and in criticizing these ideas I don't take myself to be advancing anything like an antirealism. Water *is* H_2O; gold *does* have an atomic weight of 79. The truth of these claims does not depend on a corresponding philosophical interpretation of our metaphysical situation, neither that of Dreyfus, nor that which is developed by me in these pages.

But what does come under fire from these considerations here, perhaps, is Nagel's picture of a complete and unified science of everything, including us. Everything speaks in favor of the atomic weight of gold. But nothing at all speaks in favor of the idea that facts about human life and consciousness should fall out, as it were, from the same theory that tells about gold's atomic structure. Where our lives are stake, when we are at that pole of the science/philosophy oscillation, natural science goes

silent. But that does little to take away from the vigor, reliability, and truth of what science has to tell us when are working at the opposite pole.[20]

SCIENCE AND IRRATIONALITY

In legal proceedings, there are very specific rules of evidence and rules governing who may speak, how they may speak, and what kinds of statements that they are permitted to make. A defendant in a criminal proceeding, for example, is not allowed in open court to say what he or she thinks about the charges against him or her. Ordinary rules of conversation and discourse are put in abeyance; special rules are enforced. It is no argument against the legal way of doing things to say that such rules and procedures are, as it were, artificial, esoteric, or odd. For it is just those odd and artificial procedures that sustain the special sort of confidence and authority that we are willing to ascribe to legal proceedings.

Science is a bit like this too. In the lab itself, there may be a free-for-all of conversation, brainstorming, invention, argument, and creative expression. But all this gets screened off through the imposition of what, following Strevens, we can call the Iron Rule of Explanation, roughly, the idea that, in publication for example, only statements made with experimental support will be allowed.[21]

Both science and the law get their start, in a way, by cordoning off the normal everyday rules of rational exchange and conversation. They proceed by setting up novel "language games." There's nothing metaphorical about this. But it means that there is something obstinate and in a way even irrational about science and its method.[22] Science starts with the refusal to play by ordinary rules of reasonableness and rationality, the rules that

operate in our everyday lives. If one were to try to live by the rules of science, or the law, in ordinary family or work life, or for that matter, in the back office, studios and labs of scientists themselves, one would rightly be viewed as foolish and insensitive, irrational and unreasonable.

But now we come to the crux: We are ourselves aesthetic phenomena through and through. To eliminate the unsettled, the undecidable, the uncertain in the domain of the human would be like trying to do so in the domain of art. And so science bumps up against a kind of contradiction when it seeks to make us, we ourselves, its very topic. The kind of line-drawing, precisification, and evidence-only based reasoning that serve so well in science, indeed, that lets there be a science, can have no meaningful application to human being as a phenomenon; it can only serve to distort it, and indeed, to do so arbitrarily. Instead of bracketing the aesthetic, what is required, if we are to know ourselves, is that we plunge into the aesthetic.

The upshot of these considerations is that seepage is the precondition of natural science, and not any threat to it. Our entanglement—the fact that natural science and philosophy are themselves entangled, and that the aesthetic permeates human life—is less an obstacle to natural science, than the bed in which it can take root and blossom.

12

NATURE AFTER ART

Poetry is a name we use to discount what we fear to
acknowledge.

—CHARLES BERNSTEIN

CREATURES OF OUR OWN CREATION

What happens when you present a different visual stimulus to
each eye, say a face to the left eye, and a house to the right? In
the 1990s, this question was thought to provide a way forward
for scientific research into the neural correlates of conscious-
ness.[1] Instead of experiencing a merging or blending of the
house and the face, it was observed, we experience an alterna-
tion, now house, now face, now house, now face. The dynamics
of these fluctuations were nonvoluntary, and they seemed to
reflect a competition between the two mental representations—
face and house—for dominance in consciousness. Now some
of the activity in the brain that takes place during this sort of
episode corresponds to each stimulus and can be thought of as
the representation of a house or a face, as the reasoning went.
But some of the activity will correspond, rather, to the move-
ments of these representations in and out of consciousness. In
this way, it was hoped, we could use binocular rivalry as a scal-
pel to uncover the place in the brain where consciousness, the

experiential lighting up of now one representation, now an-
other, itself happens.

The problem with this line of thought, as Evan Thompson
and I argued, is that it rests on a misdescription of the experience
of so-called binocular rivalry.[2] Instead of looking at and paying
real attention to the experience, they assumed that it conformed
to their prior model of what it must be like. In particular, they
ignored the fact that the experience of rivalry is itself a positive
phenomenon in its own right, not merely a state of shifting back
and forth between two other autonomous perceptual states, that
is, the house-state and the face-state.[3] To experience the rivalry
is not merely for house-seeing to alternate stochastically with
face-seeing, but rather, for a unique, whole experience of some-
thing special, the distinct quality of instability and fluctuation in
visual consciousness. The experience of rivalry can't be factored,
as it were, into a temporal series of A- and B-experiences, but
rather consists of something like a temporally extended experi-
ence of active A/B-meta-instability.

It is useful to compare this kind of genuinely weird and fluc-
tuating type of visual episode with what happens when you look
at an ambiguous figure, such as Jastrow's famous duck-rabbit.
Here too you experience a rivalry between the two ways of see-
ing the drawing, and here too, once you have experienced what
Wittgenstein called the "aspect-shift"—the flipping from duck
to rabbit, or rabbit to duck—the possibility for subsequent as-
pect shifts stays alive in your seeing; you now experience the
figure as actively ambiguous. To have this experience of rivalry
is to be in a third state, the state of just letting the fluctuations
happen. And this state is distinct from the series of states of
merely seeing one figure, then another; it is the experience of an
unstable ambiguity, which has its own distinct character. The
experience of an ambiguous figure is a kind of experiential unity,

rather than the experience of something compounded out of experiential parts.

These considerations suffice to undercut the arguments about neural correlates of consciousness. For one can't factor the global event into components, for example, one component corresponding to the duck or the face, another to the rabbit or the house, and a third corresponding to whatever makes one or the other of these conscious. What one is stuck with is an event in consciousness whose different aspects don't merely alternate but interpenetrate and co-inform each other. We experience the *rivalry*, the instability, *the resistance* of the different possibilities itself.

Now *all experience* shares with these experiences of rivalry what I will call *passive resistance*. Consciousness is dynamic and multiple in just this way; it is compiled out of consciousness's own resistance, its own seeming autonomy. We inhabit our experiences, if we let ourselves pay attention, much as we might inhabit stormy waters; we are buffeted this way and that.

Let's take a closer look at this. Consider that everything that shows up for you—this object, that color, these sounds, or odors, or people, or whatever—shows up only ever as the merely facing side of something whose true being exceeds what you can directly know. Things come into view, as you move, but they also go out of view. The disclosure of what there is to our curious explorations is never more than a moment of their closure. This is true of things, such as these trees, whose bodies exceed what we can be taken in at a glance. But it is also true of qualities, such as the brown of their bark; the color too has structure, hidden aspects and dispositions to disclose and unfold as we move, or as the light changes. No thing, and no quality, is so simple as to exhibit true uniformity or manifest sameness. Indeed, just the opposite is true. Every quality, even the most

atom-like we can imagine, is infinitely variegated. There is spatial extent, texture, shadow, interaction with the surroundings. All we can ever know is the aspect, and the aspect always implicates or refers to not only the hidden body, but the unattended landscape, the whole, boundless situation.

The work of consciousness, the work of perception, is never done and is always partial, unfulfilled, incomplete. Like the swimmer adrift in rough waters, we act—we look, we explore, we see—but what we accomplish is less the product of our agency on its own, than it is the product of our circumstances.

Suppose you are walking on a winter's day in a forest. The trees rise up, thin and hulking, reaching high, bare, their dendrite-like branches scratching toward the sky. They are a mass, a mess, a tangle. But some trees separate themselves from the mass; they integrate themselves before your eyes, standing forth from the general tangle. The tendrils are united into the bodies of single trees as against the background of the mess of tangled branches. At one moment there is a merging indistinctness, but at the next, the trees articulate themselves, or achieve a certain definiteness. You don't think any of this out. You don't reason from similarity of color and shape to the integrated attachment of parts. It is rather that the trees make themselves up before your eyes, or they announce themselves. At one moment there is just a film of trees and tree parts, and at the next moment they are free and whole and individual.

This example, which is adapted from Merleau-Ponty, brings out forcibly that even in the episode of looking and seeing itself there is a kind of dynamism, a push and pull, a coming in and out of focus.[4] None of this is our doing, as if it were the fruit of agency. We encounter these forces *inside* consciousness itself as we encounter physical forces in the environment around us. These are natural forces. This is nature in mind.

This is nature right at home. This is resistance in us. This is *our* nature.

Experience itself, then, is an encounter to and adaptation to (our) nature. For what is nature but that which is *before* us, apart from us, exceeding, constraining, and finally *resisting* our will, our intention, our impulse, and our curiosity?

But now we get to the crux. For this encounter with nature as manifest in the form of the most familiar passive resistance— the shape of conscious experience itself—is an aesthetic encounter. This is the very paradigm of the aesthetic. As I have been urging, it is a mistake to tie aesthetics too tightly to what we like, or the pleasures or enjoyments of perceptual appreciation. There is such a thing, of course, but this is an epiphenomenon. The aesthetic names the ever-ongoing process of bringing what there is into an always fragile focus; it is the movement, always subject to second-guessing, from not seeing to seeing, or from seeing to seeing differently. The aesthetic is the fragile, productive (but also entangled) enacting of our consciousness itself.

We both enact and encounter nature and ourselves, ourselves as natural, everywhere and always. Consciousness is an aesthetic phenomenon, and the aesthetic is our first, most immediate introduction to a nature, a reality, that outstrips us. But it is the encounter, at one and the same time, with a nature that also includes us, an encounter with what we are, with our nature.

If this is right, then our own experience—the basic challenge that we face, from the beginning—is an aesthetic one, indeed, in a way, an artistic one. "The puzzle of puzzles, and that we call being," as Walt Whitman dubbed it.[5] We make ourselves. We organize ourselves. And we do so, in part at least, by representing ourselves to ourselves. This representing is fragile: it never

evades the rivalry, the availability of the aspect shift, or the second guess. It is productive: it is the work of self-making and also world-making, for we change ourselves and change what is there for us in the very act. And it is entangled, for we do all this always against the background of the situations in which we find ourselves including, as it does, everything that has come before, including all our past self-representations.

It may be true that we are guided by a striving for optimal grip, as Dreyfus has said—or by a feel for what fits, what is right, by a kind of primitive normativity, in Ginsborg's phrase.[6] But what fits or feels right is only provisional, and optimal grip is in the end elusive.

Now *art*, and in other domains, *philosophy*, is our authentic response to this aesthetic confrontation with resistance, that is to say, with nature. Every work of art explores a channel of our mental activity. Every work of art puts that productive but fragile movement whereby we bring the world into consciousness for perception into focus for consciousness itself. All the fluctuations and movements and mergers and dissolutions characteristic of ordinary consciousness, all this is art's material.

When we talk about art and philosophy, we naturally think of the art world today and academic philosophy with their history. But art and philosophy are more primordial than that. For art is also the very work of consciousness itself. Art is our most direct grappling with the aesthetic reality of our own nature and that of nature itself. Art is our surmounting of the pregiven resistance of being. Art is the achievement of the tree and the achievement of our relation to the tree. Art is the invention of seeing, and the invention of language.

It is sometimes argued that art is grounded in the laws of the brain and that art is natural for this reason.[7] But this gets things backwards. The aesthetic attitude (art and philosophy)

is presupposed by and taken for granted when the neuroscientist theorizes. The aesthetic attitude is more basic than science, more basic even than the practical struggle to survive that motivates the animal to bridge the gap between here and there so that it may consume or consummate, or that drives us to build shelter from rain, wind, sun, and cold.

I reflected, in the last chapter, on Nagel's picture of a scientific theory that encompasses not only the physical world, but everything there is, including life and including consciousness. Now we can begin really to understand why this is an infertile hope. It isn't just that we cannot hold ourselves fixed for the purpose of explanation or reduction. It isn't just that we are aesthetic puzzles admitting of no final resolution. The point is that all consciousness, even that of the natural scientists themselves, is beset by the kaleidoscopic shifting and merging, by nature's own resistance. We are questioners by nature; answers just get in the way. The aesthetic attitude is the first attitude as well as the last attitude.

Our primordial and most authentic relation to nature, as to ourselves, is aesthetic. And this means that experience is a kind of poetry. It is creative, and we are its sustaining, fragile production. This is not an obstacle to scientific knowledge, and it is no cause for doubts, not about trees, other people, or black holes. We achieve the world through organized activity, and we are this very process of achieving.

ACKNOWLEDGMENTS

I subscribe to the view that philosophy isn't in the knot-making business; it is in the knot-untying business. Sometimes, though, you need a philosopher to show you that you have a knot you didn't know about. This is one of the reasons that philosophy, if it is serious, always begins at the beginning and strives to avoid technicality and anything that pretends to be settled, artificially clear, or already established. Other than curiosity, philosophy's only other requirement is patience and a certain dexterity of the fingers.

The word "entanglement" does not occur in *Strange Tools*. However, within weeks of its publication at the end of 2015, I began to use this term to capture what, I soon came to realize, was that book's central concern: how art loops down and changes that of which it is the representation and how this is productive and potentially emancipatory. *The Entanglement* is, then, a sequel. But really, it makes a new beginning, and it ends up covering very different ground and ending up in unanticipated places.

This book is written with the liveliest sense of Hubert L. Dreyfus's presence to memory, and it is dedicated to him. Our conversations, during the last fifteen years of his life, got me started on some of the themes that I explore here. I wrote the first draft of the book during the pandemic of 2020–2022, but often I had in mind ideas that had come up during a seminar on "The Nature of Nature" that he and I had held jointly in

Berkeley in the spring of 2014 (with Klaus Corcilius, B. Scot Rousse, David Suarez, Evan Thompson, and Lawrence Weschler in attendance, among others).

I taught a seminar on "Questions of Style" with the art historian Alexander Nagel in New York City in the fall of 2011 (jointly at the Graduate Center and the NYU Center for Fine Arts). Some of the questions and inspirations of that seminar inform this book as well. Alex also read an earlier draft and offered criticism for which I am grateful.

The enthusiasm and energetic criticism of art critic and historian Blake Gopnik has been of great benefit to me; I am grateful; my experience writing the book would have been very different if not for his lively curiosity and support.

I encountered the work of J. Reid Miller only in the final stages of writing *The Entanglement*. And yet this encounter supplied me with a better sense of the scope of my own project and has had an influence on the final version. I am indebted to him.

Many friends, students, and colleagues have helped me with the work that has gone into this book, and it is a pleasure to have this opportunity to name them, and thank them, even if it is also too difficult a task to really do justice to their various contributions. And while it is my own limitations that define this book, I am happy now to express my gratitude, in addition to those already named, to Dr Eva Lucia Backhaus, Scott Cowan, Professor Bengt Molander, Professor Andreja Novakovic, Dr. B. Scot Rousse, and Dr. Jochen Schuff. Thanks to Micah Dubreuil for valuable discussion and for his assistance in the final preparation of the manuscript, and also to Elek Lane for preparation of the index.

I have learned a great amount from critical exchange on some of the ideas in this book with Professors Georg Bertram, Horst Bredekamp, Noël Carrol, Whitney Davis, David Davies, Stephen Davies, Anne Eaton, Luca Giuliani, Daniel M. Gross,

Paul Guyer, Edward Harcourt, Chris Hutton, John Hyman, Michael Kremer, Thomas Leddy, Warren Neidich, Carrie Noland, Ezequiel di Paolo, Jesse Prinz, Thomas Rickert, Nancy S. Struever, Talbot Taylor, Jürgen Trabant, Tullio Viola, and R. Jay Wallace, as well as Dr. Scott Delahunta, Debra Hay, William Forsythe, Dr. Sabine Marienberg, and Lawrence Weschler. Thanks to the artist Karen Schiff for introducing me to the Oscar Wilde quote that serves as the epigram to chapter 4.

I am grateful to the members of my "Friday Group" at Berkeley, including, in addition to some already mentioned, Greyson Abid, Emanuele Andreoli, Ayoko Ariuchi, Dr. Caitlin Dolan, Jes Heppler, Dr. Gabrielle Jackson, Joseph Kassman-Tod, Robert de Meel, Teague Morris, Robert Reimer, Dr. Marjan Sharifi, Dr. David Suarez, and also to other Berkeley students who have generously engaged with my writing, including Deimy Chavez, Katie Coyne, Chris Kymn, Tom Kozlowski, Henry Schmidt, Caroline Eliane Simon, Coleman Solis, Alina Wang, and Jianqiu Yang.

Special thanks to Dr. Mariel Goddu for her friendship and support.

I am grateful for the support of Rob Tempio and Matt Rohal at Princeton University Press.

Finally, I could not have written this book without the support of my family. Deep felt thanks to my wife, Nicole Peisl Noë; my sons, August and Ulysses; my daughter, Ana; my brother, Sasha; and my father and mother, Hans and Judith.

As indicated in the endnotes, parts of chapters 3, 4, and 5 have been adapted, with permission, from other published writings, which I list here:

Noë, Alva. (2016) "Newman's Note, Entanglement, and the Demands of Choreography: Letter to a Choreographer."

In *Transmission in Motion: The Technologizing of Dance*, edited by Maaike Bleeker, 228–236. New York: Routledge.

Noë, Alva. (2017a) "Art and Entanglement in *Strange Tools*: Reply to Noël Carroll, A. W. Eaton, and Paul Guyer." *Philosophy and Phenomenological Research* 94, no. 1 (January): 238–250.

Noë, Alva. (2017b) "The Writerly Attitude." In *Symbolic Articulation: Image, Word, and Body between Action and Schema*, edited by Sabine Marienberg, 73–87. Berlin: De Gruyter.

Noë, Alva. (2020) "On Alva Noë, *Strange Tools. Art and Human Nature*. Precis and Reply to Critics." *Italian Journal of Aesthetics / Studi d'Estetica* 48, no. 4: https://doi.org/10.7413/18258646144.

Noë, Alva. (2021a) "Entanglement and Ecstasy in Dance, Music, and Philosophy: A Reply to Carrie Noland, Nancy S. Struever, and Thomas Rickert." *Philosophy & Rhetoric* 54, no. 1: 64–80.

NOTES

PREFACE

1. My subject matter in this book is not what Einstein called the "spooky action at a distance" characteristic of the behavior of quantum particles. Nor am I using the term "entanglement" as it has been deployed by computer scientists to capture the fact that technologies today have come to exceed in their complexity what it is possible for a person to grasp. This conception of entanglement, due to Danny Hillis, is discussed in Arbesman 2016. Closer in spirit to what I am undertaking here is Malafouris's "material engagement theory" (Malafouris 2014), and Hodder's theory of entanglement (Hodder 2012), both of which explore how things, tools, technologies, and material culture are bound up with human cognition, social organization, and, indeed, evolutionary origins. I admire this work—which can be thought of as developing variations on the theme of the "the extended mind" (Clark and Chalmers 1998; Clark 2008, but also Noë 2009 and Noë 2015b)—but as will become clear, my focus here is different (even if it is also complementary).

CHAPTER 1. ART IN MIND

1. Collingwood 1924, 52. Thanks to Nancy S. Struever (2020) for drawing me to the importance of Collingwood's writing for my own project.

2. Collingwood 1925, 14.

3. See Plato's *Meno* in Plato 1981.

4. Augustine 1995.

5. Organized activity is a central theme of *Strange Tools* (Noë 2015b), especially chapters 1–4.

6. Hacking 1999. "Looping" plays a central role in Hacking's thought and has served as a resource for me. The concepts we use to categorize ourselves don't merely sort us into groups, but also supply us with resources for realizing membership in the category. I return to this idea more directly in chapter 8. For now, I note the kinship between Hacking's conception of looping (concepts and effects) and my idea that art loops down and changes that of which it is the representation.

7. A similar understanding of "incorporation" animates Di Paolo, Cuffari, and de Jaegher's 2018 *Linguistic Bodies*. I return to this in a later note.

8. See Gopnik's (2020) biography of Warhol for excellent discussion of this.

9. George Bertram (2019) develops the idea that art is a reflective practice. There are numerous points of contact between his ideas, first published in German in 2014, and my own.

10. Davidson 1982.

11. Hilary Putnam (1992) makes a similar claim: evidence is thin that animals care about being right as opposed to being merely successful. Evolutionary approaches to cognition don't seem to have resources to keep apart this difference. Linguist Geoffrey Pullum once said to me (in a personal conversation when we were both at UC Santa Cruz) that the thing about apes, even the most symbolically adept ones, is that you never get the feeling that they are just dying to tell you something. This is right, it seems to me, and telling.

12. Isn't it possible to talk in the absence of writing? Wasn't there talking before writing? This is my topic in chapter 5. My answer, in brief, is that although you can talk without writing, you can't talk, that is to say, there is no language, in the absence of the way of thinking about speech that is made explicit in writing systems (the writerly attitude).

13. Davis 2011.

14. John 1:1.

15. Hurley 1998.

16. See Brown's *The Body & Society* (1988/2008) for discussion of some of the Biblical themes touched on here. On Augustine in particular, see pages 404ff.

CHAPTER 2. DOMESTIC ENTANGLEMENTS

1. See Boyd 2018; Henrich 2016.

2. Among philosophers, this idea is championed by Daniel Dennett. See Dennett 2018 as well as Dennett 1995.

3. Haraway 1991; Clark 2003.

4. On this use of the term "scaffolding," which I like very much, see Sterelny 2010.

5. See Caruana and Testa 2021 for a helpful review of recent work by philosophers and cognitive scientists on habit.

6. On this theme, see Noë 2015b; Malafouris 2014; Hodder 2012.

7. This is the central theme of Bertram's *Art as Human Practice* (Bertram 2019).

8. As reported in Brumm et al. 2021.

9. Hacking 1999.

Chapter 3. Dance Incorporate

1. Organized activity is a main theme of *Strange Tools* (Noë 2015b).

2. Barbara Montero has explored the ways expertise and skill leave room for and are sustained by reflection; see especially Montero 2016.

3. As examples, we might mention the avant-garde dance associated with the Judson Church, including, among others, Yvonne Ranier, Steve Paxton, Deborah Hay, but also Lisa Nelson. For a different, more contemporary example, consider the work of Jérôme Bel.

4. Here I am thinking of Tina Fey's character from *Thirty Rock*, Liz Lemon, who would frequently burst out into mock-dance, putting her cultural sophistication on display.

5. This notion of incorporation, which is critical to my understanding of entanglement, figures prominently in Di Paolo, Cuffari, and de Jaegher (2018), as noted earlier. They contrast "incorporation" with related but different notions of "incarnation" and "embodiment." Their focus is language, in particular on the "tension between the self-assertion of embodied agency through the engagement with its sociomaterial world and the assertion of social, interactive paths that reproduce ways of being human and that incarnate in human bodies" (212). To put things as they might, we achieve our individuality by incorporating a sociomaterial world and paths over which we have no direct control; we become more our selves by connecting with the larger community.

6. Carrie Noland (2021) has made this interesting criticism of my general position.

7. The idea that philosophy aims at "reorientation" is a constant theme throughout Husserl (1945/1970), as for example when he speaks of the "reorientation of the epoché" (176). See chapter 10 below for further discussion.

8. Blake Gopnik (2009) explores the way Dutch landscape and cityscape painting manipulates viewers' position in relation to the canvas.

9. Dreyfus (2005/2014) and Sean D. Kelly (2005) develop these themes of normative tension and striving for an optimal vantage point in their reading of Merleau-Ponty.

10. Dewey 1934.

11. Forsythe explores the notion of a "choreographic object" here: https://www.williamforsythe.com/essay.html.

12. This chapter reworks material previously published in Noë 2016, 2020, 2021a.

Chapter 4. Styles of Seeing

1. See Eaton 2017 for a further exploration of this point.

2. As an aside: pictures, in the appropriate rhetorical setting, frame your attention; they solve the problem of what to pay attention to. This is one of the reasons why dance on film is a creature of a totally different nature than dance witnessed live. When watching dance live, you need to decide what to look at, and some of the work of the choreography is precisely to activate the spectator's attention. The director, or the camera, makes this decision for you, however, when you watch dance on film. (Dance *for* film is a different matter yet again.) I take up this last point in Noë 2021b.

3. This section of this chapter is adapted from Noë 2017a.

4. Hollander 1978.

5. Hollander 1978, 391.

6. Brontë 1847/2007, 117–118. Here is another passage from later in *Jane Eyre*: "Leaning over the battlements and looking far down, I surveyed the grounds laid out like a map; the bright and velvet lawn closely girdling the gray base of the mansion, the field, wide as a park, dotted with its ancient timber; the wood, dun and sere, divided by a path visibly overgrown, greener with moss than the trees with foliage; the church at the gates, the road, the tranquil hills, all reposing in the autumn day's sun; the horizon bounded by a propitious sky, azure, marbled with pearly white. No feature of the scene was extra-ordinary, but all was pleasing. When I turned away from it and repassed the trap-door, I could scarcely see my way down the ladder; the attic seemed black as a vault compared with that arch of blue air to which I had been looking up, and to that sunlit scene of grove, pasture, and green hill of which the hall was the centre, and over which I had been gazing with delight" (125–126).

7. The phrase "surreptitious substitution" is due to Husserl. In *The Crisis of the European Sciences* (1954/1970, 48ff.), Husserl argues that Galileo surreptitiously substitutes a mathematized conception of nature for the ordinary world in which we reside (the life world).

8. Strawson 1979, 44.

9. Strawson 1979, 43–44.

10. Strawson 1979, 53, 54.

11. Here is philosopher John Campbell on views: "We have the ordinary notion of a 'view,' as when you drag someone up a mountain trail, insisting that he will 'enjoy the view.' In this sense, thousands of people might visit the very same spot and enjoy the very same view. You characterize the experience they are having by saying which view they are enjoying. On the Relational picture, this is the same thing as describing the phenomenal character of their experiences" (2002, 116).

12. These lines come from the first episode of the British television series *Agatha Christie's Poirot*, "The Adventure of the Clapham Cook."

13. This idea of the prejudices of the world (or *préjugés du monde*) is a central theme of Merleau-Ponty's *Phenomenology of Perception* (Merleau-Ponty 1945/2012).

14. Gibson 1979; Heidegger 1929/1962.

15. There are other conceptions of objecthood and other routes to the framing of the concept of an object that do not work from pictures. Frege, for example, argued that numbers are objects because, well, we name them and make statements about them. For example, numerals can flank the "=" sign. That numbers are objects, on this conception, supervenes on logical form. This logical concept of an object is not a picture-dependent concept, to be sure; it is, rather, a language-dependent one. In both instances, objects are, as it were, "made for" our modes of representing them. Thanks to Matt Boyle for provoking this line of thought. For more on a conception of ontology as supervenient on logical form, see Ricketts 1986.

16. We mustn't forget *logos*. Thanks to Eva Lucia Backhaus for making this point, although not in so many words, and also Shane Butler, who criticized me along these lines in a public exchange at Johns Hopkins in 2017.

17. Ruskin 1857/1971, see 27 and 28.

18. Ruskin (1857/1971, 27) writes, "The whole technical power of painting depends on our recovery of what may be called the *innocence of the eye*; that is to say, of a sort of childish perception of these flat stains of colour, merely as such, without consciousness of what they signify,—as a blind man would see them if suddenly gifted with sight" (emphasis in the original).

19. Merleau-Ponty, in "Cézanne's Doubt" (1948/1964), represents the painter Cézanne as developing an alternative to Impressionism, on the one hand, and what he calls the Classical Approach to painting, on the other. Cézanne's "task," like Merleau-Ponty's, is tantamount to finding a third way between Empiricism and Intellectualism. This phenomenological challenge is framed by Merleau-Ponty as a striving to attain to a new kind of picture.

20. Eva Backhaus (2022) makes a similar kind of claim. The besetting sin of theories of perception, she argues, is their tendency to be hierarchical, to suppose that there is something like basic seeing and that higher levels of seeing depend on this more basic perception. Against this she argues that perceptual experience is always open, unfixed, multiple, and aspectual. Like me, she proposes that perceptual experience presents something like the unfixedness of an aesthetic opportunity. Backhaus also criticizes earlier work of mine—specifically, the view that when we see, we see both *how things are* and also *how things look from here* developed by me in *Action in Perception* (Noë 2004)—on the grounds that it takes for granted that perspectival seeing—the awareness of how things merely look—is somehow fixed and basic in experience, that we only ever know how things are, in vision, by perceiving how they look. This is a fair criticism (made also, in slightly different forms, by Campbell [2008] and Kelly [2008]). But, as I wrote in my reply to their criticisms: "In fact, it is no part of my view that our awareness of appearances is basic or primitive.... Looks themselves belong to our environment; they are aspects of what there is, of the way things are. We see how things look, then, in seeing things themselves; and we see things

themselves, in seeing how they look (from here or from there). What links this double aspect of experience, I argue, is understanding. I don't first see how a thing looks and then infer that things are thus and so. How things are can show up for me in my perceptual experience because I understand what I see; that is, I see how things look with understanding. Seeing is an activity of exploring how things are by exploring how they look. Seeing isn't something that happens inside us; it is a manner of involvement with the world. It unfolds in the world" (Noë 2008, 691).

21. Descartes believed that we need "to distinguish three grades of sensory response." As he explains, "The first is limited to the immediate stimulation of the bodily organs by external objects; this can consist in nothing but the motion of the particles of the organs, and any change of shape and position resulting from this motion. The second grade comprises all the immediate effects produced in the mind as a result of its being united with a bodily organ which is affected in this way. Such effects include the perceptions of pain, pleasure, thirst, hunger, colours, sound, taste, smell, heat, cold and the like, which arise from the union and as it were the intermingling of mind and body, as explained in the Sixth Meditation. The third grade includes all the judgments about things outside us which we have been accustomed to make from our earliest years—judgments which are occasioned by the movements of these bodily organs" (Descartes 1641/1984, 294–295). For Descartes, visual consciousness is a phenomenon of the "second grade," which is basically conceived of as a kind of picture in the mind.

22. Prinz 2012; Jackendoff 1987.

23. Marr 1982.

24. Cohen, Dennett, and Kanwisher 2016.

25. On "change blindness," see O'Regan, Rensink, and Clark 1996, 1999; Rensink, O'Regan, and Clark 1997; Simons and Levin 1997; O'Regan and Noë 2001; and Noë 2004. The basic idea is that observers frequently fail to see, or to notice, what we might have expected would be easily detected, viz. big changes to what is going on right in front of them.

26. Thanks to Greyson Abid for discussion of Cohen, Dennett, and Kanwisher 2016.

27. Noë 2004.

28. The demolition of such a conception is very much the aim of Merleau-Ponty 1945/2012; Austin 1962; Gibson 1979; Dennett 1991; Latour 2016; as well as Noë 2004. Latour dubs the picture conception "the disease of the Dutch" (2016, 316). He playfully suggests that Descartes and Locke spent so much time looking at Dutch still life painting during their sojourns in Holland that the model of the still life came to infect their understanding of what vision is. And they've passed this intellectual disease on down to their descendants, to us.

29. Noë 2004, 2012, 2015b. I return to this conception of seeing and skills of access in chapter 6.

30. And so it is not surprising that there should have been significant theological debates about whether it is legitimate to allow marks to go proxy for God.

31. The idea that representations are substitutes is developed by Gombrich in *Meditations on a Hobby Horse* (1963). The importance of substitution and a logic of substitution is a central theme in Nagel and Wood 2010.

32. The art historian Heinrich Wölfflin (1929/1932) argued that "vision itself has its history." Whitney Davis draws out the full import of this claim—and I agree with him—when he says that vision itself has an *art* history. As Davis writes, commenting on Wölfflin's position, with which he takes himself to agree, "Styles of depiction— culturally located and historically particular ways of making pictorial representations—have materially affected human visual perception. They constitute what might literally be called *ways of seeing*" (2011, 6, emphasis in the original). I am in full agreement.

33. Tattersall 2017, 2019.

34. Schjeldahl 2013; Goodman 1968.

35. Factum Arte is an important case. Led by Adam Lowe, this Barcelona-based team specializes in reproductions of artworks not for the purposes of forgery but to preserve the works, or to enable them to be seen by audiences who would otherwise lack access to the originals. And so it was appropriate that when they recreated the Borgherini Chapel at the National Gallery in London in 2016, they chose to include the twentieth-century power sockets that were a later add-on. They reproduced the chapel, but as it is, for us, today. (Actually, there were some differences— the reproduction was smaller than the original.)

36. Husserl 1954/1970, 31, emphasis in the original.

37. Merleau-Ponty 1945/2012, 342.

38. Merleau-Ponty 1945/2012, 342.

39. Merleau-Ponty 1945/2012, 333.

40. Merleau-Ponty 1945/2012, 333.

41. Merleau-Ponty 1945/2012, 439.

42. Merleau-Ponty 1945/2012, 345.

43. On the concept of style in Merleau-Ponty, see Matherne 2017.

44. Levine 1983; see also Hurley and Noë 2003.

45. I have argued that you can't read off the character of experience from neural facts alone, for the neural facts govern experience only insofar as they are themselves governed by the larger context of activity and situation of the perceiving animal. See Hurley and Noë 2003; O'Regan and Noë 2001; and Noë 2004 and 2009, for more on this.

46. An idea I first struck upon in *Varieties of Presence* (Noë 2012).

47. As mentioned in an earlier note, I have argued in other writing (e.g., Noë 2004 and 2012) that seeing requires a sensitivity to perspectival properties, e.g., to the way how things look from a place and crucially also to the way how things look from a place varies as you move. Sensorimotor knowledge is precisely the term for this skillful competence. Kelly (2008) has accused me of projecting a painterly conception of detached contemplative seeing onto of ordinary seeing. It now seems true that perspectival seeing, as I thought of it, is quasi-pictorial, or that it is, in the sense of the current discussion, picture dependent. But this is not a theoretical imposition by me. Our visual culture *is* a pictorial culture, and our phenomenology is pictorial (sometimes!).

CHAPTER 5. THE WRITERLY ATTITUDE

1. Here I am inspired by Evan Thompson (2007), who argues that the original explanatory gap is not that of mind and brain, but life and matter.

2. Which is the tradition in which I was educated. Not so in other traditions of European philosophy. See, for example, Jacques Derrida (1967/1997), who takes up the theme directly and anticipates some of the ideas I develop in this chapter.

3. Frege 1879.

4. Wittgenstein 1922, §3.12.

5. Wittgenstein 1953, §122.

6. The example is from Radford 1981.

7. Patel 2008.

8. See D. Schmandt-Besserat 1978 for some evidence in support of this claim, as well as Harris 1986.

9. See Dewey 1934, especially chapters 1–3, for this conception of experience.

10. See Catoni 2017 for more on this.

11. Sandgathe 2017.

12. Harris 1986.

13. Non-alphabetic writing systems raise interesting questions in this connection, but I can't take them up here.

14. Wittgenstein 1953, §7.

15. Harris 1986.

16. This is a controversial claim. There have been many different attempts, some more successful than others, to develop dance notations. And no doubt score making—understood very broadly—is a basic part of the work of most choreographers. But this much is uncontroversial: there is no way of writing down human movement that exerts control over our experience of human movement that is comparable to the ways that writing shapes speech or that musical notation shapes music.

17. Chomsky 1980.

18. A similar idea is suggested by Baker and Hacker 2014.

19. Strawson 1952.

20. Dreyfus 2014.

21. This is perhaps the view of Stanley 2011.

22. Wittgenstein 1923/1933, see §5.6331.

23. This is a main theme of *Action in Perception* (Noë 2004) and *Varieties of Presence* (2012).

24. My point is not merely that we experience speech through text, as Derrida (1967/1997) argues. My point is that whether or not we have texts to hand, whether or not ours is a "written" language, we must already be capable of the attitude to our own activity, which is, as I put it, the moral equivalent of writing. That is, we must already occupy the writerly attitude.

25. This chapter reworks and expands upon material previously published in Noë 2017b.

Chapter 6. The Aesthetic Predicament

1. I revisit this especially in chapter 9.

2. As I argued in *Action in Perception*, Noë 2004; see also O'Regan and Noë 2001.

3. Concepts, as I proposed in *Varieties of Presence* in 2012, are themselves, like sensorimotor skills, skills of access. See also Noë 2015a.

4. Sara Ahmed (2006) makes the link between "spatial orientation" and "sexual orientation." My remarks about affective orientation in the text are indebted to her work. Thanks also to Mariel Goddu (conversation). In joint unpublished work, Goddu and I have explored the ways that something like affective orientation marks a very basic modality of intentionality that seems to be present wherever there is life.

5. It's in an effort to resist this judgmental legacy that many thinkers embrace, as we discussed in chapter 4, something like the idea that to see is to depict, where depiction is thought of on the model of the photograph, as a registration or impression unmediated by judgment. Perception is no judgment, but it isn't a mental picture either.

6. This was Gibson's (1979) central thought in connection with affordances. What an object affords is available to one, directly, in perception, no less so than, say, the shape or size of the thing. And this means that one is not forced to analyze the act of perception of affordances, as Fodor and Pylyshyn (1981) had insisted, as the direct perception of an object *x plus* the *representation* of that object *x as* affording this or that. Perceiving affordances, for Gibson, is not a kind of *seeing as*. Thus it is direct and, in my sense, nonpredicative; see Noë 2015a for more on this. For

general and insightful discussion of affordances, see Chemero 2009; Rietveld and Kiverstein 2014.

7. See chapter 10 for more on Husserl's conception of philosophical reorientation.

8. Wittgenstein 1953, §122.

9. And a further question comes up too for us, as we shall see: What is the ethical significance of all this?

10. As I put it in *Strange Tools* (Noë 2015b), the artwork says, "See me if you can!" That is its motto.

11. Something close to this paragraph, and the one before it, has occurred in earlier writing (e.g., Noë 2012, 2015b). The version here shows my indebtedness to Jochen Schuff.

12. Thanks to Coleman Solis for helpful discussion of this issue.

13. Thanks to Scott Cowan for pressing me on this.

14. See *Strange Tools* (Noë 2015b), chapter 4.

15. These considerations enable us to understand Dewey's famous statement: "By one of the ironic perversities that often attend the course of affairs, the existence of the works of art upon which the formation of an esthetic theory depends has become an obstruction to theory about them" (1934, 1).

16. See also Noë 2021b.

17. *Cognitive science is itself an aesthetic domain*, a fact that cognitive science ignores at its own peril. When we are in the space of the aesthetic, we operate with a different sort of rationality, as Kant understood. We give reasons, we offer grounds, and we make arguments. But it belongs to the very nature of these reasons, grounds, and arguments that they can never be decisive. We can persuade, but we cannot prove. This goes for artworks, but it also goes for us, for we too are aesthetic objects. This is the heart of the cultural problem about cognitive science. It would be dogmatic and irrational to think that we can prove, for example, that a work of art is aesthetically significant. But it is equally dogmatic and irrational to think that we can, as it were, give a definitive accounting of perception, or addiction. We can't use science to evade the aesthetic. So there is something misguided, maybe potentially fraudulent, or even bullying, when the scientist in a white coat tells you what you are (e.g., that you are your brain). (As Cappelletto [2022] demonstrates, neuroscience may in fact, and despite its own self-understanding, be evolving into something like what I am calling an aesthetic space. The brain gives the theme and the frame; but what the brain is, and what we ourselves truly are, this is something that we are inventing collectively.)

18. This is a long-standing topic of discussion in aesthetics; for an insightful investigation, see Ginsborg 1998/2015.

19. Dewey 1934.

20. On this expression "achieving the object": In my tai chi practice, we work hard to relax. *What*, you might object, you *work* to relax? Isn't that somehow incoherent? Relaxation, after all, is a matter of letting go. But that's not how we think of it in tai chi. Relaxation is not letting go; it is not *collapse*. It is something more delicate than that, a kind of awareness joined to the absence of effort and explicit intention. In any case, relaxation, at least as I have come to think of it—based on the research and teachings of Professor Cheng Man-Ch'ing, Benjamin Lo, and Lenzie Williams, but I suppose this goes back to Laozi—is something that we need to achieve. This is a useful comparison for what I mean, above, in the text, about achieving the object. In this case, what is achieved is not, as it were, mere causal connection, but rather something like a relationship or, as I put it below, a communion.

21. We may say, with Wittgenstein, "ethics and aesthetics are one" (1922, §6.421). He also writes, in the same numbered passage, "It is clear that ethics cannot be expressed. Ethics is transcendental." The idea that I go on to develop in this chapter offers a way of understanding Wittgenstein's insight: values are not objects in the world, but the condition of the possibility of any world at all, for they are the means by which we achieve the world's presence. But I disagree with Wittgenstein in this: these values, the background tendencies whereby we achieve the world, can and do become problems for us. Indeed, this is precisely why the work of ethics and aesthetics is one: we work with our values so that we may overcome the blind, and this is aesthetic work.

22. This way of thinking about the ethical is suggested to me by J. Reid Miller in his *Stain Removal: Ethics and Race* (Miller 2017).

23. Reflecting on principles may be one way to give us opportunities to see differently, as I take up in chapter 10.

24. Murdoch 1971, 17.

25. Thanks to Katie Coyne and Coleman Solis for suggesting this problem and also for introducing me to the work of Iris Murdoch.

26. The varieties of presence, the different ways that things can show up, is the central theme of my 2012 book, *Varieties of Presence*.

27. Murdoch writes, "At the level of serious common sense and of an ordinary non-philosophical reflection about the nature of morals it is perfectly obvious that goodness is connected with knowledge: not with impersonal quasi-scientific knowledge of the ordinary world, whatever that may be, but with a refined and honest perception of what is really the case, a patient and just discernment and exploration of what confronts one, which is the result not simply of opening one's eyes but of a certainly perfectly familiar kind of moral discipline" (1971, 38), and also "I use the word 'attention,' which I borrow from Simone Weil, to express the idea of a just and loving gaze directed upon an individual reality. I believe this to be the characteristic and proper mark of the active moral agent" (34).

28. Dewey writes, "In an intellectual experience, the conclusion has a value on its own account. It can be extracted as a formula or as a 'truth,' and can be used in its independent entirety as a factor and guide in other inquiries. In a work of art there is no such single self-sufficient deposit. The end, the terminus, is significant not by itself but as the integration of the parts. It has no other existence" (1934, 57).

29. Waismann 1959, 372. And he continued, "However forceful, it never forces. There is no bullying in philosophy, neither with the stick of logic nor with the stick of language."

CHAPTER 7. FRAGILE BODIES

1. I rely here on Jürgen Trabant's excellent *Vico's New Science of Ancient Signs* (2004).

2. Again, I have in mind here Sara Ahmed's (2006) comparison of spatial orientation to sexual orientation in her *Queer Phenomenology: Orientations, Objects, Others*. It is striking that nonhuman animals manifest the orientation that I am talking about.

3. Fanon 1952, 90, 93.

4. Fanon 1952, 91.

5. Fanon 1952, 89.

6. Fanon 1952, 93.

7. This theme is explored by Susanna Siegel (2006); see also the opposed view developed in Dretske 2015.

8. Almost every nationalist movement or religious orthodoxy of the last two hundred years is born not of self-love and contentment, but as a reaction to the unacknowledged appreciation that we are not special. We invent our pasts and our histories and our unity only when, in a way, all that is already a thing of the past or at least under threat.

9. I appreciated this in *Action in Perception* (2004), one of whose most lively contributions, for me anyway, was the idea that presence is, as I put it there, virtual. No quality, I argued, is so simple that you can take it all in at once, in a glance. A quality is an opportunity, to look here, now there, to be drawn in to what remains a landscape of possibilities, in a fractal-like way. Just as an object has hidden parts, so colors, manifest as they may be, *are* structures of presence and absence so that to know a color is to know what it conceals from you now. This is why I reject the qualia conception of experience.

10. See Brandom's (2019) commentary on Hegel's *Phenomenology of Spirit* for exploration of ideas in the vicinity.

11. I will return to this theme later. Leading proponents include the anthropologist Robert Boyd (2018) and evolutionary biologist Joseph Henrich (2016), but see also Daniel Dennett (2017).

12. On this point, see Boyd 2018; Henrich 2016; Noë 2015b.

13. See Butler's 1990 work *Gender Trouble*.

14. It is important that by "sex" here I mean something human and familiar, something lived from puberty on, e.g., menstruation, pregnancy, body hair, etc., as we encounter these alone and in relation with others. I am not talking about DNA or any other theoretical markers of sex.

15. Hacking 1999.

16. De Beauvoir 1949/1953, 273.

17. In her profound study of de Beauvoir, Sara Heinämaa (2003) shows that de Beauvoir's project is not "constructivist," but, rather, phenomenological, indeed, Husserlian. My own view, which I develop in the "Fragile Bodies" chapter, is in harmony with de Beauvoir under this reading. The bodily expression of sexual difference is itself something entangled and enacted; but it is a deep and inescapable aspect of our lived experience for all that.

18. Laqueur (1990) argues that sex, as this is understood today by biologists, only comes into focus as a biological phenomenon against the cultural background of ideas about men and women and their differences. It is only at the end of the eighteenth century, according to Laqueur, that the idea that there are two sexes gets established. I rely here also on Ruberg 2020. See also Brown 1988/2008 for more on ancient conceptions of sex and reproduction.

19. Butler 1990, 7; quoted in Ásta 2018, 57.

20. See Saul 2012; and Bettcher 2013, respectively, for explorations of the idea that "woman" is ambiguous or that its meaning systematically varies across contexts.

21. Philosopher Alex Byrne (2020) has asserted that women are adult human females, just as vixen are female foxes. Gender is sex and sex is biology. An adult female who occupies a male social and behavioral role is not a female man, but simply a woman acting like a man. But this is just to ignore the fact that human being, unlike fox being, is entangled. Women are very different from foxes; for they are people, and people become what they are in part under the influence of the ways they take themselves to be. Which doesn't mean people have a blank check when it comes to deciding what they are. It does mean that the facts about what a person is are not prior to and independent of their experience of themselves.

22. The phrase "the dream of ethically neutral embodiment" is J. Reid Miller's (Miller 2017, 31).

23. A prominent example of a recent thinker who makes this constitutive claim is Haslanger (2002, 2012).

24. Jenkins (2016) criticizes Haslanger on similar grounds.

25. This is how I understand Haslanger and her commitment not so much to an analytic project as to an ameliorative one. She writes, "I am sympathetic to radical rethinkings of sex and gender. In particular, I believe that we should refuse to use

anatomy as a primary basis for classifying individuals and that any distinctions between kinds of sexual and reproductive bodies are importantly political and open to contest" (Haslanger 2012, 243). Thanks to Deimy Chavez and Andreja Novakovic for discussion of this and related points.

26. This is a reformulation of Miller's (2017) question, although his focus is race. "On seemingly all logically admissible accounts, the idea that racially and otherwise marked bodies could speak the true worth of subjects lacks any reasonable justification, its rhetoric consigned to the language of fantasy and ethical dystopia" (30). And yet the dream of "ethically neutral embodiment" is hardly in the offing. Might it be, he wonders, that "the body marked by race and other material signifiers *could and does attest* to the ethical qualities of the subject?" (29, emphasis in the original). His book looks at race, but it might just as well explore gender, as "a historical instantiation of an irreducible, necessary, and mythic logic that fashions a synthetic arrangement of subjectivity, materiality, and value" (34).

27. Miller 2017. The phrase "dynamically embodied" is mine, not Miller's.

28. Of course, it may very well be that, in this new age of neuroaesthetics, there are composers who try to do just that, to make music responding to "pure feeling," or "pure sound," or maybe "nature," uninflected by shared musical culture. I recently heard of an Ecuadorian musician who credited the birds as his teachers. He seems to have forgotten how much knowledge and cultural memory was already built into the very flute with which he strove to match nature's sounds.

29. The experience of oneself, from the inside, can be a kind of passionate, nonvoluntary, risky, exciting, terrifying, and dangerous navigation through a space of ideas and images about what one is or should be, or can be turned on at the thought of being. This is thematized powerfully in the novel *Detransition, Baby* by Torrey Peters (2021).

30. Miller 2017, 34.

Chapter 8. Existential Style

1. Hollander 1978. I discussed this important text earlier in chapter 4.

2. I invited Hollander to give a lecture on style in relation to fashion in my 2012 seminar on style cotaught with Alexander Nagel jointly at the CUNY Graduate Center and the NYU Institute of Fine Art. She responded sharply with the correction that her writing on clothing had nothing to do with fashion, which was a distinct and to her uninteresting phenomenon.

3. Thanks to Lilian Wilde and Tristan Hedges for conversation about this topic.

4. Aristotle (1920), in his *Poetics*, writes, "Imitation is natural to man from childhood, one of his advantages over the lower animals being this, that he is the most imitative creature in the world, and learns at first by imitation. And it is also natural

for all to delight in works of imitation. The truth of this second point is shown by experience: though the objects themselves may be painful to see, we delight to view the most realistic representations of them in art, the forms for example of the lowest animals and of dead bodies" (§4).

5. Wollheim 1979. See Hopkins and Riggle (2021) for more on the question how artists achieve individual style.

6. As Miller (2017, 30) reminds us, to aspire to color blindness as a social and political ideal is, in a way, to aspire to a kind of illiteracy. The idea that one might learn to see better, or more faithfully, and that in so doing one might learn to overlook race (for example, but the same point goes for other aspects of human identity and cultural embodiment) represents a failure to appreciate the distinctive ways in which race, like other features of style, is precisely intelligibly connected to and expressed in how we really look, that is, in how we visibly are. See Alcoff (2006) for a different view.

7. In connection with style and imitation, consider this from Jeff Dolven's *Senses of Style: Poetry before Interpretation* (2017, 173): "The only way to know a style is by making it. The claim is descriptive: knowing it is having a feeling for its likenesses, trying them on whether or not you act them out. But it is also normative, a discipline, a pedagogy, close to a humanist *imitatio*. To know a style, try it; to know a maker, imitate her. An encounter with style is always with a *how*, and knowing is know-how." Dolven's topic is style in poetry, but the book is a general study of style. A central interest, for Dolven, is style's contradictions, some of which show up in my discussion here: style as something that marks us apart even as it also groups us together, for example.

8. Even within the family there is likely to be variety. In my own case, my mother was born in Brooklyn, raised on Long Island; my father and all his relatives were immigrants. I grew up in New York City, but I didn't acquire my father's German accent, my mother's Long Island one, or the local accent of friends and teachers.

9. Plessner 1961.

10. I once had a conversation with Malcolm Gladwell about this, in which, as I recall, he articulated an idea similar to the one that I am developing here.

11. You can see a vibrant and productive sensitivity to styles on display in the popular television show *The Great British Bake Off*. One of the delightful features of the show is that the baker-competitors always reflect a very diverse sampling of British society, and one of the dimensions along which there is always striking and amusing variation is accent. As a viewer, it's hard not to be struck by the different regional accents; some of them are hard to understand; but it is also noticeable that the participants themselves often mention their own accents and tease each other about their different ways of talking. For example, one character will express a feeling of solidarity with another based on a shared regional origin that is reflected in their

accents. What I want to call attention to is the way different ways of talking don't merely coexist side-by-side in the show (or in the larger community); they coexist side-by-side but always also in comparison and in contrast with each other. Everyone is conscious of and, to some degree I think, amused or even titillated by the open displays of difference; and this must be true, not least, presumably, of the producers who literally curate this particular kind of diversity. The show is like a lesson in how to, and also in what it is to, live up to expectations we have of how "we" are supposed to act and talk. The show directly explores the ways in which language, and style more generally, are entangled.

12. Hacking 1999.

13. This is a place for me to signal my gratitude to Alexander Nagel for many instructive conversations about style.

14. I was recently asked to participate in a test, carried out by Eric Schwitzgebel and colleagues and with the collaboration of Daniel C. Dennett, a former teacher and a friend of mine; the task of test takers was to figure out which of Dennett's putative remarks were actually by him and which were by the text processing system "trained up" on the corpus of his writings. I did reasonably well, getting the right answer seven out of ten times. But that means that at least three times I mistook text cranked out by a machine for Dennett's own words!

15. See Du Sautoy 2019 and Mitchell 2020 for helpful surveys for the non-expert of work in this area. See Smith 2019 for a devastating criticism of the exaggerated claims on behalf of Artificial Intelligence. The classic and original criticism of AI's claims is Dreyfus's *What Computers Still Can't Do* (1972/1992).

16. Binstock 2009.

17. On the relic conception of art, see Nagel 2018, as well as the discussion of Nagel and Binstock in Noë 2021b.

18. This is surely a most important development in AI gaming and arts research: our whole understanding of go and chess, what counts as a good move, has been transformed by computer play. What computers do thus loops down and changes our own conception of what these games are. There is no reason why we won't see similar transformations, or at least, influences on our own lives, thanks to what we can learn from computers and the way that they, as it were, do things differently from us in other areas. My argument is that this is important and wonderful, but not a game changer. There is no artificial intelligence.

19. A similar point is developed by Sean D. Kelly (2019).

20. Gopnik (2013) has argued that even a forgery, to the extent that it succeeds at copying the style of an original, is, properly understood, an authentic move opened up in the space of an artist, a variation on his or her themes. On the topic of using authorship as a locus for art-making, see Gopnik's *Warhol* (2020).

21. Not really. He signed it, after all (using a pseudonym). Also, the urinal is rotated through 180 degrees from its normal orientation in the famous 1917 Stieglitz photograph, and with significant effect (see Weschler 2014 for a discussion). However, it may have been Stieglitz who rotated the urinal. Thanks to Blake Gopnik for this observation (in conversation).

22. Blindness is something not well understood by the nonblind. Most blind people have partial vision of one kind or another. I use the term "deep blindness" to refer to a strong absence of sight sufficient to motivate the disuse of the eyes in almost all perceptual coping. Here I rely on the writings of Georgina Kleege (1999, 2005).

23. The point that I am making is limited in its reach. In *Touching the Rock*, John Hull (1990), who is by then deeply blind, meets a woman whom he finds attractive. When she leaves, he turns to his friend and asks, Is she good-looking? He notes the absurdity of this. Looks are superficial and don't matter as much as we typically think, and anyway, he is blind; he can't enjoy the looks. And yet his attachment to a conception of her as having a look, and thus as having a certain kind of visually indexed social standing, is a commitment that even his blindness cannot loosen.

CHAPTER 9. TOWARD AN AESTHETICS FOR THE ENTANGLEMENT

1. Merleau-Ponty 1945/2012, 59, emphasis in the original.

2. Wittgenstein 1953, §435.

3. This is not formalism. To learn about the larger situation in which a work was made can change the work for us, can alter where we look for its significance, where we think its work is happening. As an example, considers the paintings of Susan Valadon, the subject of an exhibition at the Barnes in Philadelphia in 2021/2022. These paintings take on a whole new life when we learn that the artist is well known not as a painter, but as a model for established painters (all men). No information is off limits where art is at stake, so there is nothing formalist about the position that I am exploring. But the view is, as I would put it, anti-empiricist. *Empirical data is never dispositive.* The art encounter is always an encounter with something that needs to be brought into focus. Data feeds the puzzle; it doesn't provide solutions.

4. Baldwin 1961/1998, 670: "The artist cannot and must not take anything for granted, but must drive to the heart of every answer and expose the question the answer hides."

5. The trigger conception is pretty standard in the field of "neuroaesthetics." I offer a critical assessment of neuroaesthetics in Noë 2015b. For a recent, somewhat less critical appraisal, see Cappelletto 2022.

6. Kant 1790/1978; McDowell 1994.

7. This is a theme in the work of Thomas Leddy (2012) and Yuriko Saito (2010, 2020).

8. Some art historians might be surprised that a point like this even needs making.

9. This is a controversial claim that I pursue in some detail in *Strange Tools* (Noë 2015b).

10. Kant 1790/1978.

11. This point is implicit in the discussion of the writerly attitude and the limitations of the logician's picture of language in chapter 5. It is also a theme in the recent linguistic research of N. J. Enfield (2017) and his collaborators, especially Mark Dingemanse (e.g., Dingemanse, Torreira, and Enfield 2013), work that I discuss in Noë 2018.

12. Wittgenstein 1953, §123.

13. This paragraph is adapted from Noë 2012.

14. Frege 1884/1978.

15. See Kenny 1995 for a user-friendly overview of Frege's contributions to logic and the philosophy of mathematics.

16. Frege 1979, 269.

17. This sort of comment was characteristic of Burton Dreben and Warren Gold-farb, who were teachers of mine (the former when he was already at Boston University, the latter at Harvard).

18. Noë, in preparation.

19. As I discussed in chapter 5 and will pursue further in the discussion of Wittgenstein in the next chapter.

20. Noë 2015b.

21. Trabant 2004; Crease 2019.

22. Dreyfus 2014.

CHAPTER 10. REORIENTING OURSELVES

1. See, for example, Husserl's 1907 letter to the writer Hofmannsthal, in which he wrote, "This method [i.e., the phenomenological one] requires taking a stance towards objectivity which essentially leads away from the 'natural' stance, and which is closely related to the stance and attitude into which your art, as a purely aesthetic one, leads us with regard to objects represented and to the whole surrounding world." For an illuminating exploration of this issue, see Cowan 2020.

2. Husserl 1954/1970, 142–143.

3. Husserl 1954/1970, 143. And he writes, "The visible measuring scales, scale-markings, etc., are used as actually existing things, not as illusions; thus that which actually exists in the life-world, as something valid, is a premise" (125/226).

4. Husserl 1954/1970, 136.

5. As I understand "disinterestedness," in the relevant Kantian context, it bespeaks fairness, impartiality, and lack of bias, but not lack of concern or interest (in the sense of curiosity). One can be deeply invested in an outcome and also disinterested.

6. Husserl 1954/1970, 210, my emphasis.

7. For a valuable exploration of Wittgenstein's philosophy of art, see Schuff 2019.

8. Wittgenstein 1979, 38.

9. Wittgenstein 1979, 38, emphasis in the original.

10. Wittgenstein 1979, 38.

11. Wittgenstein 1979, 38.

12. It is the mistake at the root of what is today called neuroaesthetics and also so-called experimental philosophy (x-phi). See Noë 2015b and Cappelletto 2022 for discussion of neuroaesthetics.

13. As Tom Kozlowsky has suggested (personal communication).

14. Wittgenstein 1967, 27.

15. Wittgenstein 1953, §122. Hacker, in his recent revision to Anscombe's translation of the *Philosophical Investigations*, has translated "übersichtliche Darstellung" as "surveyable representation" instead of "perspicuous representation." The meaning of the root word, *Übersicht*, is overview.

16. Wittgenstein 1953, §123.

17. Wittgenstein 1922/1933.

18. See, e.g., Wittgenstein 1922, §5.5563. And in his earliest writings on logic—notes from August 1914—Wittgenstein insisted that "logic must take care of itself" (Wittgenstein 1961, 2).

19. See Noë (1994) for an exploration of these Wittgensteinian themes.

20. Wittgenstein 1922, §4.002.

CHAPTER 11. THE SEEPAGE PROBLEM

1. Nagel 2012, 3.

2. Nagel 2012, 4.

3. Collingwood 1945, 175.

4. Collingwood 1945, 175, my emphasis.

5. A thought beautifully illustrated in Rembrandt's painting of Dr. Tulp's anatomy class. The artist depicts the students perusing neither the cadaver, nor the demonstration, but the book; for it is the book alone through which they can make sense of what there is before them that they might otherwise plainly see. I take this up in Noë 2021b.

6. Quine's (1951/1953, 42–46) famous remarks on this to the contrary notwithstanding.

7. Thanks to Louis Miller for discussion of this idea (back in 1984 or 1985!).

8. I once heard a famous philosophy professor explain to an audience of graduate students over dinner that Russell was a far greater philosopher than Wittgenstein, for the latter was unclear, he complained, indeed, obfuscatory. This remark was doubly misguided, in my opinion. First of all, philosophy *must* be obfuscatory, if it is philosophy. That is, it operates through unsettling that which is taken for granted, through disturbing the habits of thought and talk by which we find ourselves organized. Second, it is just wildly mistaken to suggest that Russell was clear in any but the most superficial sense. Dreben, in his seminars at Boston University in the early nineties, used to like to emphasize that Russell's surface clarity masked nonsense; and he combined this observation with a celebration of Russell's philosophical importance.

9. Some readers, particularly those sophisticated in arts culture, might balk at my use of "design" as non-art, bound up with engineering and problem solving rather than, as I would put it, reorganization, transformation, and disruption. This is no mere quibble about words. The striking fact about the phenomenon to which I am directing attention—the distinctness of what I am calling "art" and "design"—is the fact of their entanglement. If you are to appreciate the rich, defining, and productive entanglement of art and design, you need to start out with a clear understanding of their difference. Their distinctness is, we might say, a condition of the possibility of their entanglement.

10. Kuhn 1962.

11. Collingwood 1945.

12. For two very different recent explorations of the question of scientific method, see Cowles 2020 and Strevens 2020. Cowles is generally skeptical there is any such thing, whereas Strevens believes that it was the commitment on the part of scientist to "the Iron Rule of Explanation," in effect the requirement of testability, that sets the stage for science's extraordinary accomplishments. Strevens argues that there was something dogmatic, even irrational, about the commitment to this rule of testability; as his subtitle suggests, this irrational commitment gave rise to science with all its power and authority.

13. As Smolin 2013 suggests.

14. See Dreyfus 1991a, 1991b; Dreyfus and Taylor 2015.

15. On felt sense, see Gendlin 1978. See also Peisl 2022.

16. "Primitive normativity" is a central theme in the work of Hannah Ginsborg; see Ginsborg 2006/2015.

17. Heidegger 1929/1962, 94/65, 106/75, 147/112. See also Dreyfus 1991a/2017, 19191b/2017 for more on de-worlding.

18. Putnam 1975; Kripke 1980.

19. This is the point of Wittgenstein's famous discussion of the Standard Meter in *Philosophical Investigations* (1953, §50). Of the standard meter we can neither say that it is, nor that it is not, one meter in length. For its functioning as a standard is a condition of the very sense of the phrase "one meter" or of "this is one meter long."

20. Relevant here is the fact that, as Dupré (2002) argues, science is plural; explanation in biology is very different from what we find in geology, or chemistry, or environmental science. There isn't a theory of everything.

21. Strevens 2020.

22. As Strevens (2020) argues. His subtitle is "How Irrationality Created Modern Science."

CHAPTER 12. NATURE AFTER ART

1. See, for example, Crick 1996; Crick and Koch 1995, 1998; Logothetis 1999; Logothetis and Schall 1989; Leopold and Logothetis 1996, 1999.

2. Noë and Thompson 2004.

3. A partial explanation may have to do with the reliance of some of the relevant experiments on "reports" elicited from electrodes in the brains of anesthetized and immobilized monkeys.

4. See Merleau-Ponty, 1945/2012, 17–18.

5. Walt Whitman, *Song of Myself*, in *Leaves of Grass* (1855/1950, 26).

6. Ginsborg 2006/2015.

7. E.g., Zeki 1999.

BIBLIOGRAPHY

Ahmed, Sarah. (2006) *Queer Phenomenology: Orientations, Objects, Others*. Durham, NC: Duke University Press.

Alcoff, Linda Martin. (2006) *Visible Identities: Race, Gender and the Self*. New York: Oxford University Press.

Arbesman, Samuel. (2016) *Overcomplexity: Technology at the Limits of Comprehension*. New York: Current.

Aristotle. (1920) *Poetics*. Translated by Ingram Bywater. Oxford: Clarendon Press.

Ásta. (2018) *Categories We Live By: The Construction of Sex, Gender, Race, and Other Social Categories*. New York: Oxford University Press.

Augustine. (1995) *Against the Academicians and The Teacher*. Translated by Peter King. Indianapolis: Hackett.

Austin, J. L. (1962) *Sense and Sensibilia*. Oxford: Oxford University Press.

Backhaus, Eva Lucia. (2022) "Der menschliche Blick—Über den Zusammenhang von Wahrnehmen und Handeln." PhD diss., Johann-Wolfgang-Goethe-Universität zu Frankfurt am Main.

Baker, G. P., and P.M.S. Hacker. (2014) *Wittgenstein: Rules, Grammar and Necessity: Volume 2 of an Analytical Commentary on the "Philosophical Investigations," Essays and Exegesis §§185–242*. 2nd ed. Oxford: Wiley-Blackwell.

Baldwin, James. (1961/1998) "The Creative Process." In *James Baldwin: Collected Essays*, edited by Toni Morrison, 669–672. New York: Library Classics of the United States.

Beauvoir, Simone de. (1949/1953) *The Second Sex*. Translated and edited by H. M. Parshley. New York: Alfred A. Knopf.

Bertram, George W. (2019) *Art as Human Practice: An Aesthetics*. Translated by Nathan Ross. London: Bloomsbury.

Bettcher, Talia Mae. (2013) "Transwomen and the Meaning of 'Woman.'" In *Philosophy of Sex: Contemporary Readings*, 6th ed., edited by Alann Soble, Nicholas Power, and Raja Halwani, 233–250. Lanham, MD: Rowman & Littlefield.

Binstock, Benjamin. (2009) *Vermeer's Family Secrets: Genius, Discovery, and the Unknown Apprentice*. New York: Routledge.

Boyd, Robert. (2018) *A Different Kind of Animal: How Culture Transformed Our Species*. Princeton, NJ: Princeton University Press.

Brandom, Robert. (2019) *A Spirit of Trust: Reading Hegel's "Phenomenology."* Cambridge, MA: Harvard University Press.

Brontë, Charlotte. (1847/2007) *Jane Eyre.* London: Penguin Classics.

Brown, Peter. (1988/2008) *The Body & Society: Men, Women & Sexual Renunciation in Early Christianity.* New York: Columbia University Press.

Brumm, Adam, Oktavband, Adhi Agus, Basran Burhan, Hakim Budianto, Rustan Lebe, Jian-xin Zhao, Hadi Priyantno Sulistyarto, Marlon Ririmasse, Shinatria Adhityatama, Iwan Sumantri, and Maxim Aubert. (2021) "Oldest Cave Art Found in Sulawesi." *Science Advances* 7, no. 3: https://www.science.org/doi/10.1126/sciadv.abd4648.

Butler, Judith. (1990) *Gender Trouble: Feminism and the Subversion of Identity.* New York: Routledge.

Byrne, Alex. (2020) "Are Women Adult Human Females?" *Philosophical Studies* 177: 3783–3803.

Campbell, John. (2002) *Reference and Consciousness.* Oxford: Oxford University Press.

Campbell, John. (2008) "Sensorimotor Knowledge or Naive Realism?" *Philosophy and Phenomenological Research* 86, no. 3 (May): 666–673.

Cappelletto, Chiara. (2022) *Embodying Art: How We Think, See, Feel and Create.* New York: Columbia University Press.

Caruana, Fausto, and Italo Testa. (2021) "The Pragmatist Reappraisal of Habit in Contemporary Cognitive Science: Neuroscience and Social Theory: Introductory Essay." In *Habits: Pragmatistic Approaches from Cognitive Science, Neuroscience, and Social Theory,* edited by Fausto Caruana and Italo Testa, 1–37. Cambridge: Cambridge University Press.

Catoni, Maria Luisa. (2017) "Symbolic Articulation in Ancient Greece." In *Symbolic Articulation: Image, Word, and Body between Action and Schema,* edited by Sabine Marienberg, 131–152. Berlin: De Gruyter.

Cavell, Stanley. (1976) *Must We Mean What We Say?* Cambridge: Cambridge University Press.

Chemero, Anthony. (2009) *Radical Embodied Cognitive Science.* Cambridge, MA: MIT Press.

Chomsky, Noam. (1980) *Rules and Representations.* New York: Columbia University Press.

Clark, Andy. (2003) *Natural Born Cyborgs.* Oxford: Oxford University Press.

Clark, Andy. (2008) *Supersizing the Mind: Embodiment, Action and Cognitive Extension.* New York: Oxford University Press.

Clark, Andy, and David J. Chalmers. (1998) "The Extended Mind." *Analysis* 58, no. 1: 7–19.

Cohen, Michael A., Daniel C. Dennett, and Nancy Kanwisher. (2016) "What Is the Bandwidth of Perceptual Experience?" *Trends in Cognitive Sciences* 20, no. 5: 324–335.

Collingwood, R. G. (1924) *Outlines of a Philosophy of Art*. Oxford: Oxford University Press.

Collingwood, R. G. (1925) *Speculum Mentis*. Oxford: Oxford University Press.

Collingwood, R. G. (1945) *The Idea of Nature*. Oxford: Oxford University Press.

Collingwood, R. G. (1954/1970/2003) *R. G. Collingwood: An Autobiography & Other Writings*. Edited by David Boucher and Teresa Smith. Oxford: Oxford University Press.

Cowan, Scott. (2020) "Aesthetic Reflection and Philosophical Reflection: Kant, Husserl, and Beyond." Unpublished manuscript.

Cowles, Henry M. (2020) *The Scientific Method: An Evolution of Thinking from Darwin to Dewey*. Cambridge, MA: Harvard University Press.

Crary, Alice, and Rupert Read, eds. (2000) *The New Wittgenstein*. New York: Routledge.

Crease, Robert P. (2019) *The Workshop and the World: What Ten Thinkers Can Teach Us about Science and Authority*. New York: Norton.

Crick, F. (1996) "Visual Perception: Rivalry and Consciousness." *Nature* 379: 485–486.

Crick, F., and C. Koch. (1995) "Are We Aware of Neural Activity in Primal Visual Cortex?" *Nature* 375: 121–123.

Crick, F., and C. Koch. (1998) "Consciousness and Neuroscience." *Cerebral Cortex* 8: 97–107.

Davidson, Donald. (1975) "Thought and Talk." In *Mind and Language*, edited by Samuel Guttenplan, 7–23. Oxford: Oxford University Press.

Davidson, Donald. (1982) "Rational Animals." *Dialectica* 36: 318–327.

Davis, Whitney. (2011) *A General Theory of Visual Culture*. Princeton, NJ: Princeton University Press.

Dembroff, Robin. (2020) "Escaping the Natural Attitude about Gender." *Philosophical Studies* 178: 983–1003.

Dennett, Daniel C. (1987) *The Intentional Stance*. Cambridge, MA: MIT Press.

Dennett, Daniel C. (1991) *Consciousness Explained*. Boston: Little, Brown.

Dennett, Daniel C. (1995) *Darwin's Dangerous Idea*. New York: Touchstone.

Dennett, Daniel C. (2018) *From Bacteria to Bach and Back Again*. New York: Norton.

Derrida, Jacques. (1967/1997) *Of Grammatology*. Translated by Gayatri Chakravorty Spivak. Baltimore, MD: Johns Hopkins University Press.

Descartes, René. (1641/1984) *Objections and Replies*. In *The Philosophical Writings of Descartes*, edited by John Cottingham, Robert Stoothoff, and Dugald Murdoch, 2:63–397. Cambridge: Cambridge University Press.

Dewey, John. (1934) *Art as Experience*. New York: Penguin.

Dingemanse, Mark, Franciso Torreira, and N. J. Enfield. (2013) "Is 'Huh?' a Universal Word? Conversational Infrastructure and the Convergent Evolution of Linguistic Items." *PLoS One* 8, no. 11: e78273. https://doi.org/10.1371/journal.pone.0078273.

Di Paolo, Paolo, Elena Cuffari, and Hannah de Jaegher. (2018) *Linguistic Bodies*. Cambridge, MA: MIT Press.

Dolven, Jeff. (2017) *Senses of Style: Poetry before Interpretation*. Chicago: University of Chicago Press.

Dretske, Fred. (2015) "Perception versus Conception." In *The Cognitive Penetrability of Perception: New Philosophical Perspectives*, edited by John Zeimbekis and Athanassios Raftopoulos, 163–173. Oxford. Oxford University Press.

Dreyfus, Hubert. (1972/1992) *What Computers Still Can't Do*. Cambridge, MA: MIT Press.

Dreyfus, Hubert. (1991a/2017) "Defending the Difference: The Geistes/Naturwissenschaften Distinction Revisited." In *Background Practices: Essays on the Understanding of Being*, edited by Mark Wrathall, 77–93. Oxford: Oxford University Press.

Dreyfus, Hubert L. (1991b/2017) "Heidegger's Hermeneutic Realism." In *Background Practices: Essays on the Understanding of Being*, edited by Mark Wrathall, 94–108. Oxford: Oxford University Press.

Dreyfus, Hubert L. (2005/2014) "The Myth of the Mental: How Philosophers Can Profit from the Phenomenology of Everyday Experience." In *Skillful Coping: Essays on the Phenomenology of Everyday Perception and Action*, edited by Mark Wrathall, 104–125. New York: Oxford University Press.

Dreyfus, Hubert L. (2014) *Skillful Coping: Essays on the Phenomenology of Everyday Perception and Action*. Edited by Mark Wrathall. New York: Oxford University Press.

Dreyfus, Hubert, and Charles Taylor. (2015) *Retrieving Realism*. Cambridge, MA: Harvard University Press.

Dupré, John. (2002) *Human Nature and the Limits of Science*. Oxford: Oxford University Press.

Du Sautoy, Marcus. (2019) *The Creativity Code: Art and Innovation in the Age of AI*. Cambridge, MA: Harvard University Press.

Eaton, Anne. (2017) "Strange Tools vs. Plain Tools?: Comments on Alva Noë." *Philosophy and Phenomenological Research* 94, no. 1 (January): 222–229.

Enfield, N. J. (2017) *How We Talk: The Inner Workings of Conversation*. New York: Basic Books.

Fanon, Frantz. (1952) *Black Skin, White Masks*. Translated by Richard Philcox. New York: Grove Press.

Fodor, Jerry A. (1975) *The Language of Thought*. Cambridge, MA: Harvard University Press.

Fodor, J. A., and Z. W. Pylyshyn. (1981) "How Direct Is Visual Perception? Some Remarks on Gibson's 'Ecological Approach.'" *Cognition* 9: 139–196.

Forsythe, William. n.d. "Choreographic Objects." https://www.williamforsythe.com /essay.html.

Frege, Gottlob. (1879) *Begriffsschrift, eine der arithmetischen nachgebildete Formelsprache des reinen Denkens*. Halle a. S.: Louis Nebert.

Frege, Gottlob. (1884/1978) *The Foundations of Arithmetic*. Translated by J. L. Austin. Oxford: Blackwell.

Frege, Gottlob. (1979) "Sources of Knowledge of Mathematics and the Mathematical Natural Sciences." In *Posthumous Writings*, translated by Peter Long and Roger White, 267–274. Oxford: Basil Blackwell.

Gendlin, Eugene T. (1978) *Focusing*. New York: Bantam.

Gibson, J. J. (1979) *The Ecological Approach to Visual Perception*. Boston: Houghton Mifflin.

Ginsborg, Hannah. (1998/2015) "Kant on the Subjectivity of Taste." Reprinted in *The Normativity of Nature: Essays on Kant's "Critique of Judgment,"* 15–30. New York: Oxford University Press.

Ginsborg, Hannah. (2006/2015) "Aesthetic Judgment and Perceptual Normativity." Reprinted in *The Normativity of Nature: Essays on Kant's "Critique of Judgment,"* 170–201. New York: Oxford University Press.

Gombrich, Ernst. (1963) *Meditations on a Hobby Horse*. London: Phaedon.

Goodman, Nelson. (1968) *Languages of Art: An Approach to a Theory of Symbols*. New York: Bobbs-Merrill.

Gopnik, Blake. (2009) "The 'Golden' Compass: Dutch Cityscapes Point to Liveliest of Details." *Washington Post*, February 3, 2009.

Gopnik, Blake. (2013) "In Praise of Forgery." *New York Times*, November 2, 2013.

Gopnik, Blake. (2020) *Warhol*. New York: Harper Collins.

Gottleib, Sara, and Tania Lombrozo. (2018) "Can Science Explain the Human Mind? Intuitive Judgments about the Limits of Science." *Psychological Science* 289, no. 1: 121–130.

Grice, H. P. (1962) "Some Remarks about the Senses." In *Analytical Philosophy*, edited by R. J. Butler, 133–153. Oxford: Blackwell.

Hacking, Ian. (1999) *The Social Construction of What?* Cambridge, MA: Harvard University Press.

Haraway, Donna. (1991) *Simians, Cyborgs and Women: The Reinvention of Nature*. London: Routledge.

Harris, Roy. (1986) *The Origin of Writing*. Chicago: Open Court.

Haslanger, Sally. (2002) "Gender and Race: (What) Are They? (What) Do We Want Them to Be?" *Nous* 34, no. 1 (March): 31–55.

Haslanger, Sally. (2012) *Resisting Reality: Social Construction and Social Critique*. New York: Oxford University Press.

Hawking, Stephen, and Leonard Mlodinov. (2010) *The Grand Design*. New York: Random House.

Heidegger, Martin. (1929/1962) *Being and Time*. Translated by John Maquarrie and Edward Robinson. New York: Harper.

Heinämaa, Sara. (2003) *Toward a Phenomenology of Sexual Difference: Husserl, Merleau-Ponty, Beauvoir*. New York: Rowman & Littlefield.

Hempel, Carl G. (1950) "Problems and Changes in the Empiricist Criterion of Meaning." *Revue Internationale de Philosophie*, no. 11: 41–63.

Henrich, Joseph. (2016) *The Secret of Our Success: How Culture Is Driving Human Evolution, Domesticating Our Species, and Making Us Smarter*. Princeton, NJ: Princeton University Press.

Hodder, Ian. (2012) *Entangled: An Archeology of the Relationships between Humans and Things*. Oxford: Wiley-Blackwell.

Hollander, Anne. (1978) *Seeing through Clothes*. New York: Viking.

Hopkins, Robert, and Nick Riggle. (2021) "Artistic Style as the Expression of Ideals." *Philosophers' Imprint* 21, no. 8: 1–18.

Hull, John M. (1990) *Touching the Rock: An Experience of Blindness*. With a foreword by Oliver Sacks. London: Society for Christian Knowledge.

Hurley, Susan L. (1998) *Consciousness in Action*. Cambridge, MA: Harvard University Press.

Hurley, Susan L., and Alva Noë. (2003) "Neural Plasticity and Consciousness." *Philosophy and Biology* 18: 131–168.

Husserl, Edmund. (1907) Letter to Hugo von Hofmannsthal, January 12, 1907, in Husserl, *Briefwechsel*, edited by Karl and Elisabeth Schumann. Dordrecht: Kluwer.

Husserl, Edmund. (1954/1970) *Crisis of the European Sciences and Transcendental Phenomenology: An Introduction to Phenomenological Philosophy*. Translated by David Carr. Evanston, IL: Northwestern University Press.

Jackendoff, Ray. (1987) *Consciousness and the Computational Mind*. Cambridge, MA: MIT Press.

Jenkins, Katherine. (2016) "Amelioration and Inclusion: Gender: Identity and the Concept of Woman." *Ethics* 126 (January): 394–421.

Jonas, Hans. (1966) *The Phenomenon of Life: Towards a Philosophical Biology*. New York: Harper and Row.

Kahneman, Daniel. (2011) *Thinking, Fast and Slow*. New York: Macmillan.

Kandel, Eric. (2016) *Reductionism in Art and Brain Science.* New York: Columbia University Press.

Kant, Immanuel. (1790/1978) *The Critique of Judgment.* Translated by James Creed Meredith. New York: Oxford University Press.

Kelly, Sean D. (2005) "On Seeing Things in Merleau-Ponty." In *The Cambridge Companion to Merleau-Ponty,* edited by Taylor Carmon and Mark B. N. Hansen, 74–110. Cambridge: Cambridge University Press.

Kelly, Sean D. (2008) "Content and Constancy: Phenomenology, Psychology and the Content of Perception." *Philosophy and Phenomenological Research* 76, no. 3 (May): 682–690.

Kelly, Sean D. (2019) "A Philosopher Argues That an AI Can't Be an Artist." *MIT Technology Review,* February 21, 2019. https://www.technologyreview.com/2019/02/21/239489/a-philosopher-argues-that-an-ai-can-never-be-an-artist/.

Kenny, Anthony. (1995) *Frege: An Introduction to the Founder of Modern Analytic Philosophy.* Oxford: Blackwell.

Kleege, Georgina. (1999) *Sight Unseen.* New Haven, CT: Yale University Press.

Kleege, Georgina. (2005) "Blindness and Visual Culture: An Eyewitness Account." *Journal of Visual Culture* 4, no. 2: 179–190.

Krakauer, John W., Asif A. Ghanzanfar, Alex Gomez-Marin, Malcolm A. MacIver, and David Poeppel. (2017) "Neuroscience Needs Behavior: Correcting a Reductionist Bias." *Neuron* 93 (February): 480–490.

Kripke, Saul. (1980) *Naming and Necessity.* Cambridge, MA: Harvard University Press.

Kuhn, Thomas. (1962) *The Structure of Scientific Revolutions.* Chicago: University of Chicago Press.

Laqueur, Thomas. (1990) *Making Sex: Body and Gender from the Greeks to Freud.* Cambridge, MA: Harvard University Press.

Latour, Bruno. (2016) "Sensitizing." In *Experience: Culture, Cognition, and the Common Sense,* edited by Caroline A. Jones, David Mather, and Rebecca Uchill, 315–319. Cambridge, MA: MIT Press.

Leddy, Thomas. (2012) *The Extraordinary in the Ordinary: The Aesthetics of Everyday Life.* Peterborough, CA: Broadview Press.

Leopold, D. A., and N. K. Logothetis. (1996) "Activity Changes in Early Visual Cortex Reflect Monkeys' Percepts during Binocular Rivalry." *Nature* 379: 533–549.

Leopold, D. A., and N. K. Logothetis. (1999) "Multistable Phenomena: Changing Views in Perception." *Trends in Cognitive Sciences* 3: 254–263.

Leslie, Sarah-Jane, and Adam Lerner. (2016) "Generic Generalizations." In *Stanford Encyclopedia of Philosophy,* Stanford University, 1997–. First published April 24, 2016. https://plato.stanford.edu/archives/win2016/entries/generics/.

Levine, Joseph. (1983) "Materialism and Qualia: The Explanatory Gap." *Pacific Philosophical Quarterly* 64, no. 4 (October): 354–361.

Logothetis, N. K. (1999) "Vision: A Window on Consciousness." *Scientific American* 281: 68–75.

Logothetis, N. K., and J. D. Schall. (1989) "Neuronal Correlates of Subjective Visual Perception." *Science* 245: 761–763.

Mack, A., and I. Rock. (1998) *Inattentional Blindness*. Cambridge, MA: MIT Press.

Malafouris, Lambros. (2014) *How Things Shape the Mind: A Theory of Material Engagement*. Cambridge, MA: MIT Press.

Marr, David. (1982) *Vision*. San Francisco: W. H. Freeman.

Matherne, Samantha. (2017) "Merleau-Ponty on Style as a Key to Perceptual Presence and Constancy." *Journal of the History of Philosophy* 55, no. 4 (October): 693–727.

McDowell, John. (1994) *Mind and World*. Cambridge, MA: Harvard University Press.

McGinn, Colin. (2002) *The Mysterious Flame: Conscious Minds in a Material World*. New York: Basic Books.

Merleau-Ponty, Maurice. (1945/2012) *The Phenomenology of Perception*. Translated by Donald A. Landes. New York: Routledge.

Merleau-Ponty, Maurice. (1948/1964) "Cézanne's Doubt." In *Sense and Non-Sense*, translated by Hubert L. Dreyfus and Patricia Allen Dreyfus, 9–25. Evanston, IL: Northwestern University Press.

Miller, J. Reid. (2017) *Stain Removal: Ethics and Race*. New York: Oxford University Press.

Mitchell, Melanie. (2020) *Artificial Intelligence: A Guide for Thinking Humans*. New York: Farrar, Straus and Giroux.

Montero, Barbara. (2016) *Thought in Action: Expertise and the Conscious Mind*. New York: Oxford University Press.

Murdoch, Iris. (1971) *The Sovereignty of Good*. New York: Schocken Books.

Nagel, Alexander. (2018) "Beyond the Relic Cult of Art." In *Bending Concepts: The Held Essays on Visual Art*, edited by Alexander Nagel and Jonathan T. D. Neil, 127–133. New York: Rail Editions.

Nagel, Alexander, and Christopher S. Wood. (2010) *Anachronic Renaissance*. Cambridge, MA: Zone Books/MIT Press.

Nagel, Thomas. (1974) "What Is It Like to Be a Bat?" *Philosophical Review* 83, no. 4: 435–450.

Nagel, Thomas. (2012) *Mind and Cosmos: Why the Materialist Neo-Darwinian Conception of Nature Is Almost Certainly False*. New York: Oxford University Press.

Neisser, Ulrich. (1976) *Cognition and Reality: Principles and Implications of Cognitive Psychology*. San Francisco: W. H. Freeman.

Noë, Alva. (1994) "Wittgenstein, Phenomenology, and What It Makes Sense to Say." *Philosophy and Phenomenological Research* 54, no. 1 (March): 1–42.

Noë, Alva. (2004) *Action in Perception*. Cambridge, MA: MIT Press.

Noë, Alva. (2007) "Magic Realism and the Limits of Intelligibility: What Makes Us Conscious." In "Philosophy of Mind," edited by John Hawthorne, special issue, *Philosophical Perspectives* 21: 457–474.

Noë, Alva. (2008) "Reply to Campbell, Martin and Kelly." *Philosophy and Phenomenological Research* 86, no. 3 (May): 691–706.

Noë, Alva. (2009) *Out of Our Heads: Why You Are Not Your Brain and Other Lessons from the Biology of Consciousness*. New York: Hill and Wang / Farrar, Straus and Giroux.

Noë, Alva. (2012) *Varieties of Presence*. Cambridge, MA: Harvard University Press.

Noë, Alva. (2015a) "Concept Pluralism, Direct Perception, and the Fragility of Presence." In *Open MIND*: 27(T), edited by Thomas Metzinger and Jennifer M. Windt. Frankfurt am Main: MIND Group. https://doi.org/10.15502/9783958570597.

Noë, Alva. (2015b) *Strange Tools*. New York: Hill and Wang / Farrar, Straus and Giroux.

Noë, Alva. (2016) "Newman's Note, Entanglement, and the Demands of Choreography: Letter to a Choreographer." In *Transmission in Motion: The Technologizing of Dance*, edited by Maaike Bleeker, 228–236. New York: Routledge.

Noë, Alva. (2017a) "Art and Entanglement in *Strange Tools*: Reply to Noël Carroll, A. W. Eaton, and Paul Guyer." *Philosophy and Phenomenological Research* 94, no. 1 (January): 238–250.

Noë, Alva. (2017b) "The Writerly Attitude." In *Symbolic Articulation: Image, Word, and Body between Action and Schema*, edited by Sabine Marienberg, 73–87. Berlin: De Gruyter.

Noë, Alva. (2018) *Infinite Baseball*. New York: Oxford University Press.

Noë, Alva. (2020) "On Alva Noë, *Strange Tools. Art and Human Nature*. Precis and Reply to Critics." *Italian Journal of Aesthetics / Studi d'Estetica* 48, no. 4: https://doi.org/10.7413/18258646144.

Noë, Alva. (2021a) "Entanglement and Ecstasy in Dance, Music, and Philosophy: A Reply to Carrie Noland, Nancy S. Struever, and Thomas Rickert." *Philosophy & Rhetoric* 54, no. 1: 64–80.

Noë, Alva. (2021b) *Learning to Look: Dispatches from the Art World*. Oxford: Oxford University Press.

Noë, Alva. (in preparation) *Show Business*.

Noë, Alva, and Evan Thompson (2004) "Are There Neural Correlates of Consciousness?" *Journal of Consciousness Studies* 11 (1): 3–28.

Noland, Carrie. (2021) "Choreography as Breakdown. Alva Noë and Dance." *Philosophy & Rhetoric* 54, no. 1: 45–62.

Offit, Paul A. (2017) *Pandora's Lab; Seven Stories of Science Gone Wrong.* Washington, DC: National Geographic Press.

O'Regan, J. Kevin, and Alva Noë. (2001) "A Sensorimotor Approach to Vision and Visual Consciousness." *Behavioral and Brain Sciences* 24, no. 5: 939–973.

O'Regan, J. K., J. A. Rensink, and J. J. Clark. (1996) "'Mud Splashes' Render Picture Changes Invisible." *Investigative Ophthalmology and Visual Science* 37: S213.

O'Regan, J. K., R. A. Rensink, and J. J. Clark. (1999) "Change-Blindness as a Result of 'Mudsplashes.'" *Nature* 398: 34.

Patel, Aniruddh D. (2008) *Music, Language, and the Brain.* Oxford: Oxford University Press.

Peisl, Nicole. (2022) "A Moving: Felt Sense Practices and the Not Yet Known." PhD diss., UC–Davis.

Peters, Torrey. (2021) *Detransition, Baby.* New York: One World.

Plato. (1981) *Five Dialogues: Euthyphro, Apology, Crito, Meno, Phaedo.* Translated by G.M.A. Grube. Indianapolis: Hackett.

Plessner, H. (1961) *Lachen & Weinen: Eine Untersuchung nach den Grenzen menschlichen Verhaltens.* Bern: Franke Verlag.

Prinz, Jesse. (2012) *The Conscious Brain: How Attention Engenders Consciousness.* Oxford: Oxford University Press.

Putnam, Hilary. (1975) "The Meaning of 'Meaning.'" In *Language, Mind and Knowledge,* edited by Keith Gunderson, 131–193. Minnesota Studies in the Philosophy of Science 7. Minneapolis: University of Minnesota Press.

Putnam, Hilary. (1992) *Renewing Philosophy.* Cambridge, MA: Harvard University Press.

Quine, W.V.O. (1951/1953) "Two Dogmas of Empiricism." Reprinted in *From a Logical Point of View,* 20–46. Cambridge, MA: Harvard University Press.

Radford, Andrew. (1981) *Transformational Grammar: A First Course.* Cambridge: Cambridge University Press.

Rensink, R. A., J. K. O'Regan, and J. J. Clark. (1997) "To See or Not to See: The Need for Attention to Perceive Changes in Scenes." *Psychological Science* 8, no. 5: 368–373.

Ricketts, Thomas. (1986) "Objectivity and Objecthood: Frege's Metaphysics of Judgment." In *Frege Synthesized,* edited by Leila Haaparanta and Jaako Hintikka, 65–95. Dordrecht: Reidel.

Rietveld, E., and J. Kiverstein. (2014) "A Rich Landscape of Affordances." *Ecological Psychology* 26, no. 4: 325–352.

Ruberg, Willemijn. (2020) *History of the Body.* London: Red Globe Press.

Ruskin, John. (1857/1971) *The Elements of Drawing.* New York: Dover.

Saito, Yuriko. (2010) *Everyday Aesthetics*. Oxford: Oxford University Press.

Saito, Yuriko. (2020) *Aesthetics of the Familiar*. Oxford: Oxford University Press.

Sandgathe, D. M. (2017) "Identifying and Describing Pattern and Process in the Evolution of Hominid Use of Fire." *Current Anthropology* 58, supplement 16 (August): 360–370.

Saul, Jennifer Mather. (2012) "Politically Significant Terms and the Philosophy of Language: Methodological Issues." In *Out from the Shadows: Analytical Feminist Contributions to Traditional Philosophy*, edited by Sharon L. Crasnow and Anita M. Superson, 196–216. Oxford: Oxford University Press.

Schjeldahl, Peter. (2013) "Fakery." *New Yorker*, November 8, 2013. https://www.newyorker.com/culture/culture-desk/fakery.

Schmandt-Besserat, D. (1978) "The Earliest Precursor of Writing." *Scientific American* 238, no. 6 (June): 38–47.

Schuff, Jochen. (2019) *Ästhetisches Verstehen: Zugänge zur Kunst nach Wittgenstein und Cavell*. Paderborn: Wilhelm Fink.

Siegel, Susanna. (2006) "Which Properties Are Represented in Perception?" In *Perceptual Experience*, edited by Tamar Szabo Gender and John Hawthorne, 481–503. New York: Oxford University Press.

Simons, Daniel J., and C. F. Chabris. (1999) "Gorillas in Our Midst: Sustained Inattention Blindness for Dynamic Events." *Perception* 28: 1059–1074.

Simons, D. J., and D. T. Levin. (1997) "Change Blindness." *Trends in Cognitive Sciences* 1, no. 7: 261–267.

Smith, Brian Cantwell. (2019) *The Promise of Artificial Intelligence: Reckoning and Judgment*. Cambridge, MA: MIT Press.

Smolin, Lee. (2013) *Time Reborn: From the Crisis in Physics to the Future of the Universe*. New York: Belknap.

Stanley, Jason. (2011) *Know How*. New York: Oxford University Press.

Sterelny, K. (2010) "Minds: Extended or Scaffolded?" *Phenomenology and the Cognitive Sciences* 9 (4): 465–481.

Strawson, P. F. (1952) *Introduction to Logical Theory*. London: Methuen.

Strawson, P. F. (1979) "Perception and Its Objects." In *Perception and Identity: Essays Presented to A. J. Ayer, with His Replies to Them*, edited by Graham Macdonald, 41–60. New York: Macmillan.

Strevens, Michael. (2020) *The Knowledge Machine: How Irrationality Created Modern Science*. New York: Norton.

Struever, Nancy S. (2020) "'Not Theory, Thought': Collingwood's Early Work on Art." *Philosophy and Rhetoric* 53, no. 1: 21–33.

Tattersall, Ian. (2017) "The Material Record and the Antiquity of Language." *Neuroscience and Biobehavioral Reviews* 81: 247–254.

Tattersall, Ian. (2019) "The Minimalist Program and the Origin of Language: A View from Paleoanthropology." *Frontiers in Psychology* 10: 677. https://doi.org/10.3389/fpsyg.2019.00677.

Thompson, Evan. (2007) *Mind and Life*. Cambridge, MA: Harvard University Press.

Trabant, Jürgen. (2004) *Vico's New Science of Ancient Signs: A Study of Sematology*. Translated by Sean Ward. London: Routledge.

Tulving, E., D. L. Schacter, and H. A. Stark. (1982) "Priming Effects in Word-Fragment Completion Are Independent of Recognition Memory." *Journal of Experimental Psychology: Learning, Memory, and Cognition* 8, no. 4: 336–342.

Varela, Francisco, Evan Thompson, and Eleanor Rosch. (1991) *The Embodied Mind*. Cambridge, MA: MIT Press.

Vico, Giambattista. (1744/1968) *The New Science of Giambattista Vico*. Revised translation by Thomas Goddard Bergin and Max Harold Fisch. Ithaca, NY: Cornell University Press.

Waismann, Friedrich. (1959) "How I See Philosophy." In *Logical Positivism*, edited by A. J. Ayer, 345–380. Glencoe, IL: The Free Press.

Weschler, Lawrence. (2014) "Variation of a Theme by Duchamps." *Glasstire*, June 1, 2014. https://glasstire.com/2014/06/01/variations-of-a-theme-by-duchamp/.

Whitman, Walt. (1855/1950) *Leaves of Grass and Selected Prose*. Edited by John Kouwenhoven. New York: The Modern Library.

Wilde, Oscar. (1889) "The Decay of Lying: A Dialogue." *Nineteenth Century*, no. 143 (January): 35–56.

Wittgenstein, Ludwig. (1922) *Tractatus Logico Philosophicus*. Translated by C. K. Ogden. London: Routledge.

Wittgenstein, Ludwig. (1953) *Philosophical Investigations*. Translated by G.E.M. Anscombe. London: Macmillan.

Wittgenstein, Ludwig. (1961) *Notebooks 1914–1916*. Translated by G.E.M. Anscombe. Oxford: Basil Blackwell.

Wittgenstein, Ludwig. (1967) *Lectures and Conversations on Aesthetics, Psychology, and Religious Belief*. Oxford: Blackwell.

Wittgenstein, Ludwig. (1979) *Wittgenstein's Lectures. Cambridge, 1932–1935. From the Notes of Alice Ambrose and Margaret Macdonald*. Edited by Alice Ambrose. Chicago: University of Chicago Press.

Wölfflin, Heinrich. (1929/1932) *The Principles of Art History: The Problem of the Development of Style in Later Art*. 7th ed. Translated by M. D. Hottingen. London: G. Bell and Sons.

Wollheim, Richard. (1979) "Pictorial Style: Two Views." In *The Concept of Style*, edited by Berel Lang, 183–204. Ithaca, NY: Cornell University Press.

Zeki, Semir. (1999) *Inner Vision: An Explanation of Art and the Brain*. Oxford. Oxford University Press.

INDEX

Abid, Greyson, 234n26

accents, 151, 243n8, 243n11; New York, 150–52

activity: building, 182; cognitivism or intellectualism about human, 86; first-order (*see* organized activity); linguistic, 84–85; making (*see* making activity); natural, 7; organized (*see* organized activity); perceptual, 34, 98; philosophical, 186, 189; picture, 10, 22, 42; reflective, 20; scientific, 187, 203, 205, 209; second-order (*see* making activity); of seeing, 233n20; and style, 63–64, 146; tool-using, 9, 42; writing, 75, 78, 89, 237n24

aesthetic, the, xi, 24, 70, 97, 102, 116, 162–63, 173–74, 185, 190, 192–93, 206, 213–14, 217, 223–24; and art, xii, 100, 109–10, 167–69, 238n17; and cognitive science, 238n17; and conversation, 137, 166, 172; coping with, 102, 109; disagreements of, 54, 173; empirical approaches to, 171–72; and the ethical, 109–12, 114; and gender, 136–38; investigation into, xi, 100, 163; and philosophy, 175, 177–78, 186, 192; and style, 65, 145, 149, 153; values of, 106, 109, 167; Wittgenstein on, 190–96, 239n21

aesthetic attitude, xi, 148, 189–90, 195, 201, 208, 223–24

aesthetic blind, 97, 100–101, 104–5, 109, 169

aesthetic experience, xiii, 105–8, 164–75, 180

aesthetic judgments, 105, 173, 191

aesthetic predicament, 97, 100–101, 104–5, 109, 169

aesthetic response, xiii, 105–8, 164–75, 180

aesthetic work, 104–6, 108–9, 140, 167, 169–71, 173–74, 191–92; fragility of, 173–74, 180

affordances, 49, 100, 121, 237n6

analytic tradition, 73

a prioricity, 67

archaeological records, 76

architecture, 37, 127, 205

Aristotle, 90, 144

art, 4, 7, 83, 104, 108–9, 114, 141–42, 146, 159, 162, 171–72, 178, 245n3; and the aesthetic, xii, 100, 109–10, 167–69, 238n17; and consciousness, 164, 169–70; and culture, 11–12, 166; and design, 204–5, 248n9; ecstatic aim of, xii, 4, 33, 136, 158; and life, xi, 13–14, 30; looping of, 11–12, 22, 97; and making activity, 10, 180; Paleolithic, 6;

entanglement (*continued*)
science, 205, 217; of pictoriality and visuality, 46, 60–62; of picture-art and picture use, 44; of speech and writing, 78, 80, 89
epoché, 147–48, 186, 189, 213
equipment, 49–50; scientific, 201–2
ethical, the, 109–12, 114
Euclid, 87
evolution, 15, 37–38, 180; approaches to cognition based on, 230n11; cultural, 15, 18, 180; Darwinian, 18
experience, 14, 36, 49, 51, 58, 76, 129–30, 161, 219–20, 222, 224, 233n20, 235n45; aesthetic, xiii, 105–8, 164–75, 180; as aesthetic problem, 161–62; felt character of, 68; of language, 61, 79–80, 90, 237n24; language-dependent, 61–62; of seeing, 44–48, 53, 55–58, 60; of sexuality, 7, 80

Factum Arte, 235n35
Fanon, Frantz, 124–25, 139, 150
fashion, xii, 63, 142–43, 153, 242n2
first order, 19, 99, 181; activity of the (*see* organized activity); and second order, 8, 21–22, 28, 86, 180, 214
Forsythe, William, 37
Fountain (Duchamp), 158
Frege, Gottlob, 73, 90, 180, 194; on numbers, 176–78; on objecthood, 233n15

Galileo, 155, 200
gender, 133–39; and the aesthetic, 136–38; concepts of, 136; reorganization of, 137; revolutionaries of, 138; roles of, 80; and sex, 133–36, 138, 241n21
gender-nonconforming people, 138
Genesis, 14–15

Gibson, J. J., 57, 237n6
Gibsonian affordances, 49, 237n6
Ginsborg, Hannah, 223
Goddu, Mariel, 237n4
Gopnik, Blake, 245n21
graphemes, 59
graphical, the, 77, 88; and philosophy, 92, 176, 194
graphical technology, 5, 83, 89
Goodman, Nelson, 64
The Great British Bake Off, 243n11

habit, xii, 11–12, 19–20, 22–23, 34–38, 97, 105; constitutive, 104; creatures of, 8, 12, 35, 143; of dancing, 27, 32–33; failures of, 102–3; level of, 19, 21, 99; and organized activity, 8; resistance to, 8, 12, 24, 132; of talk and thought, 90, 129, 178, 248n8; worldly, 65
Hacking, Ian, 22, 31, 153; on looping, 229n6
Haraway, Donna, 18
Harris, Roy, 80
Hedges, Tristan, 242n3
Hegel, G.W.F., 130
Heidegger, Martin, 184, 211–13
Heideggerian equipment, 49
Henrich, Joseph, 17
Hollander, Anne, 44–45, 71, 142, 242n2
Homo sapiens: anatomically modern, 62, 77; psychologically modern, 7
Humboldt, Wilhelm von, 82
Hume, David, 53
Hurley, Susan, 15
Husserl, Edmund, 31, 33, 117, 200–201, 206, 211; on epoché, 147–48, 186, 189–90; on the lifeworld, 187–88; on reorientation, 100, 145, 186; on style, 65, 67